Shark Bytes

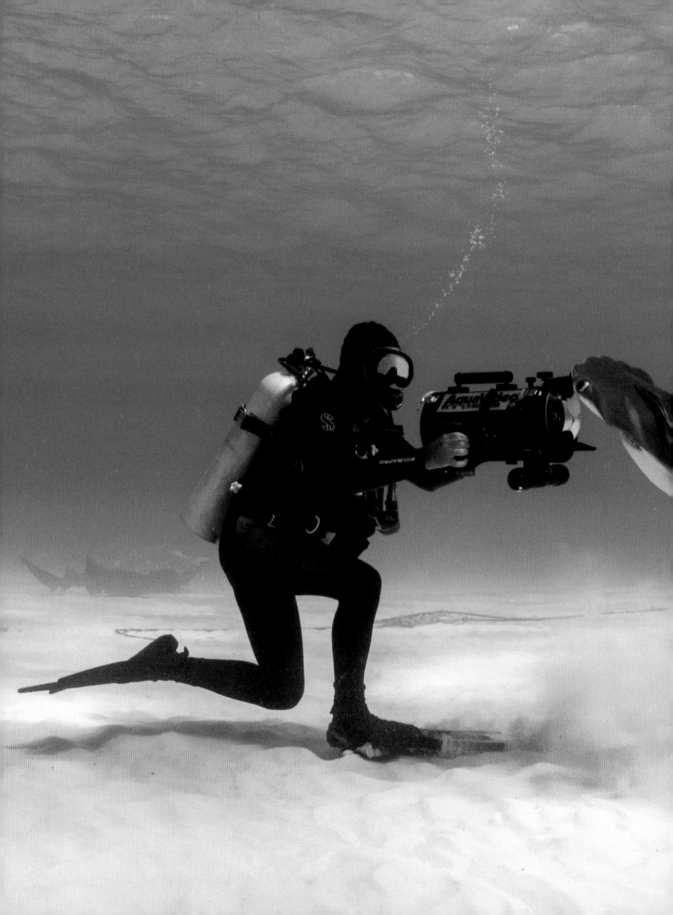

Shark Bytes

Tales of diving with the bizarre and the beautiful

John Bantin

FERNHURST
BOOKS

Published in 2015 by Fernhurst Books Limited

62 Brandon Parade, Holly Walk, Leamington Spa, Warwickshire, CV32 4JE, UK

Tel: +44 (0) 1926 337488 | www.fernhurstbooks.com

A catalogue record for this book is available from the British Library
ISBN 978-1-909911-45-1

Some of the text originally appeared in *Diver Magazine* and is used with their permission.
Tailpiece © Bret Gilliam

All cover photographs © John Bantin, except:
Back cover inset © Bob Semple
All photographs © John Bantin, except:
p148 © Bantin/Mattmueller; p197 © Shane Wasik

Edited by Becky Davidson
Designed by Rachel Atkins
Printed in Italy by Printer Trento

This book is dedicated to the memory of Gary Vanhoeck, dock manager at Stuart Cove's Dive Bahamas, whose life was ended during a failed robbery attempt, May 2015

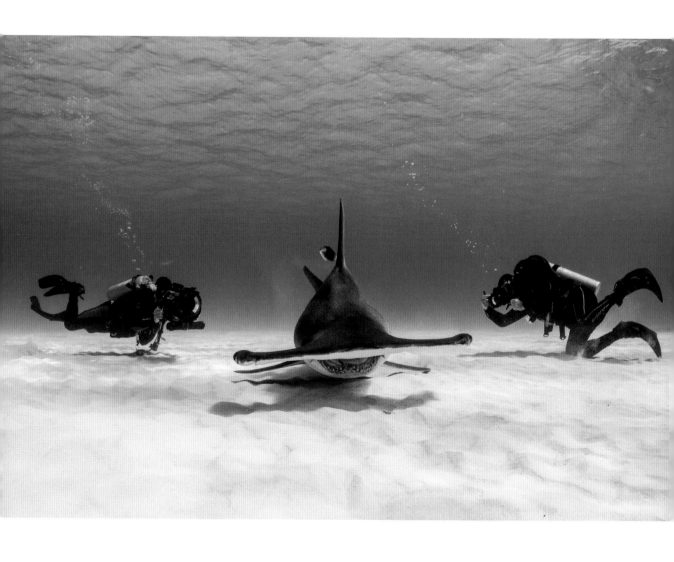

Contents

Introduction

The chilling sight of a dorsal fin cleaving the surface; those unemotional black eyes; the muscular grey body; the mouth full of razor sharp teeth; the popular image of the predatory shark is enough to make you never to want to go into the sea again yet millions of people splash about in the shallows off tropical beaches and many thousands will scuba dive every year. How come so few people get eaten by sharks?

I am not an expert regarding elasmobranchs, the scientific name for the group of animals to which sharks belong. I make no pretension to be such. I am merely a person who has done a lot of diving in tropical waters thanks to a busy career as Chief Correspondent and Technical Editor to Britain's *Diver Magazine*, a career that has spanned more than two decades. I have simply been a 'shark witness'. During that time I have seen attitudes towards shark encounters change dramatically among some divers, as have my own.

When I first learned to dive in the late 1970s, it was commonly thought that divers were at risk from shark attack and should one see a shark, any shark, during a dive, it would be best to leave the water immediately. Pioneer divers like Ron and Valerie Taylor, Dr Eugenie Clark and film cameraman Stan Waterman were breaking that mould but they were exactly that, pioneers. Getting close to sharks was not practice for the likes of ordinary folk. While Valerie was donning a chainmail suit and encouraging sharks to bite her arm, the rest of us sat back to watch on our televisions knowing that it was the act of a daredevil. We were assured sharks were dangerous.

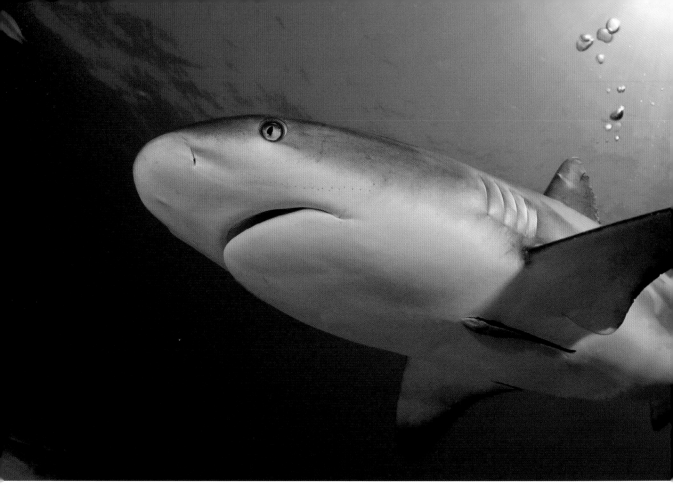

The story by Peter Benchley and consequent film directed by Steven Spielberg, *Jaws*, did nothing to dissuade most of us from that opinion, especially taking into account Robert Shaw's character Quint's monologue about supposedly surviving the shark attacks after the sinking of the USS *Indianapolis*.

Very few people, by and large, witness what happens under water. This gives an opportunity for myths and misconceptions to be turned into perceived facts. The mainstream media revels in such misinformation. When technical diving pioneer Rob Palmer died in the Red Sea, through breathing an unsuitable gas for the depth to which he was going, it was inevitable that some newspapers reported that he had been the victim of a shark attack. When a large group of British and other European divers went missing in 2004 at the Brother Islands in Egypt, the media revelled in their loss in 'shark-infested waters' only to be disappointed when they turned up unharmed, floating at the surface a little more than thirteen hours later. In 2014, the British public was confronted with newspaper headlines such as 'Cornish Snorkeller Almost Swallowed By Shark' along with a picture of someone swimming alongside a huge but harmless basking shark.

On the other hand, it has become a known fact that sharks are essential ingredients in the underwater eco-system of the Planet Earth.

Today, some divers will pay a premium to get very close to sharks, primarily for the purpose of photographing them. Invariably feeding is involved. It's the promise of an easy meal that will

encourage a shark to approach when normally discretion would be its reaction regarding scuba divers.

Other divers want to see sharks on dives but not get uncomfortably close to them. They are happy to watch sharks cruising along reef walls at a safe distance while they cling on, anchored to the reef top in the current that the sharks are obviously enjoying. A majority of divers, along with probably the majority of those that have never set foot in the sea let alone put their heads under the water, still bear an innate fear of shark attack. Each group vehemently defends their position.

The underwater world is nature red in tooth if not claw. Since nearly all the life, even what may look to the uninformed like plants, is animal life, everything is feeding on everything else. We humans are recent newcomers to the environment and, as such, don't fit into any menu that has evolved over millions of years. It gives the scuba diver the opportunity to get close to and study what goes on without actually being involved in it. That said, it cannot be denied that once there is a free source of food in the water, the rules can change and accidents can happen.

Jeremy McWilliam, the British skipper of an early liveaboard dive boat in the Red Sea, sustained a nasty bite in the face from a large moray eel. However, he was in the process of feeding it with bits of bacon held between his teeth! I was partly to blame when a girl got bitten in the face by a conger eel in the Mediterranean. You can read about it in my book *Amazing Diving Stories*. A long time ago I was swimming along a reef wall in Egypt, accompanying diving book author Lawson Wood, when we came across a group of divers in mid-water feeding a large Napolean wrasse with boiled eggs. To our amazement, a large moray eel shot out from the reef and bit away the Napolean's lower lip in an effort to get a share of the food, before dashing back to the safe cover of the reef. The Napolean wrasse hurtled round in panic, as did the accompanying divers. It could have been any one of them that had got injured and it would have been reported no doubt as an unprovoked attack. So one could say that eels are just as dangerous as sharks but no doubt if this book's title had been about eels, you probably would not be reading it!

I have tried to give an evenly balanced account of what it is like to dive with sharks, animals that are at or near the top of the underwater food chain. I have included stories of events that happened to me early in my diving career, both as a leisure diver and a professional. These can reveal how my own attitudes have changed.

This book has been written as the result of personal experience plus the research I did with others that inevitably includes opinion, conjecture and even some imagination! When non-diving friends ask what I would do if I was attacked by a shark, I boast, "I can handle it!"

Of course I could not, but I know that my chances of getting attacked by a shark are statistically far less than being struck fatally by a falling coconut on my way to the dive boat or being killed by a faulty toaster at breakfast.

As I said, I am a witness and I am indebted to other shark witnesses who have shared their knowledge and experience with me. Among hundreds of dive guides, too many to recall, there are also people like Jeremy Stafford-Deitsch, Gary Adkison, Mike Neuman, Stuart Cove and Michelle Cove.

As a new diver I was once afraid of shark attack. However, attending numerous different shark feed dives over the years has shown me that it's mainly man's input that makes the difference as to whether it is safe or not. Since witnessing them in their own environment I have always enjoyed diving close to sharks. The sharks that turn up at these feeds are the ambassadors for the rest of the shark populations of the world, most of which are now in serious decline through man's plundering of the ocean.

However, I will never forget one piece of advice given to me by Stuart Cove, the famous shark wrangler of Hollywood movies. He said, *"Never forget that sharks are at home in their own environment and they have a lot of very sharp teeth."*

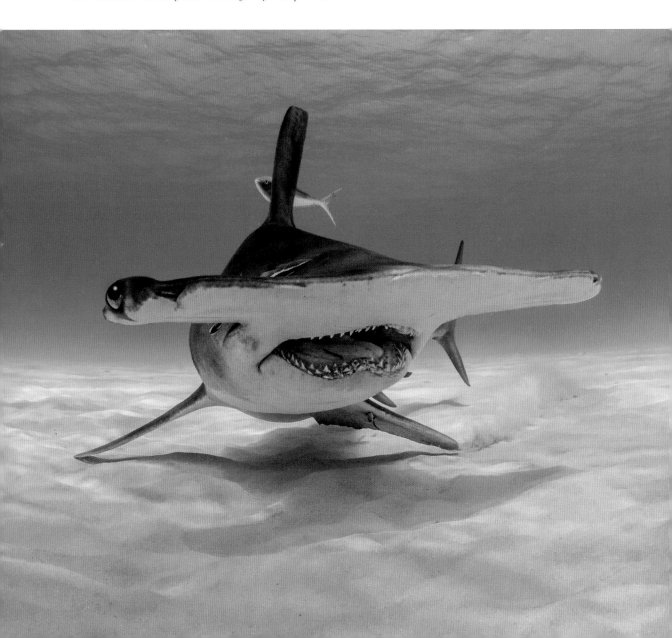

Chapter 1

The Great Hammerhead

When tourist boards organise press trips for journalists, their mission is just as political (in that they try not to upset any of their local suppliers) as it is practical in getting as many column inches of publicity as possible. That's why journalists on press trips to promote holiday destinations usually stay at a different resort every night. It's important to the tourist board that as many different resorts as possible get exposure.

With dive travel this can be quite arduous, especially if the resorts are very many miles apart and involve transfer by air between them. When you add the extra requirement that one should not fly for twenty-four hours after diving, it can make the logistics quite difficult indeed.

My first visit to French Polynesia was subject to this problem. Each resort was on a different island and French Polynesia covers an area as large as that of Western Europe. I contacted each dive centre in advance of my arrival because it meant I had no time to waste.

Flying from Papeete in Tahiti to Rangiroa took nearly two hours and I was not a little uncomfortable because I was already prepared, wearing my wetsuit. Sebastian met me at the tarmac's edge when we landed and we drove the short distance to the dive centre. I was soon kitted up in my diving equipment, camera in hand and off to the famous Tiputa Pass by Zodiac.

It's a narrow channel where the water rips through with the rising tide as it fills Rangiroa's lagoon, the second biggest lagoon in the world. There's a standing wave and a resident pod of dolphins that cavort in it. Underwater, Rangiroa is famous for its huge grey reef shark population

but there's plenty of other stuff too. The flow of oxygenated water is just what requiem sharks love since they can surf on the flow in an effortless way while the current flows through their gills.

I worked my way across the channel not without a lot of effort. With one hand occupied with holding a camera rig, I had only the other to drag myself along with. At one point veritable walls of grey reef sharks surrounded us. Wow! Not only that but there were flotillas of eagle rays and tonnes of other fishes too.

Eventually we two divers were alone in the current. Everything had seemed to magically disappear, making itself suddenly scarce. In a complete change of pace, there were no fish visible. It was surreal. I wondered why we stayed where we were. What were we waiting for?

The fact of the matter was that the time pressure put on by an itinerary written by some bureaucrat disconnected from the practical aspects of scuba-diving had given me little chance of

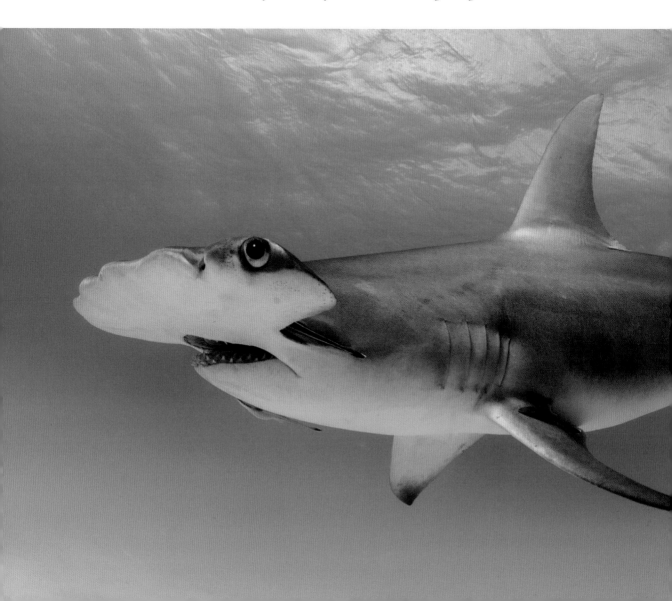

a significant dive briefing before I'd taken to the water. I wasn't expecting what happened next.

I was busy looking at Sebastian. My briefing had been composed of not much more than to stick closely with him. It was at this point a great hammerhead shark (*Sphyrna mokarran*) passed by from behind me. It came past my right shoulder within inches of my head.

This monster was around five metres long from head to tail. To meet such a massively large animal so unexpectedly underwater is unusual to say the least. It passed by me and swam with a gentle gyration of its body and long tail, in an unhurried way off through the limit of underwater visibility. I was so stunned by its sheer size, it made the grey reef sharks look toy-like by comparison and I failed to raise my camera and squeeze off a single shot of it. Evidently, it was frequently seen by Sebastian in the Tiputa Pass but that was the first great hammerhead I saw and I saw it in great close-up, if in rapidly receding perspective.

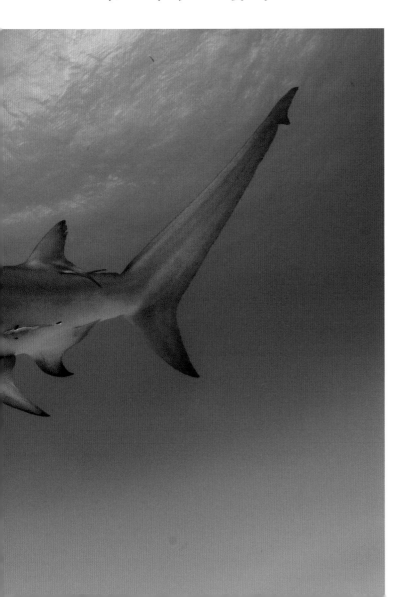

Although I often saw a distant silhouette over sunlit back reefs elsewhere in the world, plus a memorable aerial sequence on YouTube of such a shark chasing a stingray in shallow water, with twists and turns as the ray tried to evade its certain demise, it was to be years before I got so close to one again.

When you find yourself confronted head-on by a great hammerhead shark during a dive, its head held low and swaying from side to side like a fighting bull approaching a matador, it can make you stop for a moment and wonder if you had been wise, if you should have been there. Great hammerheads have a fearsome reputation among shark fishermen. They are among the biggest of the tropical requiem sharks, at up to six metres long and weighing maybe half-a-tonne, and they don't appear to have any natural enemies. Their common name is derived from their sheer size.

They don't school in social groups like the much smaller and very skittish scalloped hammerheads that divers often get so excited to see, neither do they back down when they see a diver. These are lone hunters that roam the colder currents of tropical seas, which is why a good place to encounter them is on the Gulf Stream where it runs close to the islands of The Bahamas. Even so, it's only during a short window in winter when the water is at its coldest, that these magnificent nomadic animals migrate by on their way north.

It's at this time that so-called 'brave and intrepid' shark fishermen head out from Florida to get themselves a big shark and the dose of machismo they feel they need to get from doing so.

"I've killed hundreds of them over the years," claimed a fisherman at North Bimini marina in the Bahamas. "They're dangerous man-eaters and I'm doing the world a favour."

It's all very sad because nothing could be further from the truth. They are big animals with a lot of teeth but they appear to pose no threat to either swimmers or divers.

Bimini is the site of the *Shark Lab*, run by iconic Dr. 'Sonny' Gruber of the *Shark Research Institute*. With the Gulf Stream passing close by the island it's a good place to study a wide range of sharks.

Stuart Cove's girlfriend went to do voluntary work with the *Shark Lab* and discovered that they were tagging great hammerheads. The volunteers, mainly girls like Liz, were free-diving with these big animals and attaching tags to them. It seems they were not the man-killers they were made out to be.

Armed with that information, in February 2013 we went to Bimini with Stuart Cove, Bahamian born and 'Mr Shark' to those in the world of movies. Contrary to common misconception, Stuart Cove is not a place. He's a person. He's been encouraging sharks to come up close to cameras since the making of that scene when Sean Connery as James Bond 007 had a close encounter with a tiger shark when he dived into the wreck of the *'Tears of Allah'*. Stuart Cove has been the shark-wrangler on nearly every movie that has featured sharks since then.

We weren't alone. There were some very well known wildlife cameramen who came along too, including award-winning Andy Brandy Casagrande IV and Frazier Nivens. Video-maker Mark Rackley and his girlfriend Cat Rockett preferred to free-dive with the sharks. Half-a-dozen other keen video pros, several with expensive Red Epic cameras, joined us too, so you can guess YouTube was soon to be flooded with footage gained in that short window of opportunity.

What do great hammerheads eat? They search the sand in the shallow waters of the backreefs for their favourite food source, southern stingrays. They munch through these oblivious to the poisonous spines that the rays impale in their tormentors in a vain attempt at defence. Many of the sharks we saw had the unmistakable evidence of this with spines still lodged around their mouths.

We didn't have access to any stingray carcasses but Stuart's crew had managed to acquire sacks of parrotfish heads and barracuda cleanings from the local fishing dock and these would have to do when it came to shark bait.

People don't eat barracuda for fear of lethal ciguatera poisoning and the sacks of parrotfish

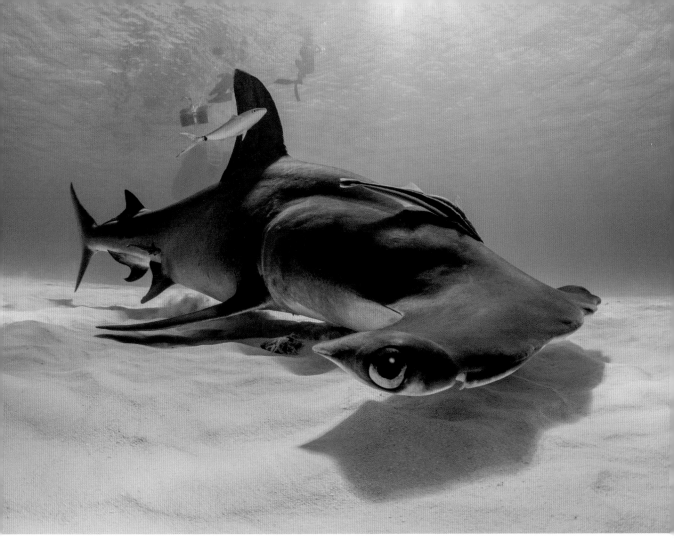

heads were labelled 'grouper heads', something to bear in mind when ordering grouper fillets in restaurants in that part of the world.

Sharks don't simply turn up without reason. The right bait is important. As Liz jokingly likes to say, "They are not like dolphins. You can't simply do yoga at the back of the boat and expect them to appear."

Besides the obvious feeling of trepidation felt when getting into the water with big and unpredictable predators, there was also the worry that none would actually turn up. We got out to the magic spot where Stuart anticipated they might come to and started chumming the water with scrapings from the barracuda. Scales and tiny bits of barracuda flesh drifted away on the current over the deep wall and a nervous couple of hours passed before the first dark tell-tale shape became ominously silhouetted against the white sand below. These boys were big.

With a gentle current persistently pushing across a soft white sandy bottom, we rigged a long rope held in place by Danforth anchors to give us something to keep us on station. Everybody was sworn to a code that included never chasing after a shark. We then divided ourselves into two groups and had forty-five minutes at one time in the water.

We, in the second group, were concerned that only the first group might get the rarely seen footage. We need not have worried. Two or three sharks at one time turned up, drawn in by the tantalising smell given off by two of Stuart's stalwart fish scrapers, standing on the sand behind us and letting a mist of seductive scent drift over us. Beto Barbosa buried parrotfish heads in the sand in front of us and the big animals came in remorselessly looking for the free meal. The show was continuous.

Great hammerheads are magnificent creatures. Big aeroplane-wing-like heads with enormous black eyes at either extremity are swayed from side to side in order for them to both get a complete image in forward vision and for the wide range of electro-receptors, the ampullae of Lorenzini, on the underside to search out possible prey. Set back behind is the mouth, full of very visible flesh-ripping teeth.

Their muscular bodies and long tails give them an amazing turn of speed that is belied in still pictures frozen in time as they are. I needed a very fast shutter-speed with my camera to get sharp pictures. When there's food in the water, sharks don't muck about. Eating is what they're good at.

These great hammerheads are fast, very fast, and we were in their element. With no hard bones to speak of, these big animals can turn in a moment and they did, frequently. I was quite glad I wasn't a stingray.

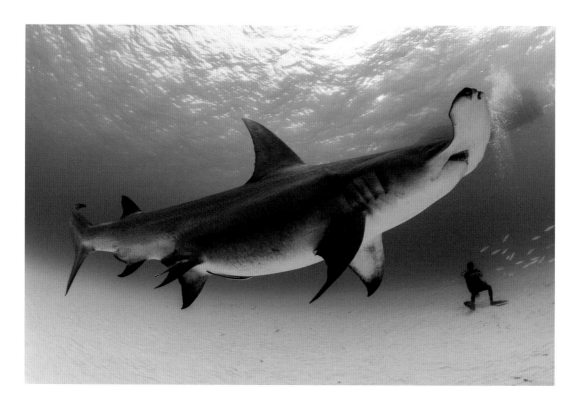

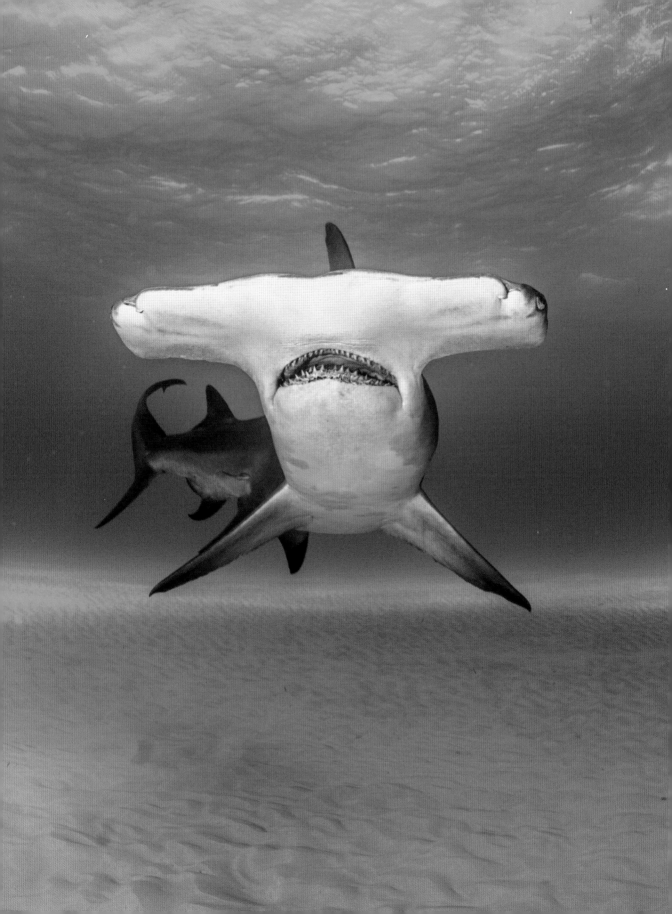

There was never any question of these sharks getting their fill and going away. When you consider the amount of flesh present on a big stingray, the bait we offered amounted to nothing more than canapés, but the sharks seemed to enjoy the game and came in again and again, searching out the treasure of fish heads buried in the sand. We kept station in the current and the sharks swam swiftly around us, sniffing out the seabed and bursting into a flurry of action when they found something. It's an amazing feeling to be in close proximity to such enormous creatures that you knew could destroy you in a moment if they so desired, but they don't. They're only looking for what they normally eat.

In some ways they reminded me of old fashioned upright vacuum cleaners. The males are distinguished from the females by their huge, sharply pointed dorsal fins.

It was ironic that at times we were distracted by a dozen or so slow-moving yet muscular nurse sharks, also drawn up to the back reef by the smell of a free meal and at times getting in the way. It could have been an iconic nurse shark dive if there had not been more spectacular animals to watch and these sharks were smothered with massive remoras clinging to them.

There were moments when we thought the great hammerheads had gone but time and time again they'd reappear wraithlike out of the gloom and without pause come directly to us for the big close-ups, and we were happy to oblige.

Sharks are quick learners. By the third day they were waiting for us as the boat was moored up. We were getting bolder too.

Beto managed to lure the occasional shark up off the seabed into open water so that we could get the classic overhead hammerhead shot. The huge beasts didn't seem interested in the fish he held in his hand and he only needed to put it out of sight behind his back for them to lose interest, not something one might try with some other sharks. There was one exciting moment when a great hammerhead dipped into the sand exactly where Beto stood waiting and picked him up so that he gave us a brief impression of an underwater surfboard rider.

By the fifth day we were getting up to five hours at a time with the sharks. The current had dropped, allowing us to dispense with the rope and sand anchors, the sun shone without break and the sharks stayed around. I was able to get wide-angle close-ups that had been unheard of before. We photographed them at dawn through midday and until dusk. In four days I got more than two-thousand useful pictures of them. The girls with us then wanted to free-dive with them and who we were to stop them? Great hammerheads are not remorseless man-eaters. They are remorseless in their search for prey buried in the sand.

While back in 2013, good pictures of these magnificent animals were rare and only obtained as a result of a fleeting encounter, the word soon got round among keen underwater photographers and by the following year the unique spot where we had been was flooded with dive boats disgorging divers armed with cameras during the short window of opportunity. Today there are endless such pictures available but most of these photographers are so pleased just to have such a magnificent large animal in front of their lenses they do little more than record the image. Few try to get truly iconic photographs.

Chapter 2

Early Experiences in the Bahamas

In 1994 I went to the Bahamas to fulfil a project for an advertising campaign that required sharks to be featured in the pictures. I went with the then famous cave diver, Rob Palmer. I also recounted the experience for the benefit of readers of Diver Magazine.

Rob Palmer looked less than comfortable as he kneeled on the seabed besides the loaded bait box. The chainmail gloves and long sleeves might protect his arms and hands from those ripping razor-sharp teeth, but if he accidentally got bitten he'd certainly sustain a bruise or two through the stainless steel links. The rest of his body, including his head, seemed strangely unprotected by comparison. I wasn't worried. I was armed with my camera and intent on getting some good pictures but I admit my heart was racing.

Rob gingerly opened the box and speared a massive lump of tuna with his over-sized fondue fork. Carefully allowing the lid of the box to fall closed, he offered the meat, doing his best to disallow the attention of a thousand yellowtails and four massive Nassau grouper that had made their way up on to the reef top. A jolly giant green moray eel nuzzled expectantly around his knees.

We each carried tuna meat in our pockets and Kentucky Dave, the resident dive guide and that day's shark feeder, crushed more pieces in his hands, allowing blood and fish oil to mix with the surrounding water.

Suddenly the sharks were upon us. There were about eight or nine of them, circling round. The smallest, at about a metre and a half, was the quickest. The biggest, much bigger than me, wore

decorative remoras or shark-suckers like badges of rank. The groupers understood the pecking order and stood down, relegated to being non-participating spectators of the ensuing action.

A shark swooped in and wrenched the meat away from Rob's spear. The others circled in repeated patterns, disgruntled and searching for easy pickings. Adrenalin pumped through the veins of the warm-blooded section of the audience.

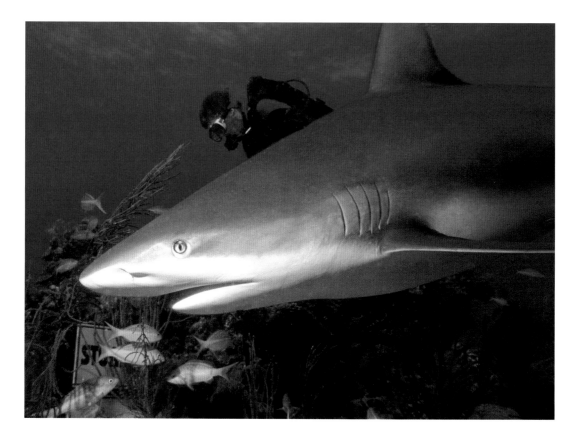

These were female Caribbean reef sharks (*Carcharhinus perezi*), requiem sharks heavy and regularly fed, the stuff of every mariner's nightmares.

I found myself continually within touching distance as they brushed past me, but I was well advised to resist the temptation, although once or twice it was necessary to gently push a heavy old black grouper out from in front of my camera lens.

Rob cautiously felt for another lump of tuna in the bait box. The closest shark snatched it from him, teeth extended in a ferocious sharky snarl. It roughly shook the bait and swam away at pace from the other competing sharks.

Rob continued to offer food. I continued to shoot pictures. We'd been given the special privilege of conducting our own shark feed and things were going rather well. Moving continuously

in a figure of eight, the sharks made repeated passes. Sometimes two would meet in a head-to-head confrontation. Forget the soundtrack from *Jaws*. It was not kettledrums that we could hear. It was the sound of our own hearts thumping.

We had positioned ourselves in a clear sandy area surrounded by coral heads, only a short distance from the deep water of the drop-off. More sharks appeared up from the depths. We were only too aware that a bull shark or a tiger might turn up, join the circus and put a very different complexion on matters. A huge great hammerhead was known to be in the area. An unexpected visitor from the outer blue might not be aware of the rules. However, we were assured that those already present were regulars. Stuart Cove, our host, has spent years studying their behavioural patterns.

People are still under the impression that sharks are voracious unselective predators that will eat anything. Evidence shows that they must be starving before they will do this. The Caribbean reef sharks of the Bahamas definitely show an order of preference for the different kinds of fish used as bait with cuts of reef fish such as grouper top of the list. Nor are the sharks entirely unpredictable. Stuart Cove and his team have proved that these sharks are no more or less predictable than any other animal, in the sea or on land.

Because of our own previous experience, Rob and I had been allowed the privilege of conducting our own shark feed. It's often stated that you cannot dive safely while sharks are feeding. Fifty years ago it wasn't thought safe to dive because of the sharks and twenty-five years ago people didn't night dive for the same reason. Our perspective on these impressive predators is changing continually.

I should point out that conducting private shark feed dives is not without risk. One year later I took a girlfriend, a keen diver, over to the Bahamas and once again we were awarded that privilege of the private shark feed. Such was the effect on her of being so close to the sharks, I ended up marrying her!

<p style="text-align:center">*</p>

In 1998 I travelled to the Bahamas to photograph a television Gladiator with the sharks. The article published in Diver Magazine was written by Nicola Tyrrell.

The voice crackled over the mobile phone, "It sounds like a great idea, but do these sharks ever bite?"

"Only when they are angry," Nicola Tyrrell, the writer from *Diver Magazine* replied.

"OK," the voice laughed. "Gotta go. What time do I need to be at the airport?"

Beefy blond prime-time television Gladiator, James Crossley (stage name: Hunter) had been invited to go to the Bahamas to dive with the sharks and being an utmost competitive individual, he took up the challenge. In the game show he appears to be totally unflappable, super-fit and a giant among men but we quickly discovered his Achilles heel. He suffered from seasickness and the Bahamian weather had taken a turn for the worse with squally weather and an unusually

choppy sea.

Nicola reported that the Caribbean reef sharks with which we were about to dive were responsible for about ninety per cent of all shark attacks in the area. Where she got that information from, we really don't know, but it gave a bit of an edge to the article she wrote. I arranged for my good friend, Canadian Graham Cove, cousin of the owner of Stuart Cove's Dive South Ocean, to be our shark feeder.

Graham sagely advised James to hide his fear. He explained, "A shark will always choose to sink its teeth into the flesh of a wounded fish rather than a human with a tank on his back," but added "But I guess there's no guarantee. These are dumb animals you know…"

We were going to participate in this shark-feeding dive on the flat deck of a wreck that was below us in shallow water. Graham pulled on the long chainmail gloves that protected the full length of his arms.

"Make your way over to the wreck and kneel on the deck. I will be feeding from the bait box. Don't reach out and touch the sharks. If they touch you, which they will do, stay still and don't panic. When the feed is over, I will signal OK and you can safely swim back up to this boat."

Dark shapes circled just beneath the surface but I jumped into the water and the fearless television Gladiator followed me. We descended down the anchor line of our boat but James seemed very reluctant. Maybe the sight of lots of sharks already circling Graham closely below him was putting him off. I went down to where Graham was waiting with the bait box but James stayed way above us. I returned back up the line to him and coaxed him slowly down to the deck of the wreck. It can be very daunting, seeing what you believe are man-eaters, circling around apparently fearless, but James was very competitive and seeing me prepared to swim amongst them, I assumed he'd conquered his fear and he soon joined us.

Nicola described in *Diver* what happened next:

"Suddenly the sharks were everywhere – and so was Hunter's head. Looking up, down, left and right, he was wide-eyed – with fascination or horror, it was hard to tell. Keeping his arms tight against his side, he shuffled a bit nearer to our shark man, who by now was getting into his stride, stroking and nudging the sharks like playful puppies.

Hunter was within arm's reach of the bait box. As one of the stockier sharks swooped in, hyper-extending its jaws to snatch a piece of fish from the feeding stick, it brushed against the side of his head. The Gladiator flinched, but only slightly. Another came at him head-on and, in its haste to grab its food, bumped into his chest, flicked its tail and darted away. Seconds later another shark pounced on the bait, missed its aim and clamped its jaws down on Graham's hand. With an easy shake of his wrist he disentangled himself and pushed it away.

Hunter looked over to me where I was kneeling, out of harm's way. His eyes were like saucers, his head shaking in disbelief, but he was in control."

Twenty-five minutes later the bait was gone and with it the sharks. Afterwards, Nicola reported Hunter as asking, "What was I supposed to do if a shark bit me? Wouldn't we be safer in a suit of armour or in a cage?"

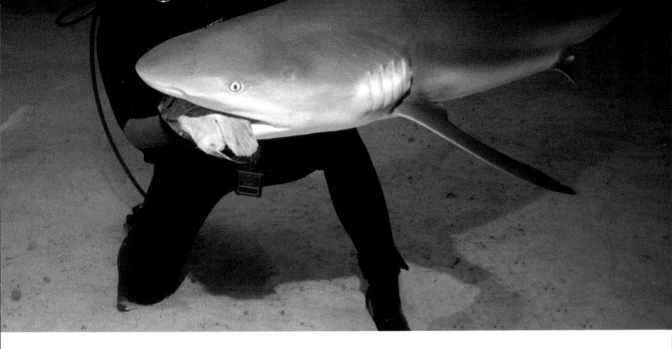

As Graham pointed out, in an effort to dispel the ill-deserved image of sharks as frenzied man-eating beasts he eschewed the full chainmail suit although by two decades later all shark feeders at Stuart Cove's dive centre used them.

"If we were to go into the water wearing full chainmail suits, what kind of message would that give people?" he asked. However, he has been dubbed the 'Bionic Man' by other dive centre staff, thanks to all the nips he has endured during the five years he had been feeding sharks.

As the photographer I had the problem of photographing someone who appeared to be very uncomfortable with the situation. Unbeknown to any of us until later, it was not the sharks that caused the discomfort. A recently certified diver, the brave television Gladiator had forgotten to clear his ears and had ruptured an eardrum during the descent. No wonder he didn't look happy!

*

In 2004, I went to the Bahamas to write a profile of Michelle Cove. She had fed sharks for years, been a stunt double in Hollywood movies, was a mother of two and gorgeous to boot.

When the producers of the Bond movie, *The World Is Not Enough*, needed to shoot an

underwater sequence in the sea, they headed, as they often have in the past, to the Bahamas. More precisely to Stuart Cove's Dive South Ocean dive centre, where the seabed is already littered with the remains of underwater sets from 007 movies. Even the dive centre itself has been a set – it was the fishing village in the film *Flipper*.

The Bond production crew spent five weeks here filming a working model of a submarine. The stunt in the closing sequence of the film sees James Bond (Pierce Brosnan) rescuing Christmas Jones (Denise Richards) from a submarine seconds before it crashes and explodes. They then make a free ascent together.

Stuntman Gavin McKinney took the part of James Bond for the underwater filming and Michelle Cove that of Christmas Jones.

A native Bahamian with the dark good looks of her father's Italian ancestry, Michelle's Canadian education has left her with a North American twang, despite the influence of her mother's Scottish Oban upbringing. Instead this has instilled her with a dry, British sense of humour. She combines the business of diving with being a very capable mother of two. She's the kind of woman that other women admire. As for men – they appear to like her too.

Michelle was known as a 'bodacious babe' when stunt-driving a ski-boat in the movie *Flipper*. The world's diving community, however, better knows her for her partnership with husband Stuart Cove and their successful business, providing shark encounters.

They have built up an enviable reputation for being able to guarantee the presence of sharks both for the countless leisure divers who book for the daily two-tank shark dives, and for the

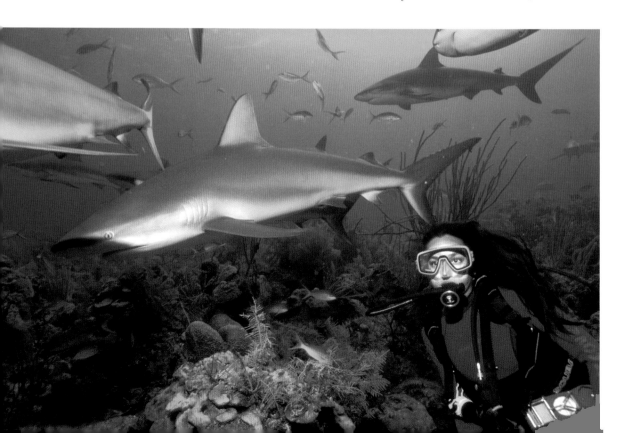

specialised needs of the world's film and television industry.

This side of the business has expanded from Stuart's humble beginnings as an extra hand on an earlier Bond film, *Never Say Never Again*, into Stuart Cove's Underwater Productions, a company that helps out many film and documentary-makers with underwater and shark sequences.

Since then Stuart has been closely involved with work on the film *Deep Blue Sea*, starring Samuel L Jackson.

Michelle has known Stuart since her childhood. "When I was sixteen years old I would come down and hang out with all the cute water sports guys. Stuart certified me as a Dive Master and I would spend the summer helping out, driving boats and so on. The girls back at school wouldn't believe me when I told them about swimming with the silky sharks out at the shark buoy." They can believe it now, as they read about Michelle's unusual life in magazines like *Hello!*

"We used to go out to the US Navy buoy in the Tongue of the Ocean, and do some fishing and then feed the sharks. You know, sharks act very differently when there's fresh-caught fish around.

"Stuart used to scare the pants off me. He started by stroking passing sharks and eventually found that if you caught one by the tail and flipped it on its back it would go torpid. It's called 'tonic immobility'.

We played around, sometimes very foolishly. When you grabbed a shark you could turn it over and aim it at one of your friends before letting it go like a missile. Another trick was to put a little ballyhoo (bait fish) down someone's snorkel!"

Eventually they started feeding the bigger Caribbean reef sharks – using a mesh bag. "It was very dangerous," Michelle admits. "Nowadays it is all very controlled but in those days we just took risks and got away with it."

Michelle's life has changed less than you might imagine since becoming a mother, despite the risks involved in what she does.

"Stuart had me feeding sharks when our son Travis, now three, was only six weeks old," she says. "His nanny would be waiting with him above in the boat so that I could take breaks to feed him.

Responsibility for your kids does settle you down, though. For example, I'm a qualified pilot, but I spend all my time in the back seat now."

It was being bitten by a shark, rather than motherhood, that stopped her from feeding sharks quite so often.

"Once bitten twice shy – it really is true. I lost some of my confidence in my ability to do the job. It was my own fault."

Michelle was controlling the bait box, filled mainly with unwanted parts of grouper carcasses from the fish market, with a length of rope. A shark got the rope caught in its teeth and, in its struggle to free itself, knocked the box over and spilled the entire contents.

"Without thinking I dived in to make things neat. In the free-for-all another shark accidentally bit me in the back of the head. I knew I was hurt, but blood looks green under water. I saw this

dark green cloud around me and felt like I'd been punched."

She had been scalped.

"It was when the boat captain nearly fainted as I climbed on board that I knew things were serious. My scalp was hanging off the back of my head and I was covered in blood. It took quite a few stitches to put it right."

Michelle still works with sharks but prefers not to feed them now. Around forty big specimens usually turn up at each of the feeds and it's quite a physical job.

"I probably don't have enough bodyweight to cope with it," she says. "Being pushed around every day is a lot of work and needs a lot of mental concentration. You have the sharks, the bait box, the videographer and the customers to worry about. I very much enjoy being in the water with sharks, it's just that feeding so many now has become a little too physical."

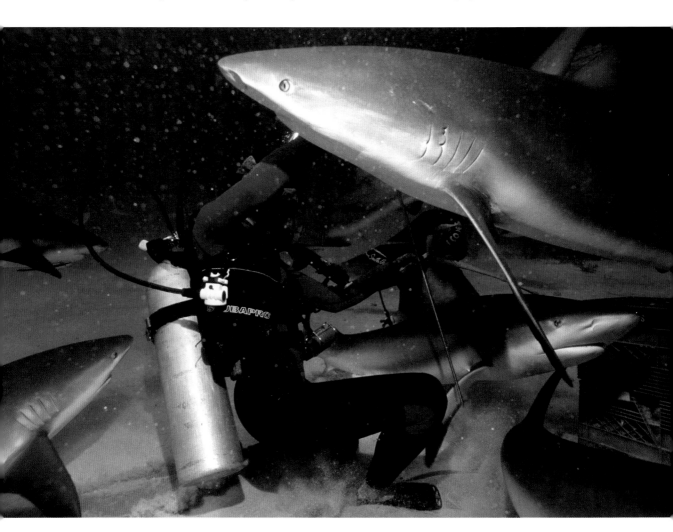

Michelle is well aware of the criticisms that are often levelled at shark-feeding by well-meaning people.

"It's a misconception for people to think that these sharks have lost the ability to hunt," she explains. "Some sharks disappear from feeds for periods of around three months. New sharks are always joining the feed. You cannot adequately feed so many sharks the way we do it. It's always about half-a-dozen dominant sharks that get the food. They are big animals and the amount of bait we offer is just not enough. They are also obviously breeding, so they must be happy."

Another view is that if people like Stuart and Michelle now stop feeding the sharks, someone will get gobbled up because there is no food available. "Unless it's fish, they don't want it," argues Michelle. "My profusely bleeding head proved that. It didn't provoke a feeding frenzy. It's only the feeder who might be in any sort of danger, and then it's from an accidental bite but he wears long chain-mail gloves and uses a short spear to offer the bait and that keeps his hand away from the sharp end."

Customers come for the adrenalin, but it would not be good for business if one were to be bitten. It did happen once, Michelle admitted:

"A customer spontaneously thrust his hand into a passing shark's mouth. He hadn't followed instructions."

Visitors are all told to sit on the bottom and keep arms folded with their hands kept to themselves. The centre always does two consecutive dives and checks that everyone can sit comfortably on the bottom, without waving their hands around, before it does the actual feed.

I needed to photograph Michelle swimming among the sharks for my article so we went to the reef where sharks were known to be. Stuart would swim ahead of us free-baiting the water and I would swim ahead of Michelle, facing backwards with my camera. In this way I got the photographs of Michelle surrounded by sharks, even if it did mean bumping into the occasional shark with the back of my head. Ironically, while we were doing this, a grouper bit Irvin, a local dive guide who was there in the capacity of a safety-diver. It dashed into the ensuing melee to competitively grab some bait and grabbed Irvin instead.

Chapter 3

Whitetip Reef Sharks

The ubiquitous whitetip reef shark (*Triaenodon obesus*) is often the first shark that the person new to diving gets acquainted with. That's because, as the name denotes, these sharks inhabit tropical coral reefs throughout the Indo-Pacific region and since they are nocturnal hunters, they are usually seen lying up during the day, resting.

They are one of the few requiem sharks that can force water through their gills without the need for forward motion so this gives them the advantage that they are able to lie about on horizontal surfaces, sometimes in large groups. Scuba divers may come across them lethargically occupying a patch of sand or a crevice in the reef during daylight hours. The sharks look quite idle and lazy until you get up close to one and it makes a bolt for it. However, at night, when it is time to feed, they become incredibly competitive and voracious, searching out small prey that might be hiding among the rocks or coral.

A site in Ari Atoll well-known for its sharks is Maya Thila. There was a time when I would have described it as the place for the world's most frenetic night dive because there used to be such a large population of whitetip reef sharks together with very many large marble rays, and both these species hunt at night.

Whitetip reef sharks are not very successful hunting in open water so it's the smaller reef inhabitants, asleep in their holes, that become the object of their fatal attention and this species of shark has evolved to be very good at extracting these helpless victims from where they hide. To

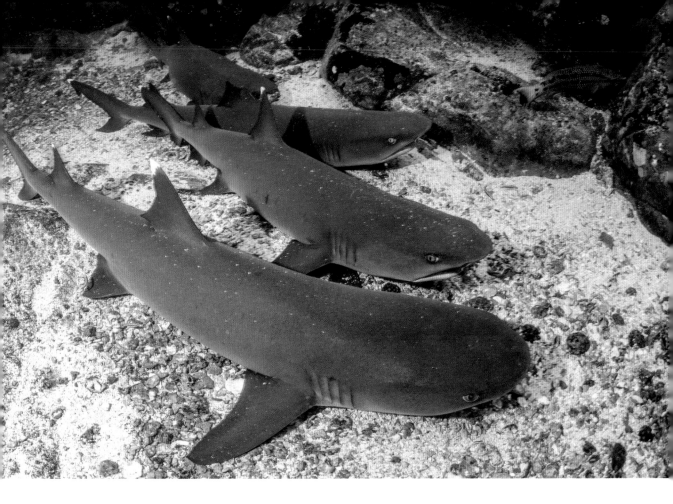

this end they have flexible rubbery bodies and tough skin that allows them to force their way into the tiniest of holes to get at sleeping reef fish and invertebrates without damage to themselves.

At this time the action can become quite violent as great hordes of these slim bodied sharks gather together and compete for the food. One of the most famous places to observe such a nocturnal mass attack of the inhabitants of a reef is Manuelita off the main island of Cocos. Rocks can get moved during the tussles between sharks and in other places with less rocky terrain, corals frequently get broken in the ensuing chaos of thrashing grey bodies.

Divers have to be sure to maintain good buoyancy control in the darkness since to reach out with a steadying hand to push off the boulders would only invite an unwanted bite in the toothy turmoil below.

Of course the whitetip reef shark is by no means at the top of the food chain and although some can grow to approach two metres in length, this noticeably slim bodied shark can itself fall prey to larger sharks. They are often the first sharks to turn up at a staged shark feed dive but they disappear off somewhere else as soon as larger sharks arrive.

Not only that, they are often preyed upon by attackers other than sharks. I have seen a small whitetip reef shark have a lump taken out of it in an instant attack by a large Queensland grouper under cover of darkness. I also once witnessed a large moray eel grab a passing small shark.

Morays have a large number of fine sharply pointed inward facing teeth that means they can

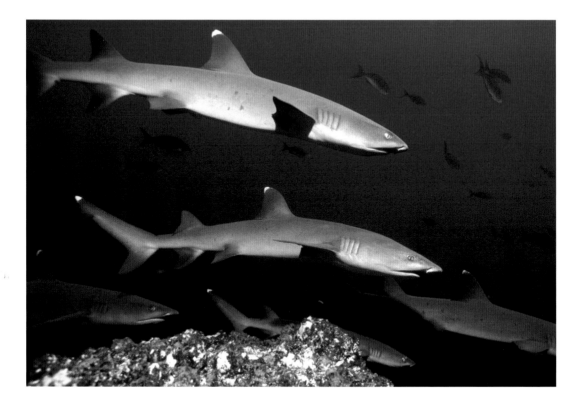

get a grip on their prey and the prey has no hope of escaping. In this case the shark struggled as best it could, bending round on itself in an effort to strike at its attacker but the moray thrashed about in a snake-like way, although it was dragged from the cover of its hole in the ensuing battle.

The shark struggled on endlessly. It wasn't going to give up in any passive way, but because the eel had grabbed it across the mid-point of its body, it was unable to finish off the shark in any meaningful way.

Moray eels like to stay close to topography. They are not normally open water swimmers. The eel was way out into open water before the shark finally made its escape, seemingly none the worse for its experience, while the eel quickly propelled itself back to the comforting cover of the reef.

If you ever have the unusual experience to witness whitetip reef sharks mating (probably the only species of shark that anyone has witnessed enjoying this very private moment), you'll know that the damage inflicted by the male upon the female in the process of grabbing a secure hold of it could be far worse than that inflicted by any moray eel.

During the day, whitetip reef sharks might look like they are posing for the would-be photographer but the challenge for the underwater camera user is to get close enough to obtain a clearly lit image and in doing so must be incredibly patient and move only a tiny amount at one time. Even then, the whitetip reef shark usually flees before you can get close enough.

Typically, whitetip reef sharks can be found in numbers close to a food source. At Sipadan, Malaysia's only truly oceanic island, you'll see lots of these little sharks lying lethargically around. The island is famous as a retreat for green turtles and you'll spy endless numbers of these aquatic reptiles roosting in the coral. They use the soft white sand of Sipadan's beaches to bury their eggs but once they hatch, the little turtle hatchlings are very much on their own and have to fend for themselves. During each full moon the surface of the water can be dotted with tiny turtles attempting to make their way into the world and they make easy pickings for the whitetip reef sharks.

There are so many whitetip reef sharks at Sipadan that the scuba diver starts ignoring their presence just as one might at Cocos Island on the other side of the world in the Eastern Pacific.

During the first of numerous visits to Cocos, I had been so enthralled by the massed schools of scalloped hammerheads that by nightfall my appetite for diving was assuaged. I didn't bother to do any night dives. On my second visit, I was stunned to see the shark action afforded by the thousands of whitetip reef sharks that had learned to take advantage of divers' lights at night, in order to hunt by. Each diver would find himself escorted by literally hundreds of sharks that turned the seabed below into a writhing mass of grey bodies. The night dive at Manuelita Island is probably the most exciting dive of any of the dives, all high-voltage, experienced around Cocos.

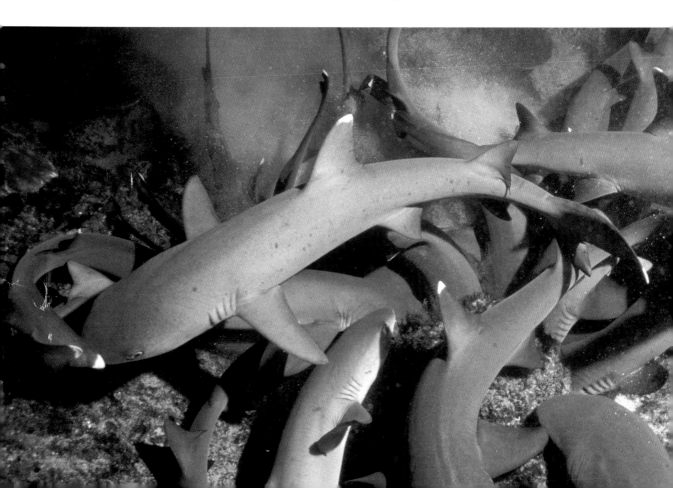

For my own part, I was privately amazed too that I had not been aware of this phenomenon during my first visit and once I returned home I telephoned one of the other divers from my previous trip and asked if there had been any sharks apparent on night dives he had done.

"Oh yes, millions of the buggers," came the laconic confirmation. Somehow, it seems that none of the other passengers had mentioned this astounding night diving experience over dinner and I had completely overlooked the chance to participate in it. I went back to Cocos more than half-a-dozen times after that and never missed another night dive there. There's an evocative description of such a dive in *Amazing Diving Stories*.

At Tubbataha reef, a reef positioned around 100 miles off-shore from Puerto Princesa in the Philippines, there lives a large whitetip reef shark population presumably for the same reason as at Sipadan, although there are no obvious dry beaches. During daylight hours the whole reef top seems to be littered with the bodies of resting whitetip reef sharks that appear oblivious to the presence of divers until the very last moment when all the photographer gets is a tail-end shot of a shark disappearing in a rapidly receding perspective.

I still remember well my first encounter with a whitetip reef shark as a recently certified diver. It was in the early 1980s in the Egyptian Red Sea. Since the water is a little cooler here than in the true tropics, reef sharks tend to be few and far between, but I was swimming along a reef at the Small Gap, a well known dive site off the west side of the Sinai, when I felt my buddy Tom Burton excitedly tugging at my fin.

He signalled 'shark' by making the shape of a dorsal fin on his head with his hand and looked to be quite agitated with excitement. He led me back down along the reef to the entrance of a small cavern in the coral substrate. At the time I had one of those new-fangled underwater video Handycams and a suitably bright video light so I did not hesitate in swimming into the cave.

There, lit up at the far end of the cave, was what was undoubtedly a shark, not big but more than a metre in length, swimming round in circles in an ever more agitated way. It looked more excited than Tom. Round and round it went. It had not occurred to me that I was blocking its only escape route from the cavern and I held the Handycam ahead of me recording on video the actions of this seemingly obliging shark.

Whitetip reef sharks might look lethargic when lying resting on the sandy seabed but they can put on quite a turn of speed when it comes to flight or fight. At some point it decided that it had had quite enough and in a moment that was too fast for me to react to, it stopped its endless circling and hurtled out past my outstretched hands holding the camera and rocketed past the top of my head in a successful effort to reach the safety of open water.

I enjoyed a full head of hair in those days and, not wearing a hood, I felt it carve a parting in my locks as it passed, it was so close. How it managed to get between my head and the ceiling of the cavern, I will never know but that is how I got my first video footage of a 'shark attack' only it was not an attack. It was a 'shark escape' and the shark had moved so quickly it had become nothing much more than a grey blur. It was not only my first encounter with a requiem shark but it had also been a close one.

Chapter 4

The French Connection

To me, when I first started diving in the early 1980s, the French divers I met had a particular style of their own. The men invariably sported a massive moustache, carried their gear in a hessian sack, wore equipment long past its sell-by-date, smoked un-tipped French cigarettes and drank Pastis between dives. The women tended to be merely decorative but they seemed to relish that state of affairs. You may think I'm describing a stereotype but there is no doubt that the majority of French divers did things differently to the rest of us.

In 1992 I took a job as a dive guide on a liveaboard dive boat that made a pioneering cruise each summer down the entire length of the Red Sea from Egypt to Djibouti.

In those days it was a stretch of water surrounded by hostile countries and in that regard it probably isn't that much different today. The diving was adventurous to say the least. The fare paying passengers were drawn from all over Europe and America. We picked up passengers en-route and they tended to stay with us for a one or two-week period before disembarking and being substituted for another group.

My dive briefings were minimal. They used to be along the lines of, "Nobody has ever dived here before so we have no idea what it will be like. Let's get into the water and find out!"

In those days, we were still regularly reminded in dive training manuals that if a shark was sighted we should leave the water immediately. We saw plenty of sharks but we were adventurous and stayed in the water with them.

Heading south after departing from Sharm el Sheikh, we first dived the twin Brother Islands, remote outposts in Egyptian waters, but on my first visit a thick green plankton bloom ruined the visibility. I could not honestly say that I then knew the sites after diving them because I really had been unable to see where I was. I'd have to return on another occasion. However, swimming along the walls, from time to time I would have a head-to-head close encounter with the occasional grey reef shark coming the other way. Each animal was always as startled as I was and disappeared each time with a flick of its tail. Naturally, the passengers blamed me, the hapless dive guide, for the poor conditions. Luckily by the time we got to the waters of the Sudan, further south, the visibility had cleared up. Things went better from then on.

The diving was spectacular. The virgin reefs of the Southern Sudan were teeming with grey reef sharks. Off the coast of Yemen we encountered the wrecks of massive cast iron Victorian-era steam ships. Of course, that said, if anything went wrong in those days, we had no back up whatsoever.

Every day there was an event in the form of a near-catastrophe that needed to be dealt with somehow. Luckily these were usually in the order of different types of mechanical breakdown of our vessel's equipment, which was frightening enough at times, but, as dive guide, my constant fear was that we might have a diving accident to deal with.

It didn't help, one week, when we had a group of French diving instructors on board who insisted on doing dives one-hundred metres deep, to look at schooling scalloped hammerheads while breathing the only gas we had available to fill their tanks with – plain air. They used to say that it was OK because they were experts and knew what they were doing but I used to counter that by saying the only medical facility I had available was a black plastic bag – should we be able to recover the body!

Of course, not all the passengers who booked passages on this very expensive trip were experts at diving or even thought they were. Most were merely those that could afford it. This meant that I had to deal with some pretty difficult situations at times.

Jacques and Yvette were also French. They joined the vessel in Egypt and were to stay on board for three weeks, finally disembarking in Massawa, Eritrea. Jacques enjoyed his sixtieth birthday on board in the company of his much younger wife. Jacques may have fulfilled the aforementioned French stereotype in appearance and he may have borne the same name of the famous French diving pioneer Cousteau, but that was where the similarity ended.

He and beautiful Yvette came on board with logbooks full of the most exciting places to dive in the world. The Maldives, French Polynesia and Costa Rica were only some of them. I was impressed. As the dive guide and supposedly tour manager, I was misled at first into thinking they were experienced divers. Well, they were experienced but their experiences had not always been good, evidently.

The first thing I noticed, once they were in the water, was that neither of them had any idea of buoyancy control. Their ideas about it were ill judged. They thought they should dump air to go down and add air to their BCs (buoyancy compensators) to come up, rather in the way a

submarine might. That may seem likely to a non-diver but any trained diver will tell you that the art of diving includes being neutrally buoyant at all times so that you add air to your BC as you go deeper and release again as you come shallower. You add air to compensate for loss of buoyancy as your wetsuit becomes more crushed by the water pressure.

This knowledge is crucial when diving on the stupendously deep walls of the Sudan. An uncontrolled descent can see you plunging past the safe limits for the gas you are breathing and an uncontrolled ascent can kill you. Burst lungs or crippling decompression sickness, both leading to death, awaits the compressed gas-breathing diver that rockets to the surface even from the shallowest depth.

The risk of an accident of any sort was unthinkable and I found that, in order to keep Jacques and Yvette out of harm's way, I had to devise a safe method to dive with them. I dived alongside them with their BC corrugated hose each in my two hands. In this way I had control of them but no hands free to do much else.

This is where the sharks come into the story. Picture, if you will, Jacques and Yvette swimming side by side with me, the itinerant dive guide, just above them. It must have looked like I had the two of them on the leashes that were actually the corrugated hoses from their BCs. Everything went well until we found ourselves at Elba Reef on the border between Egypt and Sudan, hiding under the upturned hull of the wrecked freighter, the *Levanso*, and watching a massive school of scalloped hammerhead sharks that passed close by.

Jacques would constantly reach out and try to grab the closest one as it passed despite my muffled shouts to desist from trying to do that. He believed that he had paid his money (rather a lot as it happened) to be there and no stupid English dive guide was going to tell him what to do. I began to mentally calculate that I would be able to swim faster than the rather portly Frenchman and, should the sharks finally take offence at his frantic attempts to grab one, I decided that he would be left to his own devices while I made a dash for safety.

I was so inexperienced that I never knew in those days that scalloped hammerheads are normally very skittish and that to be in such close proximity was a privilege in itself. I suppose this phenomenon merely existed because we were on the fringe of a school that numbered maybe thousands and our exhaled bubbles were going up inside the wreck rather than escaping into open water – something that I later learned would send the scalloped hammerheads scattering in a hasty retreat.

Not long after we were further south at a sun-blasted and deserted island called Dahrat Abid, near the border with Eritrea. Again underwater we had a memorable encounter with a large shark, with me closely taking care of the safety of these two French passengers as usual.

A very large silvertip shark decided to take an interest in us. Jacques and Yvette appeared fearless, something I put down to ignorance, but I was certainly wary that this was not a healthy situation to be in.

The shark might have been magnificent but, as it made ever closer and closer passes, I ushered them closer to the reef wall and felt lucky when I found a small cavern in which we could

take cover. The shark was testing our defences, which amounted to none.

The refuge was not an ideal solution because, once we were inside the cavern and looking out into the blue of open ocean, rather like people enjoying the view from a private box at the opera, the shark simply patrolled up and down, effectively trapping us where we were.

It might have given me time to appreciate the silver edges to its pectoral fins, its tail and the tip of its dorsal fin, features from which the species gets its name, but I started to become concerned that although we were relatively shallow, our air supplies were not going to last forever whereas the shark continued to patrol in a timeless way.

The shark came so close at times that it was the first time I was able to notice the rows of tiny holes around its snout. A distinctive feature of most sharks and rays, these are the ampullae of Lorenzeni, which evidently allow the shark the benefit of electro receptors, a sixth sense.

These sensory organs help sharks to sense electric fields generated by prey fish in the water.

These ampullae are jelly-filled canal openings to the skin surface by way of pores, each ending blindly in a cluster of small compartments full of the same jelly.

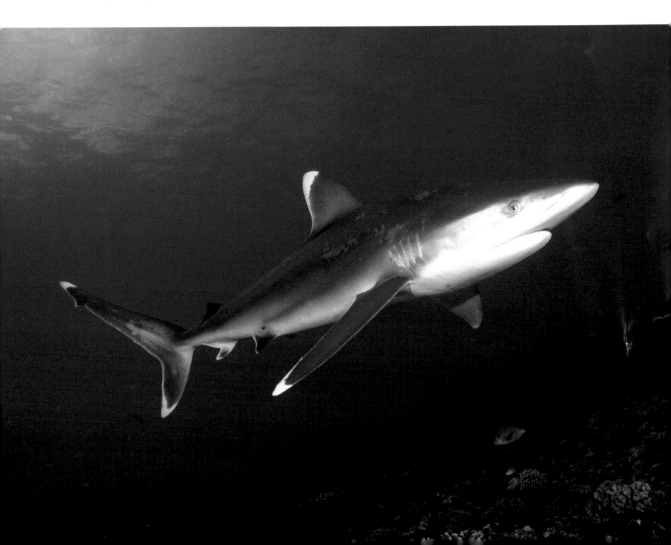

The ampullae are plainly visible as dark spots in the skin, ranged above the mouth, if you are close enough to the shark, and I was.

It could obviously sense my heart beating evermore quickly and I knew I was being considered potential prey. The big silvertip shark would not leave us alone but luckily it was reluctant to swim head-on into the narrow entrance of the cavern. Requiem sharks need perpetual forward motion so that water is forced through their gills in order for them to breathe. They are not good at swimming backwards, a fact that proved to be our salvation.

From time to time the shark would yawn, dropping its jaw and showing an amazing array of dental equipment. There seemed to be rows of serrated teeth behind the forward row. Things were not auguring well for us.

Sharks have a jaw structure that is unique. It makes their mouths especially effective weapons. Unlike most other animals the upper jaw of the shark rests below the skull, but can be detached when the shark attacks its prey. This allows the shark the facility to thrust its entire mouth, otherwise under-slung, well forward to grab onto its prey. This jaw mobility may vary from species to species, but all sharks have this ability to some degree. This big silvertip was affording me a dramatic reminder that to swim out next to it might be among the last things I did.

For their part Jacques and Yvette seemed totally unfazed by the seriousness of our predicament. Jacques would reach out with his hand as the shark came by only for me to snatch his wrist back from danger. I don't know what he was hoping to do apart from sustain a bad bite. He looked at me accusingly through his mask, eyes unnaturally magnified by the refracting effect of the air and water combined, and at that time I could imagine that he was formulating what complaint about my behaviour he would lay on me once we were back on the boat. I, for my part, wondered if we were ever going to make it back to the boat.

Well, at least their apparent ignorance of the gravity of our situation meant that they weren't panicking and I monitored their gauges to see that they were not consuming their precious air supply any faster than I was. However, it was an impasse as far as the big silvertip shark was concerned and it continued to patrol mindlessly up and down in the open water at the entrance to the cavern. We were stuck there.

Eventually we had the luck we were in dire need of. The other divers from our boat came swimming together in a tight cluster along the reef wall and the combined noise of a dozen regulators and the masses of exhaled air they bubbled out into the water was enough to make the shark retreat and finally disappear to look for easier pickings. I returned to the boat exhilarated by the close encounter with such a large beast but unsure as to whether this had been my best dive ever or my worst.

When I later tried to explain my actions, Jacques merely dismissed the possibility of danger with a shrug and a very Gallic "Mon Dieu!"

*

The islands of French Polynesia are famous for their healthy shark populations but not everyone welcomes that. One log from a visiting leisure yacht typically read, "The sea is a perfect azure blue with crystal clear water under an amazingly clear arc of sky. We waited to jump in the water for a refreshing swim as soon as the yacht was securely anchored but could not. The sea was thick around the boat with voracious sharks waiting to eat us."

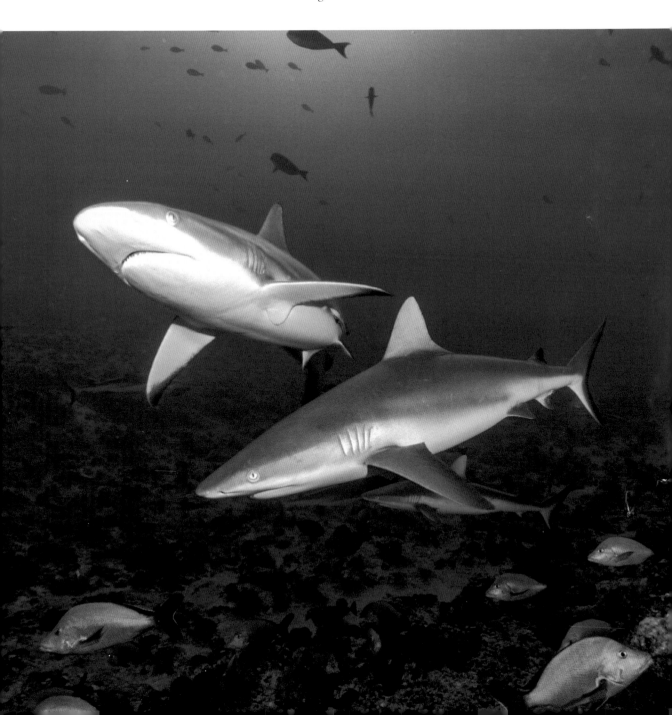

The French connection continued for me the first time I arrived in Tahiti Iti, the tiny promontory of land that is attached to the main island of Tahiti. It is known for some good surfing, where the pressure built up over thousands of miles of Pacific meets the immovable reef wall. It also has some good diving and as soon as I arrived, I met up with the indubitably French owner of the dive centre based there. He immediately took me on a dive.

I soon found myself with him down at fifty-metres deep while he proudly showed me a lot of little yellow gorgonia that stood only a few centimetres high. I was unimpressed. In Egypt, a lot closer to my home, the gorgonia are measured in metres. However, I was down deeper than I would have liked and my air supply was depleting fast because of it. We made our way back to the shallows where my computer told me I needed to stay for twenty minutes before I could safely return to the surface. Alas, I was by this point very short on air remaining in my tank so I tried to stay as relaxed as possible and breathe as lightly as I could. It was during this time I found myself surrounded by pretty little blacktip reef sharks (*Carcharhinus melanopterus*).

They have characteristic black and white dorsal fin markings. They darted around me while I attempted to take pictures of them, at the same time not putting in any effort to swim much myself since that would cause me to inhale harder and use up what little air I had left in my tank.

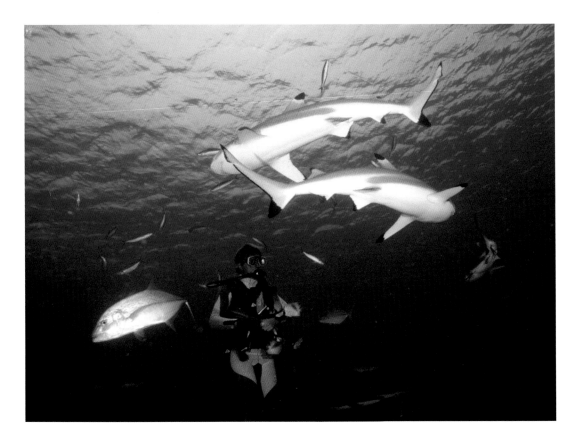

Later, back safely on land, I asked my host why he had taken me down so deep. He replied that gorgonia were very rare. I countered, "Possibly in French Polynesia but not elsewhere." I observed that I was much more interested in the blacktip reef sharks and would have liked to have done a shallow dive and preferred to have spent my time with them. Again I witnessed that typical Gallic shrug and heard the reply, "Mon Dieu! Blacktip reef sharks are very common. What on earth do you want to photograph them for?"

*

These French divers also seemed to be very cavalier about decompression times. At Tikehau, an island in the Tuamotus, I stayed at the Pearl Beach Resort, which has to be one of the most beautiful places I have ever stayed. My luxurious water bungalow even had a glass floor so that I could watch little juvenile blacktip sharks hunting at night among the shallows directly below my bed. The article I wrote about my stay was entitled 'Sunny and Cher', which I thought adequately summed up that part of the world.

Alas, it was otherwise a little boring for me in the evenings since the only other six guests were all on their honeymoon. This meant, once dinner was done, I spent a lot of time in my fabulous bedroom alone.

I was the only experienced diver staying at the resort and the resident dive guide made a special request. This French girl was a rather attractive long-legged blonde who had a predilection for a close-fitting anatomically shaped wetsuit that she pulled on over a bikini so miniscule it was almost non-existent. She had my full attention.

Since there was only one channel out into the ocean from the lagoon where the hotel was, and since the lagoon was so large, she asked if I would mind if we journeyed out in the boat, and stayed out and did two dives rather than coming back for lunch before doing the second as was usual? It was something of a long haul but sandwiches and soft drinks would be provided for the trip.

I saw no problem with this and the next day she and I, together with one of the lady honeymooners, a beautiful Belgian lady who used rented diving equipment, set off in the dive centre's boat. The sea was remarkably blue and the palm fronds rustled in a gentle breeze as we left the dock. One could well appreciate that this place was Paradise on Earth, but it must have taken a good hour to get across the lagoon, through the channel and to the dive site on the ocean side of the atoll. The site was called 'The Shark Cave'.

We swam down more than forty metres deep to a hole in the reef. As we arrived, a hundred or so grey reef sharks came buzzing out of the hole like so many bees disturbed from a hive. The Belgian lady looked quite startled at first as the sharks rushed past her. It was very dramatic because there were simply so many of them, even though none of these sharks had cause to pause or hang around.

Eventually our guide signalled it was time to go back up and I noted that my computer told

me I needed to wait for about ten minutes of decompression stops in shallow water before I could safely climb back into the boat. Decompression stops are calculated as a function of depth and time.

Back on board our guide announced that the next dive would be in twenty minutes time. In my mind that was not enough surface interval to off-gas before subjecting our bodies to the pressure of depth again.

I asked where we would be diving next and was surprised when she bluntly stated that we would be diving in the same place, the Shark Cave. I was anxious that to do so deep a second dive with such a short surface interval was asking for a case of the bends so I insisted that we had at least forty-five minutes and then prevaricated in getting my dive kit ready until the full hour had gone by.

The body needs time to off-gas the nitrogen it has absorbed while under the pressure of depth and it was my opinion that to go back in again for such a deep dive so soon was asking for trouble.

Nevertheless, we were soon down at forty metres again watching a repeat performance of the grey reef sharks, disturbed and buzzing out of the hole in the reef from what was obviously their daytime dormitory. By the time we were back in the shallows, my computer was showing forty-five minutes of decompression-stop time so I hung on the anchor line of the boat and waited it out. Meanwhile the two women, the honeymooner and the dive guide, swam in circles around me, asking from time to time to examine the display on my wrist-mounted computer.

Once we were back on the boat, the dive guide berated me for doing such a long stop.

"I think that ten minutes of stop-time is quite enough," she complained.

"What did your computer say?" I enquired, my curiosity aroused. She tossed her long blonde hair away from her face.

"Mon Dieu! I don't need a computer," came the rather surprising reply.

It was at this juncture that I realised that neither of these two women had really appreciated the hazards of repeat diving to such depths. With such a cavalier attitude to decompression theory, suffering the debilitating bends after two such dives is much more likely than any shark bite.

*

All the Tuamotus in French Polynesia are coral atolls with huge lagoons and narrow channels in and out of them. Some atolls have only one channel so that, although the change in tidal height is very little, the amount of water that must squeeze through the channel with the changing tides is colossal and they become almost river-like, some with standing waves at the surface, during the rise and fall of the tide, four times a day.

Rangiroa has the largest lagoon in the world save that of Kwajalein in the Marshall Islands. It has two channels, known locally as the Tiputa Pass and the Avatoru Pass. You can read about my first experience at Tiputa Pass in Chapter 1, *The Great Hammerhead*.

The current rushes through and there are veritable walls of grey reef sharks enjoying the flow. Once they can surf on a current they no longer need to expend any energy swimming. Hence great aggregations of sharks collect where this strong current is a regular event.

Divers get into the water up current and allow themselves to be washed down through the curtain of sharks before hooking in with a large hook and strong line attached to themselves, to watch the show. It is spectacular.

There are often so many resident grey reef sharks that they can become prey to other larger sharks. Pascal Jagut, a French dive operator based at the Kia Ora hotel, once even managed to photograph a tiger shark chomping on a grey reef shark – a very rare thing to witness indeed. The resulting picture, shot on film, was not of the best quality but very dramatic all the same.

While I was there, Pascal also conducted a shark feed in the less violent environment of the Avatoru Pass. Here grey reef sharks would circle round him waiting for a free hand out of fish, deferring only to the much larger and grander-looking silvertips that turned up. He reminded me very much of a circus ringmaster orchestrating the dangerous beasts but it was all done in a considered and controlled manner.

Other atolls also have passes that afford some spectacular grey reef shark encounters. Fakarava and Apataki are two that come to mind. It's hard to imagine the massive number of grey reef sharks that congregate in these places. The water becomes thick with these grey-suited fish.

The channel at Apataki is so narrow that it is akin to being in a deep gorge with a torrent of water running through it. The force of the water is so strong that at times it becomes impossible to raise an underwater camera to take a picture.

While I was at Apataki with a group of divers I spotted a rock sticking up from the seabed in the channel that I knew would provide me with an eddy – a place where the current would lapse and give me a comfortable position from which to photograph the vast numbers of grey reef sharks that hesitated in a seemingly solid wall of grey bodies further up the channel from us. One of the other divers noticed my chosen position, with me apparently hovering there without effort, and decided to join me. Alas the eddy was not big enough for two of us so he opted to attach himself to me instead. We were then both dragged off by the force of the water passing over us. The effect was similar to the two of us being helplessly tumbled in a washing machine – a washing machine that was full with ravenous sharks. We bumped off quite a few of them before we regained our composure and dragged ourselves back along the seabed to where we had started.

Another time I went with a group of divers from a liveaboard dive boat, the now defunct *Tahiti Aggressor*, led by Bertran, a typically handsome young Frenchman sporting a permanent tan with hair bleached blond by the tropical sun. He was going to conduct the shark feed in one of the two channels at Fakarava. The on board underwater photographer, a cheeky Canadian lad by the name of Mike Veitch, asserted, "We always let the Frenchies do the feeding."

I noticed Bertran did this feeding by carrying the severed head of a mahi-mahi under his arm, cutting off slices with a knife and offering them up to passing sharks with an unprotected hand.

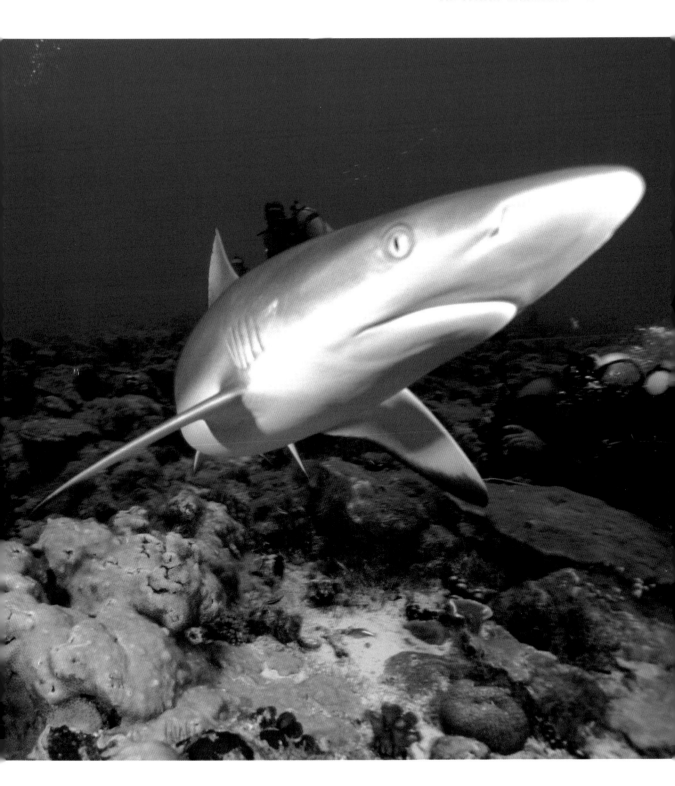

It looked a bit risky to me, positioning his hand so close to those flashing teeth, so during the surface interval I asked him if he didn't think it was dangerous to hold a bit of dead fish in his hand and allow a passing shark to take it from him. Bear in mind that sharks close their eyes with a nictitating eyelid at the last moment when they bite and in doing so are sometimes less than accurate. I wouldn't want my unprotected hand so close to those flashing teeth.

Once again I heard that magic French "Mon Dieu!" and witnessed that Gallic shrug, followed by the assertion, "I 'ave been doing zees for ten years."

He was in front of my camera with me looking through the eyepiece when he got bitten. I never saw it happen because it happened so quickly. One minute he was there and the next he was gone. We were all very depressed as we searched the surface for him with the pick-up boat later but without luck. We thought he was lost.

The vision of him waiting for us back on the *Tahiti Aggressor*, albeit by now with a heavily bandaged hand, was met with relief all round. He'd swum down the channel, bleeding profusely, through the hoards of waiting sharks and then swum the mile or so back to the mother ship where first aid awaited. He could have passed out through loss of blood and drowned, but he didn't. Twenty stitches to put his hand back together at the island clinic in Rangiroa saw him on the mend but I don't know if he still feeds sharks that way now.

Chapter 5

Grey Reef Sharks of the Indo-Pacific

My first visit to the Maldives in the middle of the Indian Ocean saw me visiting the submerged reef known as Mushimashmagili in North Ari Atoll, so named because it's a gili where great shoals of a local small brown fish called the mushimashma congregate. Nowadays it's more commonly known among non-Dhivehi speakers as 'Fish Head'.

Incidentally, the word 'atoll' is the only Dhivehi word that has been adopted into the English language. In Dhivehi it means 'administrative district' whereas in English it has come to mean a series of islands or reefs in the ocean that surround a body of water known as a lagoon.

Ari Atoll distinguishes itself from the other atolls by having many channels allowing plenty of open-ocean water to flow through its lagoon.

The Maldives were always thought of as having extremely clear water but few who have not visited realise that this water is often subject to extremely fierce currents, especially in the earlier part of the year.

It was unfortunate that we were dropped in by our inexperienced dive guides at the wrong end of the reef. We needed to be at the steep-sided front where the current struck the reef and was directed upwards because it was here that the fish, including the sharks, congregated. I found myself having to drag my body against the flow the whole length of the reef, using my reef hook in the way of an ice-pick. It was a distance approaching a couple of hundred metres and it must have taken me an excruciating fifteen minutes to make it to where I needed to be. When I got

to the current-point I was surprised to find that I was the only one of our party to have made it. There I was, alone with the sharks.

I allowed myself to get washed up on to the top of the submerged cliff that forms that end of Mushimashmagili and dug my reef hook deep into a convenient hole in the rocky substrate. I was in this way securely tied off and, provided I didn't turn my head to one side causing my regulator to free-flow precious breathing air and not let my mask get dislodged, I was able to watch the ongoing show in relative comfort.

The grey reef sharks (*Carcharhinus amblyrhynchos*) cruised effortlessly up and down, seemingly oblivious to the effects of the torrents of water roaring in from the open atoll, but in actual fact enjoying the oxygenated water that meant they didn't need to swim to pass it through their gills. There were probably a sufficient number to make double figures but it's sometimes difficult to count since so many of them are doubles for their kith and kin.

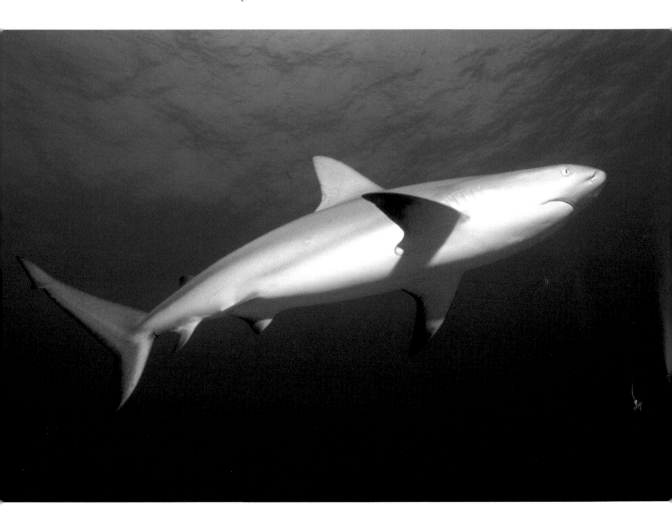

It was at this point that a large octopus decided to take advantage of my otherwise stationary body and climbed out of a hole close beneath me. It was the catalyst for a complete change in atmosphere. In a moment the calm turned to chaos as the sharks went crazy, competing with each other in a sudden explosion of activity in an attempt to be the one to gobble up this delicious prize.

I, for my part, was transfixed. The sharks bumped into me and hurtled around, treating me like a part of the topography. If I was to have been bitten there was precious little I could do to prevent it. The speed of these predators during this brief moment was almost faster than the eye could register. Luckily for me, the octopus realised its serious error and retired quickly and safely back into its hole.

The sharks instantly returned to cruising mode, patrolling up and down where the reef wall obstructed and speeded up the flow of water, ever waiting and ever patient for some other unsuspecting prey to make the mistake of revealing its whereabouts. Tranquillity returned but it gave an indication of how things could change in a moment.

<center>*</center>

When diving first took off in the Indian Ocean archipelago of the Maldives, a dive centre operator called Hereward Vöitmann used to feed the grey reef sharks in an effort to bring some excitement to the dives he led. His confidence grew and soon he was feeding them by holding the bait in his own mouth. Not only that but I'm told his beautiful young daughter took to feeding the sharks whilst totally naked, and nobody complained about that either – not until he got badly bitten! Shark-feeding by divers has since been banned within the territory of the Maldives.

Anywhere in the tropics that has topography that causes the ocean currents to speed up as they pass over it, rather like the air passing over the wing of a plane, will be a good place for close encounters with grey reef sharks and the otherwise very similar blacktip sharks (*Carcharhinas limbatus*). In fact, I find the two species so similar that often it's only once I've got back from a dive and had time to study my pictures that I can really determine exactly what species I've been looking at.

Blue Corner in Palau is another spot where such sharks congregate when the tide is right and the ocean flows up to the reef wall over the sunken reef top. Like Mushimashmagili in the Maldives, it's another place famous for reliable grey reef and blacktip shark encounters provided the tide is right and the current flowing.

I went to Bikini Atoll in the remote Marshall Islands to dive the military wrecks sunk as a result of the two atomic bomb detonations from 1946. It was only at the end of the week that we needed to take a day off from diving to off-gas that we went out to the solitary channel that fed the water from the Pacific Ocean in and out of the lagoon with the tides.

We had with us the Bikini islander who had been diving with us. Edward Maddison was built like a boulder. He was as wide as he was tall and appeared to be nothing but muscle. He

tossed a few scraps of fish cleanings into the water and it began to boil with the bodies of sharks, mainly grey reef sharks but with a few silvertips dotted amongst them.

Edward would lean over the side of our boat occasionally and grab a conveniently handy small shark by the dorsal fin and tail and, happily grinning, haul it out of the water for us to photograph. I suspect doing this harmed the sharks since they have no bony structure to support their organs but they seemed very happy to swim off quickly after their unscheduled visit to the air-breathing world.

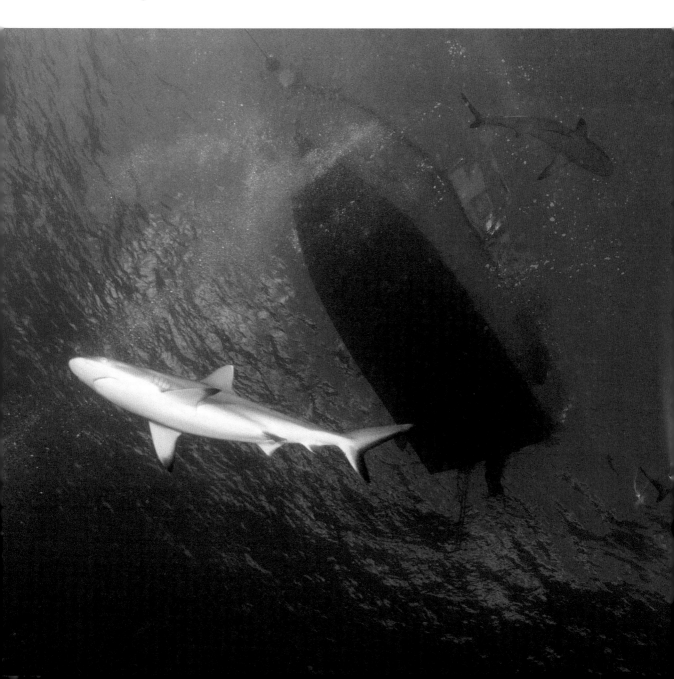

Chapter 6

Beveridge Reef

In 1996, while I was concentrating on such things as investigating the diving in Scotland's Outer Hebrides or experiencing my first use of a prototype closed-circuit rebreather off the shores of Cornwall in South-West England, Pete Atkinson was continuing to cruise around the tropical Pacific in his little Moody-built cutter, *Eila*. While an Autumn edition of *Diver Magazine* contained the results of my own endeavours in the UK, it also carried a report of his diving experiences revisiting a favourite remote site, Beveridge Reef, which, quite frankly, looked a lot more enticing than what I'd been doing that year.

Whereas the pages of the magazine devoted to my work were full of dark and gloomy pictures, his feature was illustrated throughout with a background of predominantly bright blue ink thanks to the clarity of the Pacific water lit by tropical sunshine in the photographs. It was this that determined me to spend more time diving outside the UK than within its territory. This is what he wrote:

"Lost in the immensity of the South Pacific between the Cook Islands and Tonga lies a tiny ring of coral enclosing a shallow lagoon. No trees, no islands, no land at all, just the ocean and coral beneath an endless sky. That's Beveridge Reef.

On the leeward side, the ring is cut by a single, wide pass where grey reef sharks laze in the current. The centre of this azure lagoon is 15 metres deep and studded with small coral heads. Ringing the deeper water and extending to the back-reef margin inside the reef, lies a turquoise,

shallow sand flat.

Although the tidal range is small, at high water small waves come across the lagoon from the ocean swells breaking on the reef. At low water, the lagoon lies like a mirror in a frame of coral rock, reddened by calcareous algae. There are many good reasons to visit Beveridge Reef. The best one is to photograph the sharks. This was my third visit and I had with me underwater photographer David Nardini. Feeding sharks whilst alone at Beveridge Reef can get a little too exciting. The closest hospital is 125 miles away in Niue, and it's doubtful anyone would choose to be treated there.

In the lee of the reef, the water is staggeringly clear. We could see fish among the coral 25 metres below us. We entered the pass in *Eila* where the swell thundered on either side, motored two miles across the lagoon and anchored on the shallow sand flat, sheltered from the ocean by the windward reef. To the south we could see a recent wreck, the *Nicky Lou*, a fishing boat from Seattle.

Nearby was a coral head on a slope between the sand flat and the lagoon depths. I had fed grey reef sharks here before. Although tired from our long journey, David and I just had to go for a dive with a small offering of bait.

As soon as I rolled into the water two sharks zoomed in. I hit the sand until we had all calmed down a bit. There were three grey reef sharks, a bit frisky, but very pleased to see us. We hid the fish in a plastic box and took out chunks as required, when the sharks were looking the other way.

The crystal clear water made it feel like an aquarium. Among the coral there were many clownfish and their anemones, clams and red pencil urchins, but it was difficult to concentrate on

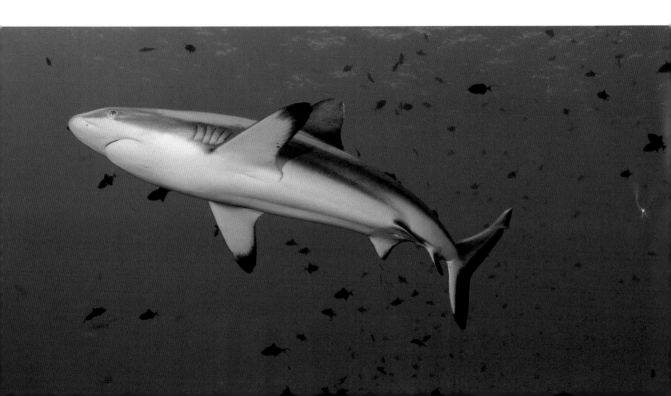

these smaller animals with the big grey distractions all around.

In the morning we tried again. Since the sharks' niche seemed to be the lagoon depths and they seemed reluctant to pass across the sand flat, we anchored our dinghy 100 metres away from the slope. In this way we found that we were able to get in and out of the dinghy unmolested.

There were five sharks now. One gently bit our flashguns, but it was easy enough to bump them with our camera housings. They passed half-a-metre in front of the camera many times, showing no fear of us at all, but they behaved impeccably.

From the water coming over the reef there was a slight current, which helped the sharks to locate the food hidden under a rock. Although we were very close, they were able to discern the source of the odour clearly and I felt in no danger. At low-water it became a bit more exciting since there was no current and the smell of our fish bait was everywhere. Then their detection of the food source was a little more haphazard.

That afternoon we dived the shallow water just inside the reef. The back-reef margin is shallow, no more than three metres deep, but the coral is lush, with plenty of fire coral too. In places clams are packed tightly together. There are many parrotfish, groupers and snappers, and sometimes an octopus or turtle.

The only change I could see in the nine years since my first visit was the behaviour of the blue-bar jacks. Previously they would swim around me not more than an arm's length away. This time, obviously more acquainted now with spearguns, they kept their distance.

Our first dives outside the lagoon were disappointing. Only once when we approached the entrance to the pass did we see any sharks, together with lots of snappers. A couple of hours later we were back again, diving inside the pass with many small grey reef sharks.

Before attacks unrelated to feeding, grey reef sharks adopt a posturing display, with downward pointing pectoral fins, an arched back and a very exaggerated and contorted swimming motion. We saw more of this behaviour here than ever before. When we moved away from it, a displaying shark would calm down. If you wanted to calm a posturing shark, feeding it might well be the quickest way. Later in the dive they left us completely alone.

Returning to our anchorage on the sand flat, the boat was immediately surrounded by sharks. That these sharks associate yachts with food may explain the distinct unpopularity of swimming among the few human visitors. Each day, it was impossible to look overboard without seeing at least one, sometimes several, grey reef sharks milling around in expectation.

Inside the lagoon, with sunshine and clear water, the surface looked utterly beautiful from under water. David fed some sharks at the stern of *Eila* while I took pictures from below. As it was low tide, there was insufficient water breaking over the reef to provide a clear smell corridor so the sharks were very frisky.

David hung his underwater housing over the side on a tripod, triggering the shutter with a length of string, but the sharks seemed far more interested in biting his camera than eating the bait. I just leaned over the side and held my housing, trying to remember that my arms were more useful than great pictures!"

Chapter 7

Hammerhead Madness

Scalloped hammerhead sharks can be found throughout the tropics, schooling in numbers where cold upwellings of deep water meet the warmer shallower water. It is as if they enjoy surfing on the thermoclines that exist where water of two distinctly different temperatures mix, using their wing-like heads to do so.

At the same time, groups of divers head out into the blue, leaving the safety of the reef behind them in order to catch a glimpse of these creatures and compete with each other for the number of specimens they claim to have seen. In the Indo-Pacific region there are many destinations that now try to attract divers by promising encounters with schooling hammerheads. Even the Red Sea, from the reefs of the Suakin in the Sudan through offshore reefs in Egypt like Daedalus Reef and the northern reefs of the Straits of Tiran can attract schools of such sharks when the conditions are right and divers return from dives excitedly banging their fists to either side of their heads and claiming all sorts of numbers. However, such is the skittishness of this species, rarely do they get close enough for anything more than the poorest quality photographs.

The dive centre based on Layang Layang, an artificial island built on a disused military landing strip in the Spratly chain of islands and sand spits of the South China Sea, has marketed itself as providing reliable scalloped hammerhead shark encounters. Last time I visited I found that the main group of divers in residence had journeyed there for specifically that. Each day they would head out into the blue looking for their elusive quarry, finning energetically until they were

short on air and forced to give up the hunt. I on the other hand elected to simply swim in a more relaxed manner alone along the extensive and pristine coral reef wall, photographing whatever I could come across.

This put the dive guide in a bit of a quandary. He didn't like me diving alone but, at the same time, I didn't respond to his exhortations to join his group out in open water. Despite his pleading, I refused to join the 'unspeakable in pursuit of the inedible'.

Each day the hammerhead-hunting group would return without a successful sighting and eventually tempers began to fray at this lack of success. The resort was failing to live up to its promise. I on the other hand had better luck.

The scalloped hammerheads in open water sensed their pursuers long before their pursuers were able to see them and would split either side of them beyond the range of their vision before forming up again in an orderly school after the divers had passed. How did I know that?

Layang Layang is situated upon a steep reef wall, the same reef wall that I meandered along each day. Some of the sharks would pass the divers on the side that was open ocean while others would pass through the channel of water so formed between the divers in the blue and the reef wall – where I was. Several times I had fleeting encounters with solitary sharks that were close enough for me to light effectively with the electronic flash of my underwater camera. It was during the days when we still used conventional film so I had no real evidence of this until I returned home and got the film processed. Tempers back at the resort after a day's diving were becoming so short that I chose not to mention these shark encounters of mine to the official shark hunters. I didn't want to rub salt in any wounds.

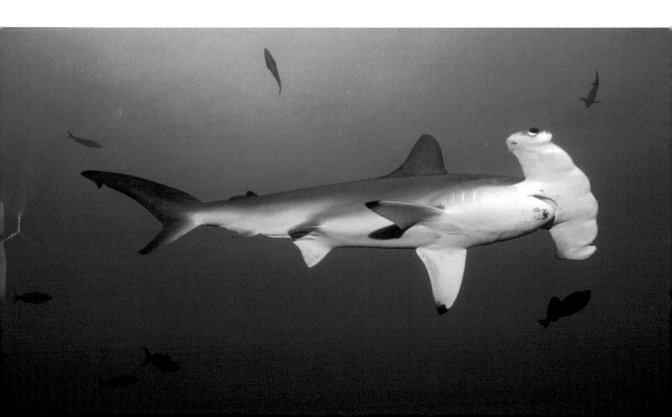

Nevertheless, an encounter with schooling hammerhead sharks once got me into trouble of my own. Hammerhead Point is a dive site at Rasdhoo, a solitary little atoll close to North Ari Atoll in the Maldives. On several different occasions I got up before dawn to join divers on a quest to get an encounter with the scalloped hammerheads that were said to school there. Still half asleep and fresh from our bunks, it's quite daunting to enter water in the pitch black of what is still night, with the expectation of meeting lots of sharks, but I can confess that on no occasion was I lucky. That is until I found myself out in the Maldives with Martin Parker of *AP Valves* and the first production models of his Buddy Inspiration closed-circuit rebreather. Rebreathers can give much reduced decompression requirements over conventional open-circuit scuba because they automatically mix exactly the most appropriate breathing mix for the particular depth you are at, meaning that you can stay deeper for longer.

These early examples of the equipment were very basic in comparison to rebreathers available today. They had only the most basic electronics, without any decompression software, so we had to plan our dives using a desktop PC, writing out a dive plan with run-times on the plastic slates we took with us strapped to our forearms. We managed our actual dive using a standard wrist-mounted open-circuit decompression computer set to the equivalent nitrox mix for the deepest depth we were likely to achieve.

We made a plan to dive to 50 metres deep for twenty minutes with alternative back-up plans of 50 metres for twenty-five minutes and 55 metres for twenty minutes. We thought that should have covered every eventuality.

We dropped into the water just as the sun made the first announcement of its arrival in the form of a huge orange globe at the horizon. Axel Horn and Peter Aulinger, both later to become expert rebreather divers, accompanied us equipped with open-circuit scuba equipment. Soon they were out of gas from their four tanks and had to abort their dive. Martin and I carried on and, exactly at twenty-five minutes into the dive, the schooling hammerheads appeared.

Martin went one side of them while I went the other. It was a magnificent, if long awaited, encounter with the scalloped hammerhead sharks of Rasdhoo. The Maldivian sunshine, by now penetrating down to that depth, lit them up to be a rather unusual bronze colour, but of course it meant that we had both outstayed our welcome at that depth. Not only that, but we had become separated from each other too.

I looked at my computer, set for nitrox 21, and noted a total ascent-time needed of eighty-eight minutes. It was only after I reached my first mandatory stop-depth at 30 metres that it occurred to me that the total ascent-time was wrong. The computer could only display two digits and the total ascent-time had actually been one-hundred-and-eighty-eight minutes.

What to do? As I had enough gas, I decided that the only plan available was to wait out the decompression stops as required by my open-circuit computer. It was some hours later when I was bobbing along the top of the Rasdhoo reef at 6 metres deep that those in our diving dhoni spotted me and Martin was able to lower his own computer on a rope to me so that I could see it displayed 'SOS', meaning he had forgone the stops. I abandoned the last fifty-five minutes

my computer demanded and went back up to the boat. That said, I still felt so unsure, with my computer telling me I had missed mandatory stops that this concern tended to overshadow the experience with the hammerheads.

This experience with the first production model of the Inspiration rebreather gave me great confidence in it as a piece of equipment for use when deeper diving and soon I was taking one away with me to use on regular dive trips. This needed the cooperation of those providing the diving facilities because in those days I was one of few people using a rebreather for leisure diving.

*

Egyptian Guido Sherif was a retired industrialist from Alexandria who had decided to spend his retirement on the liveaboard dive boat he owned, the *Coral Queen*. He knew me well, trusted me and allowed me to dive alone with my rebreather. Karim Helal, from *The Diver's Lodge* and another friend, provided me with the pure oxygen I needed, albeit in standard scuba tanks that I cascade-filled from. The main worry was that other divers aboard *Coral Queen* might accidentally use one of these tanks of oxygen for open-circuit scuba, the result of which would have been fatal.

That said, I found myself on a boat surrounded by other divers but actually doing entirely different dives from that which they were doing. At Sha'ab Mansour I left the others in shallower water while I went down to 50 metres and bided my time. I kept as still as I could and after maybe half an hour or so I was rewarded by the appearance of four scalloped hammerheads and a grey reef shark that approached me from deeper water. Aware that I was probably bigger than they were, I pressed myself against the reef wall and tried to look inconspicuous; easier said than done when you have the big yellow box that was the rebreather on your back. I kept very still, camera at the ready and waited. Although I could see them clearly, they were too far away for a high quality picture. After around twenty minutes two of them decided to come over to examine me and allowed me to squeeze off a couple of pictures before they were startled, probably by the clatter of my camera, and disappeared into the abyss with a sudden twitch of their tails. I was left with just the grey reef shark, which nearly mesmerised me into outstaying my welcome and incurring unwanted long decompression stops.

During that same trip I used the rebreather to spend time at depth at the northern plateau of a reef known as the Elphinstone where I saw more schooling hammerheads as well as browsing grey reef sharks but, alas, never got close enough for effective pictures. I had been accompanied by Nicholas Forest, a lovely young Frenchman who was the dive guide on *Coral Queen* and shortly to lose his life in an unfortunate accident aboard a different vessel. He used a conventional twinset and always needed to finish his dive long before I did because of the necessary decompression differences between using open-circuit scuba and a rebreather. He kindly allowed me to carry on alone, breaking what some would say was a hard and fast rule. On one occasion, ascending from a dive on the Elphinstone, he was met by a group of divers from another boat who queried with him that he appeared to have no buddy. As he said, recounting this incident later, "How could I

tell them I was diving with John Bantin?"

It's curious to think that when the resulting pictures taken at Sha'ab Mansour were published full-page in the UK's *Diver Magazine* around twenty years ago, they received accolades from numerous shark experts, such was the rarity of close-up pictures of scalloped hammerheads. Today, the use of closed-circuit rebreathers is almost as common as pictures of these fascinating looking elasmobranchs.

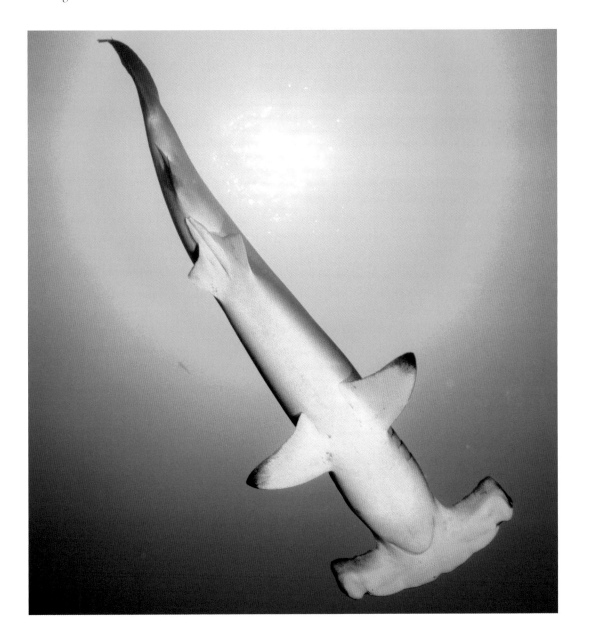

Chapter 8

Dirty Rock, Cocos Island

One of my favourite dive sites in Cocos Island's waters must be Roca Sucia or "Dirty Rock", so-called because the small part that breaks the surface has been a roosting point over centuries for boobies and other large seabirds. It's an interesting spot because the currents that push round it attract all manner of pelagic fish. There has been something different there every time I've dropped in. While there I have photographed whale sharks, massed schooling jacks, mantas, the large marble rays that are almost ubiquitous in this part of the world, mobs of whitetip reef sharks and, of course, schooling scalloped hammerheads.

Terry Fisher, the engineer from Ambient Pressure Diving, manufacturers of the latest rebreathers we were using on one visit, had never dived outside British waters before and I'm afraid he might have been spoiled by the trip to Cocos that he took with me.

We dropped in for our last dive of the trip at Roca Sucia, armed with those rebreathers and hoping for a close encounter with any of the animals mentioned above, and were pleased to find ourselves on a cleaning station with a few Galapagos sharks getting a manicure. Galapagos sharks (*Carcharhinus galapagensis*) are extremely elegant looking, slim and streamlined and frequent the waters of the Golden Triangle formed by Cocos, Galapagos and Malpelo.

I hid behind a turret of rock and managed to get off a few pictures of these lovely-looking, large, fast-swimming, streamlined sharks. I did this by popping above the parapet from time to time as they circled and it was only when we were joined by a group of conventionally equipped

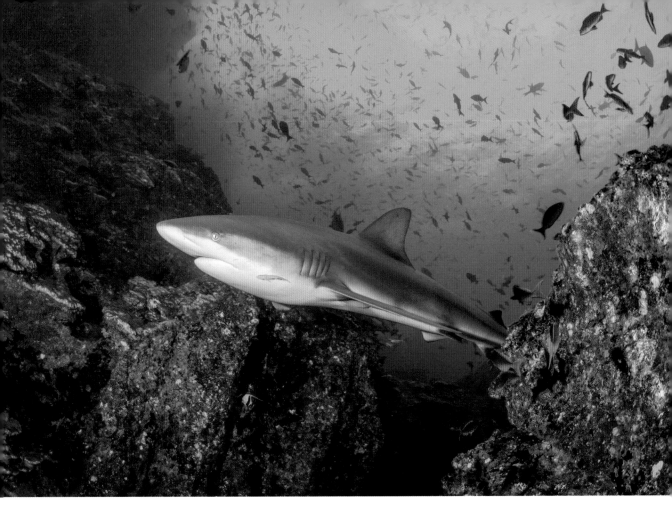

divers, who didn't feel that it was necessary to hide, that the show was over. Well, it was their holiday too!

Rebreather or open-circuit divers, none of us are invisible under water. The CCR merely affords you the luxury of ambush without your exhaled bubbles giving away your position.

People always think of Cocos as the place to see schooling hammerheads, and it is, but there are far more animals to catch the eye of the photographer and you soon grow tired of attempting to get close enough to the skittish schooling sharks.

If anything, Cocos is the land of the whitetip reef shark. These appear to be almost as common here as anthias might be in the Red Sea. Large marble rays are almost as frequently encountered, and it's relatively easy to get a photograph of the two species lying side by side during the daylight hours. At night the little sharks turn into voracious hunters and it's bedlam down there as they compete in great packs in the dark to flush out unfortunate prey from between the rocks.

Alcyone is a seamount discovered by Jacques Cousteau and named after the vessel he was using for his Cocos expedition all those years ago. You need to drag yourself down a fixed line from the panga against a ripping current but once you're down it's relatively easy to take shelter among the red rocks, joining plenty of large almaco jack (the biggest of the jack family) and squadrons of other fish such as yellowtail and golden snapper and yellow grunts. Some of the largest whitetip

reef sharks lie about lethargically on sandy patches between the rocks and, provided you've got time, it's relatively easy to approach without disturbing them, for the close-ups.

Then it's slowly back up the line in that powerful unrelenting current with all sorts of animal encounters still waiting. I photographed some schooling horse-eye jack that conveniently came within range of the line, while our dive guide went drifting off in the flow in an attempt to get some pictures of an untidy group of common dolphin that cavorted temptingly around him.

I say temptingly because, should all of us have left the line, the panga driver would have had a merry old time searching for us later at the surface. As Terry astutely observed when he first saw the Pacific Ocean for the first time, "Big, isn't it?"

Every dive in Cocos is different but equally eventful. Stan Waterman, that grand old man of diving who has been to Cocos more times than some of us have had hot dinners, once opined that Cocos "always delivers".

It's a lonely outpost 350 miles off the coast of Costa Rica, and a place where cold upwellings bring nutrients and deepwater sharks up close to the surface.

These upwellings can play havoc with your photography. With surface water temperatures at around 26°C and the temperature at 30m around 14°C, the mixing zone in between can cause a lot of refraction of the light, making it very difficult to get sharp pictures.

It's not all about big fish, either. I had a lot of fun photographing the barberfish and angelfish that clustered under the great arch at Dos Amigos Grande. That's the bigger of the 'two friends' that form a pair of isolated rock outposts off the shore at Cocos itself.

These little fish are confused. They gather close to the rocky underside of the arch and swim the wrong way up. Well, nobody said they were clever!

Lobster Rock sounded inauspicious during the dive briefing. You go into and swim out across the current over the sand looking for batfish. These may not be the sort of batfish you expect. These batfish look less like table-tennis bats and more like the type of animal you might find in a belfry.

Our guide told us to wait at the bottom of the rocky substrate that forms Lobster Rock while he grouped the other divers together. He abandoned Terry and me for a time. You may know that it's possible to talk through the mouthpiece of a rebreather and I asked Terry what we were waiting for. He didn't understand me so I got closer. Eventually I had him in a close embrace while I attempted to enunciate in his ear and it was at this very moment, as I held him close, that a huge shark swam by.

"Tiger!"

He knew what I meant but it was too late to deploy my camera, which by now was wedged between us against the effects of the current. That's Cocos Island. Anything can swim by. I had to content myself with photographing the snapper that were piled up in the tight gaps between the rocks instead.

Roca Sucia is still my favourite dive site at Cocos. I have fond memories of one dive when a huge whale shark, accompanied by numerous black jacks and with huge remoras clinging to

it and taking advantage of the free ride, swam up to me and passed me before circling the rock time and time again and giving me the repeated opportunity to photograph that great mouth and those tiny eyes on an animal as big as a bus. The biggest problem when it comes to photographing these creatures is the sheer size. Even in the clearest water it's sometimes difficult to get back far enough to get the whole animal included in your camera's frame, even with a super-wide-angle lens.

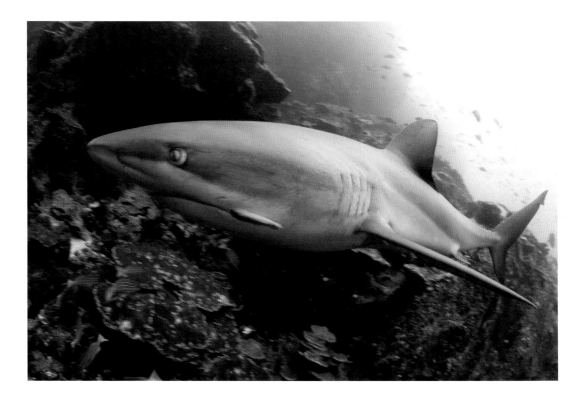

*

Terry and I travelled and stayed aboard *Sea Hunter*, part of the Undersea Hunter fleet. This fleet also includes *Argo*, which is bigger than *Sea Hunter* and carries something special in its moon pool at the stern. This is the *DeepSee* research vessel, which is capable of diving deeper than 300m.

When not being used for research it's available to take tourist divers for a ride. The trip is expensive and takes up most of half a day, but it certainly is a once in a lifetime experience. Two passengers and a pilot sit inside a hemispherical bubble. Before departing, the passengers are briefed as to what to do should the pilot unexpectedly die during the trip, and also what to do should a fire break out on board. It certainly concentrates the mind. Our young pilot assured us before we set off that he was feeling in the best of health.

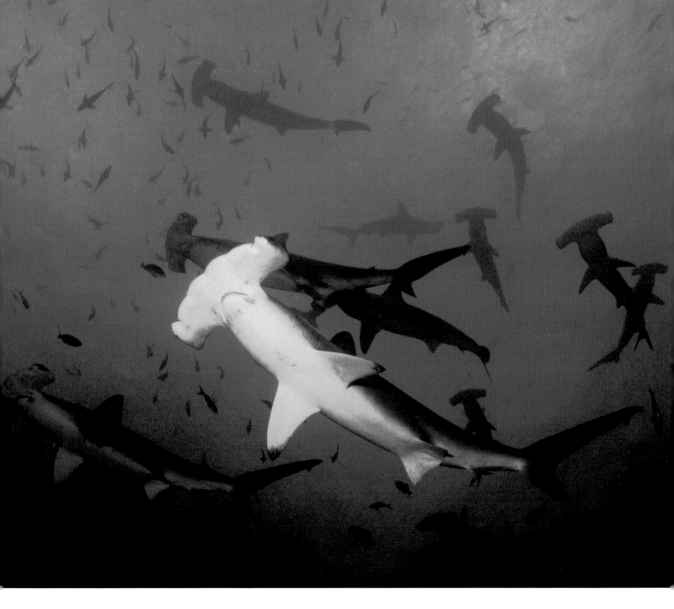

Sea Hunter is not a beautiful vessel but is a great tool for the job. It's comfortable with its twin engines and has great sea-keeping qualities that one might come to appreciate during the 36-hour crossing from Costa Rica. It is also a fantastically efficient dive platform.

Avi and Yosi, the Israeli owners, are keen divers and run their fleet with a passion that reflects this. Avi has been an enthusiastic rebreather diver ever since he first used a military spec. Mk15, and the dive vessels are equipped to support closed-circuit divers.

Over the years I have been privileged to make multiple trips on their boats. It's not always the same under water, but it is always good. I remember one trip, when I was doing a first check-out dive next to Manuelita Island and trying to photograph the schooling hammerheads, I enjoyed a large eagle ray jammed between my legs. Because you are dealing primarily with pelagic animals, it's difficult to anticipate what you're going to see, but you can certainly anticipate seeing something good at Cocos Island.

Chapter 9

Nurses and Leopards

Imagine, if you will, a brand new diver, someone who has trained in a hotel swimming pool, practised all the skills and completed maybe four shallow dives in the ocean. That person is not going to be a very confident diver at this time, are they? Everything is new. The unfamiliar equipment, the unfamiliar environment, there's the sense that if anything went wrong, one could easily drown in a moment. There will always be an underlying sense of anxiety at this time, no matter how much bravado is displayed outwardly.

Well, that was me. I learned to dive in Antigua, in the Caribbean. The 20th Century still had two decades left to run. I was not a natural swimmer. The pair of young German men, Pieter and Bert, who oversaw my certification, certainly put me through the hoop during training in the pool. One exercise was to swim round underwater collecting the various items of equipment that go to make up a scuba kit and to assemble and don it all correctly. The trick I discovered was to get the weightbelt on first so that there was no unwanted floating to the surface the moment I took that desperately needed gasp of air from the regulator on the scuba tank. That was long before I actually donned the tank.

Every time I experienced difficulty with any aspect of what they asked me to do, they would tell me it would be all right because it was easier in the sea.

In the sea! In the pool there was the comforting vision of the tiled walls and the bottom of the shiny stainless-steel ladder glinting in the Caribbean sunshine. In the sea there would be

nothing but a mind numbing endless blueness, a vast expanse of water that went on forever. So you can imagine that, once I was in the sea, every time I took a breath, I was relieved to find that the regulator still worked.

In those far off days we didn't have a pressure gauge, effectively a contents gauge that told the diver how much air he had left in his tank. Instead there was a device called a J-valve. When the tank emptied and the regulator began to be harder and harder to pull any air from, one would pull the long spindly wire attached to the valve and hear the gratifying sound of the last quarter of the tank whooshing into the by now empty hoses. At this point it was time to get back to the surface.

When all was said and done, I was less than confident during my first shallow training dives in the sea. So Pieter, my instructor, took a group of us on what was to be my first proper dive. I forget how many there were of us but the dory they used to get to the dive site seemed crowded. There was probably no more than half-a-dozen of us.

We were soon where we intended to be and I obediently followed Pieter as he swam down, long free-diving fins propelling him much faster than I could swim. Already I was getting anxious that I might lose him since I had trouble keeping up with him. He followed the sloping reef down and I followed him.

Down and down he went with me chasing after. Soon we were down at 30m (100 feet) deep. I'd never been that deep before. My heart was racing.

It didn't slow down when Pieter invited me into a coral cave but, confident my instructor knew best, I followed him in. So there we were. Deeper than I had ever been before, inside a cave with no clear direct route to the surface and what was he indicating I should look at?

It was a large grey animal lying on the sandy floor of the cave surrounded by smaller fishes. I was no expert but I noted the pointy dorsal fin and quickly deduced that I was deep, inside a cave and with a shark for company. My heart began to gallop.

It was time to take matters into my own hands. I backed out of the cave, swam back along the reef ledge, back up to ten metres deep, past the recent wreck of a white dory that I hadn't noticed on the way down and found the anchor of our boat, only there was no boat on it, just a length of rope floating languidly in the water. That had been our boat I had just passed. The dory was now lying on the reef top below me, sunk.

At that exact moment of realisation, my regulator started to get difficult to breathe from. I pulled the wire that operated the reserve valve and was relieved to hear that rush of newly available air. I was soon bobbing at the surface where Pieter joined me.

"Where's the boat?" he asked somewhat confused. "Why did you swim off?"

By now the other divers had surfaced, equally bemused to find there was no boat to climb into. Pieter instructed us to stay over the shallow reef while he swam off to get help. He was gone for more than two hours, during which time I expressed my shock that he had led me into a cave that contained a huge shark. The other divers laughed at me.

"That was only a nurse shark. They're harmless. Having your dive boat sink while you are

underwater is much more serious."

Eventually Pieter returned in another boat, marked the spot with a weighted line and buoy so that he and Bert could come back later to raise the dory, and we set off back to our hotel with a tale to tell. During the journey Pieter confessed that during the long swim back to get help he constantly endured the nagging feeling he might be the object of attention of a marauding shark but obviously he wasn't.

The nurse shark (*Ginglymostoma cirratum*), known as the tawny nurse shark in some parts of the world to distinguish it from the entirely different ragged-tooth or sand tiger shark that often bears the same common name, is probably the shark most often encountered by divers in the Caribbean area. Its Latin name translates as the shark with the flexible curly mouth.

Nobody really knows how it got its common name. Maybe it's because it makes a sucking noise when it feeds by sucking prey out of holes where they might have sought safety. Maybe it's from the old English name for a dogfish, 'huss'. Some even suggest that it is a corruption from the 15th Century name 'nusse' meaning a large fish. They certainly can grow to be extremely impressive in size.

It is a strange looking shark in that it has two dorsal fins, a heavy body, a large head and small blue eyes. It can walk along the seabed on its pectoral fins if need be and this enables it to reverse-up out of tight spaces. Nurse sharks are normally seen lying about lethargically during the day because they tend to feed at night.

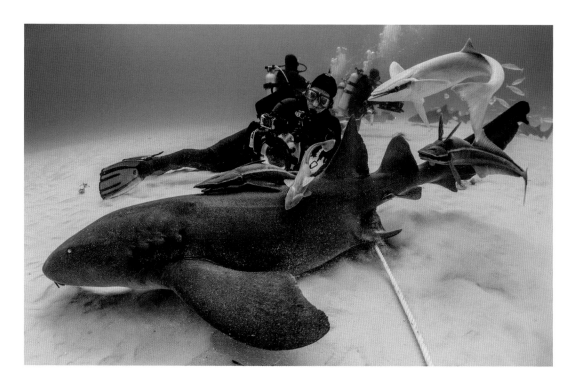

To this end nurse sharks have whiskery-like barbels hanging down from their small mouths, which they use to locate or taste for shellfish and other invertebrates that might be hiding under the sandy seabed. I've witnessed nurse sharks feeding at night, using their small mouths to literally suck their prey out of tight holes. They do this by extending their throats to create a vacuum to hoover out their hapless prey. It is said, but whether there is any truth to it I cannot confirm, that the vacuum provided by a feeding nurse shark is sufficient to suck the flesh off a man's thigh.

Nurse sharks have bitten a few unlucky divers but that is because these animals are often found lying with their heads under an overhang or in a small cave, and divers are tempted to interfere with them, maybe attempting to drag them out for a better look. Sometimes they get their just desserts.

Nurse sharks have been known to turn up and compete for a free meal at staged shark feeds in the Bahamas, attempting to suck the bait directly from the bait box.

In Curaçao, the *Sea Aquarium* offers a shark-channel dive where a number of nurse sharks and lemon sharks are confined in a flowing channel of water that is separated from visiting divers by a clear transparent acrylic wall. Small holes have been cut in this acrylic sheet at intervals to allow visiting divers to poke little bits of baitfish through and the captive sharks gratefully finish the job by sucking from the other side. Because the acrylic has the same refractive index as the water, it is conveniently invisible in photographs. Conservationists and those working at nearby scuba centres are appalled at the prospect of captive sharks and regularly decry the *Sea Aquarium*.

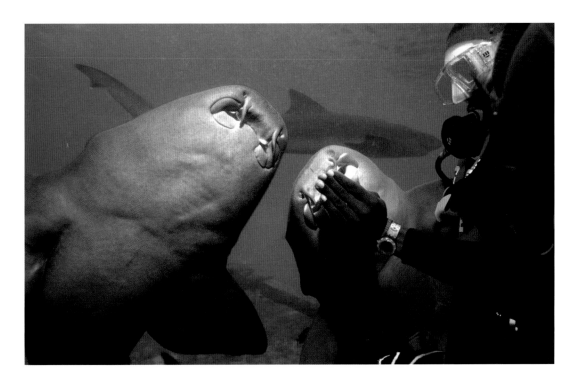

During an underwater photo shoot where we were intent on baiting for and photographing great hammerhead sharks in the Bahamas, a number of huge nurse sharks would attempt to get in on the act. Great hammerheads hunt for stingrays buried in the sand and we had buried suitable bait in a similar way only the temptation for these nurse sharks was beyond endurance and they would turn up and try to get in on the act. It's a strange concept but we were intent on getting pictures of one type of shark while we had another equally massive shark maybe nuzzling between our legs. These nurse sharks invariably sported a collection of huge remoras too.

It was interesting to see these nurse sharks active during the day. I've seen nurse sharks sleeping together like so many puppy dogs on sandy shelves inside Blue Holes, north of Nassau. Blue Holes are very ancient cave systems where the roofs have collapsed giving the impression of deep blue holes in the otherwise turquoise seabed when viewed from the air.

Nurse sharks rarely stray far from the seabed although at Alimata Island, in the Indian Ocean archipelago of the Maldives, they can be witnessed at night schooling in mid-water in large numbers. Nurse sharks have learned that returning fishermen dump their fish cleaning over the side near a jetty. Divers at night not only get close encounters with these large animals hunting around the seabed alongside big stingrays and highly active big black jacks, but if they shine their diving lights up into the darkness of mid-water, they'll witness the unusual phenomenon of curtains of nurse sharks schooling above them.

*

The leopard shark (*Stegostoma fasciatum*) is entirely different yet similar in many ways to the nurse shark in that it lives its life in a similar way. They are sometimes called 'zebra' sharks because the young of this species start off with stripes that only evolve to spots when reaching maturity. An Indo-Pacific species, the leopard shark can be seen lying about in its favourite roosting places during daylight hours and hunting at night when it searches for molluscs, crustaceans, octopuses and small fishes. Leopard sharks have the same forward pectoral fins as the nurse shark and a similarly long tail fin but their dorsal fins are less pronounced and, instead of having a soft amorphous body, two lines along its length give the leopard shark an almost geometrical look. This combined with its pale skin with darker spots makes it a most attractive creature.

I've seen leopard sharks lying among the coral reefs of the Egyptian Red Sea, the Maldives and Australia's Great Barrier Reef but nowhere have I seen more than in the waters off Thailand and Burma. This is something I wrote in *Diver Magazine* after a diving trip to Thailand:

"Today, the weather is going to be hot. Damned hot." (So were the opening lines of Robin Williams in the movie Good Morning Vietnam in which he played the part of a US Forces radio disc jockey.)

I was in Thailand, not Vietnam, but I couldn't help thinking of the movie as I struggled with my lightweight wetsuit in the humidity, sweat trickling through my eyebrows and stinging my eyes.

Frank Van Der Linde, the Dutch on board owner of the pinisi-rigged liveaboard *Siren*, always thinks positively. He is something of a gentle giant and is inclined to come out with lines like this, but with the tag, "How nice is that?" or "It's nice to be nice!" supplemented by a broad contagious grin. His Thai crew, headed by Captain Jack, are programmed to grin in agreement.

One of a minority on board who actually bothered to struggle with a wetsuit, and the only one with an underwater camera to worry about, I always seemed to be the last to leap down into the RIB from the main vessel. The other divers, in this case from Norway, Denmark and Germany, waited somewhat impatiently but were far too polite to say anything.

It was an unusually short liveaboard trip. We only had four days of diving, so I suppose every moment was precious, far too precious to spend sweating and waiting in the awkwardly bobbing boat while some underwater photographer got his act together.

The Boxing Day Tsunami of 2004 had blasted away the hard corals that formerly clad the massive granite boulders that make up the underwater topography of the Similan Islands, but it is still worth diving.

There is plenty to see and, although the water is comfortably tepid in places, there remain tonnes of fish of all the Indo-Pacific species.

'Similan' means number 8 in Thai, and the individual islands are handily numbered rather than named.

It was good to get away from the holiday island of Phuket, with its sometimes-oppressive hustle. Inevitably the proximity of the islands to such a centre of population means that plenty of other dive-boats will always be present. We were amused to see divers arriving the hard way, in primitive dragon-tail boats powered by all manner of different and equally smoky engines.

We aboard *Siren* managed to stay out of sync with divers from most other boats, so the dive sites we visited didn't get too crowded.

How did the sites vary? Those familiar with Thailand will recognise the expression "Same, same, but different". I think in some ways this summed it up.

At first we would see the same smooth, round granite features. Often these underwater hills, polished smooth by years of wave action, reminded me of the upturned hulls of wrecked battleships.

Big round boulders piled up beside them where they disappeared into a sandy seabed. Gorgonia and other fan corals marked the points where currents speeded up to squeeze through confined places.

Where water was forced up and over slopes, great areas of pink soft corals flourished like a display at the Chelsea Flower Show. Banks of anemones gave the impression of bedding plants. Feather stars, often cadmium yellow, added to the bouquet. Clouds of glassfish glittered in the sunlight. Black snapper clustered in groups in crevices between the boulders.

If my mention of currents makes the diving seem energetic, I'd be misleading you. The current flows are very localised, and you need only to pick an alternative route in the lee of some convenient rock if you find the going too arduous. In many ways I found the diving too easy!

The water was bath-like until a chilly upwelling from the deep ocean rolled in, bringing with it both shivers for most of my companion divers and water loaded with murky green plankton. Refraction, as different densities mixed, caused eyes to lose focus temporarily and I was then glad of my 3mm full-length wetsuit. Alas, it left many of my pictures a little less than sharply focused than I might have hoped.

We island-hopped northwards from the Similans, stopping off at Koh Bon and Koh Tachai on the way to Koh Surin. Always with one eye on a possible change in the weather, our final destination was the unprotected moorings at Richelieu Rock.

French for 'rich place', the name probably came from fishermen travelling from what was once French Indo-China. This isolated outpost has earned an enviable reputation among international divers for encounters with whale sharks, mantas and other pelagics.

These things don't arrive to order and we could only spare two dives there, such was our short itinerary. So apart from one large white manta that continually circled the rock, causing endless camera-toting divers to break into a sudden and pointless sprint, we had to content ourselves with observing the permanent residents.

You'd have to be pretty unemotional not to be turned on by the sight of a huge manta ray escorted by cobias gliding majestically over your head.

It's marvellous to watch a group of sweetlips gathered by a rock face in a pathetic attempt to

look like one big fish. It's wonderful to swim within a pulsating crowd, an enormous golden host, of yellow snapper doing a much better job of it.

It's always nice to encounter a hawksbill turtle. A couple in the Similans are in the habit of eating bananas offered to them from the boats. You may object in that this is not their natural food, but their shells look so glossy and perfect that they must be doing well on this diet.

Normally you see hawksbills eating sponges among the assorted corals of a tropical reef. Under water here, it made a change to see them surrounded by granite boulders that were covered in a thin layer of red sponges.

Different moray eels lurked, gulping the water in a threatening manner, with the brown spotted version ubiquitous. Venomous scorpion fish are so common that one pays them little attention, but it's a thrill to watch a banded sea krait, one of the most virulently poisonous creatures on the planet, hold its breath and calmly hunt in every nook for any tiny creature it can devour.

The one I photographed seemed oblivious to the wide-angle dome port pushed persistently in its face. I guess it knew nothing was going to try to eat it.

That said, it was the leopard shark that captured my imagination and, in the waters off Thailand, there seem to be plenty. Leopard sharks here appear to fulfil the role of nurse sharks elsewhere in the world.

You find them lying lethargically on the seabed, pumping water through their gills and reluctant to move until you get really close. Then, with a swish of their long tail and double dorsal fin, they turn and launch themselves into deeper water on their broad, wing-like pectoral fins, just as a nurse shark would do.

The difference is that these sharks of the Far East look, well, so Oriental!

Chapter 10

The Oceanic Whitetip

The Oceanic whitetip shark (*Carcharhinus longimanus*) gets its Latin name from its 'long hands' or aeroplane-wing-like pectoral fins. These predators roam the open oceans of the world, often with a characteristically large dorsal fin breaking the surface of the water. They are seen investigating any object that might be the source of nourishment.

It was 1992. I'd recently given up my regular job in London to work as a diveguide on a liveaboard dive boat in the Red Sea. In those days it was the adventure of a lifetime. We had dropped our passenger divers from our inflatable annex boat, over the plateau of a submerged reef that jutted out from the main reef wall where they submerged. Unfortunately one of the passengers experienced a technical problem with his equipment so, instead of entering the water with the others, he and I returned to our mother ship, where it became apparent that the problem was going to take longer to sort than I would have preferred. I needed to be back underwater with the rest of the guests.

Being a less experienced diver than I liked to think I was, I eschewed a second trip offered by the deckhand driving the inflatable and opted to swim over to the plateau instead. Some decisions are made in a moment and one is left to regret them at leisure, only it wasn't exactly leisure. I found that I needed to swim extremely hard.

My intended destination looked quite close whilst standing on the deck of the boat but I had not considered the effect of a persistent current that I would need to swim against. In order

to conserve my air supply, I stayed shallow and went for it. My pride wasn't going to allow me to return to the boat with my tail between my legs in order to ask for a ride.

I swam a few metres deep in the clear warm tropical blue water, breathing calmly from my regulator. The distant reef wall seemed a lot further away than it had looked before I submerged but I wasn't going to let that put me off.

I felt as if I could see for miles, the underwater visibility was so good – but that was evidently not the case. It was an optical illusion. I didn't see the animal coming but suddenly it was there, right next to me; a large bronze coloured shark with long pectoral fins tipped with white and a distinctive round dorsal fin, also splashed with white. It was gone again as quickly as it had appeared. It had taken one look at me and decided that I was of no interest. My heart had raced for a moment but then I relaxed and carried on with the task of swimming over to the distant reef wall.

Before I had gone very far, the shark was back, in a repeat performance, this time coming that bit closer. The shark cruised up and then accelerated away. It was checking me out.

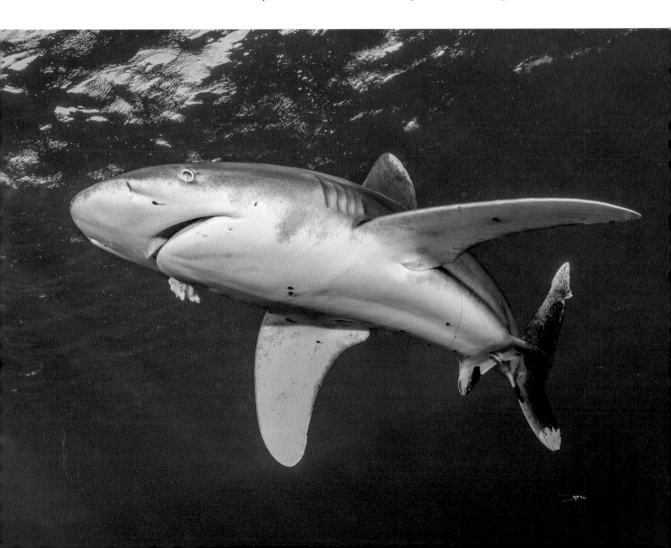

The current stayed a little stronger than I would have liked and the reef wall was still further to swim to than I had anticipated. Five minutes must have passed. I seemed to be no nearer the reef before the shark was back. Anxiety was beginning to build. I was starting to feel unsure and particularly alone. This time the animal came within arm's length before, with a flick of its tail, it was gone again.

I realised that it was circling me with a large enough radius that it effectively vanished before I found it coming back again, always from the same direction, a direction that made it difficult to spot its approach. Was I an intended prey? It's not a very nice feeling being thought of as someone else's dinner.

My experience with sharks in those days was minimal. As far as I was concerned, they were all man-eaters. I stared intently against the direction of the sunlight, for that was from where it tended to approach, but I was still swimming hard towards the distant reef wall. I was holding an underwater camera within a large metal housing. It became my intention to try to hit the shark on the nose with it, should it come close enough. It did and I did. There was a momentary collision between the animal and the hard metal surface of my camera housing, a quick bump and it was gone. Stupidly, it never occurred to me to take a photograph. This was the early 1990s. It was the first oceanic whitetip shark I'd ever seen and I believed at the time that I was surviving a shark attack.

*

Once the most prolific large predator on Planet Earth, the oceanic whitetip must have been among the most misunderstood of all the sharks. During World War 2, the disaster that affected the battleship USS *Indianapolis* highlighted the existence of these animals. Hit by Japanese torpedoes in the final weeks of hostilities, hundreds of crewmen from the stricken vessel leapt into the water to escape the resulting fires and waited for a response to their SOS. There was none.

In late July 1945, USS *Indianapolis* had been on a special secret mission, delivering parts of the first atomic bomb to the Pacific Island of Tinian where American B-29 bombers were based. Its job done, the warship, with 1,196 men on board, was sailing west towards Leyte in the Philippines when Long Lance torpedoes from a Japanese submarine struck it. At that time Japanese torpedo technology was far in advance of any other nation and, with counter-rotating propellers, these lethal devices could be sent with great accuracy over a great many miles.

The American crew, mostly badly injured and suffering from time in the water, were picked off by marauding oceanic whitetip sharks that circled them. In fact the sharks were doing what they were designed to do and that is to keep the shallow upper waters of the ocean clear of carrion, which the injured sailors were rapidly becoming.

About 900 men were left floating in small groups and the few survivors later told harrowing tales of how the sharks began to circle them, picking off and feeding on the bodies of their dead comrades. Emboldened by such easy pickings, the sharks soon started to feed on the living

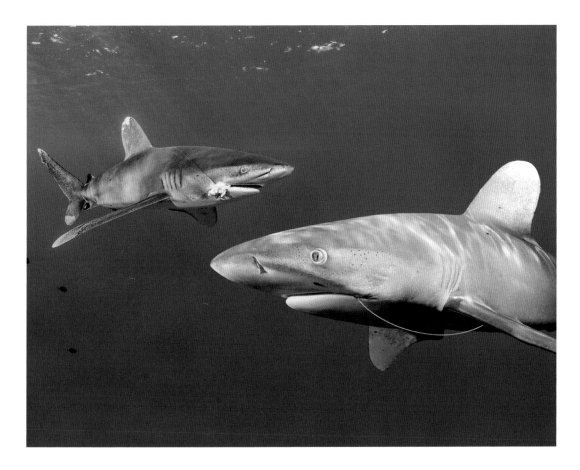

too. Eye witnesses told how the sharks would come up and bump people and after several such inquisitive investigations, would start to feed on anyone who didn't react in defence.

The sharks were not the main killers of course. After days in the water under a tropical sun, men died of dehydration and from injuries received during the torpedo attack. Life jackets became waterlogged and men drowned. The sharks simply cleared up the resulting mess but that is not how the media prefer to see it.

A legacy of that can be seen in Spielberg's movie *Jaws* when the old seadog character Quint, played by Robert Shaw, describes at length his experience as a survivor from the USS *Indianapolis* and the battle with the sharks.

Another legacy of this reputation earned by oceanic whitetip sharks as merciless killers can be seen in an early Jacques Cousteau production when they allow their converted British minesweeper, the *Calypso*, to run over and kill a baby whale. A lot of oceanic whitetip sharks come in to feed on the corpse and the crew of *Calypso* are seen in the movie hauling out large numbers of the sharks and slaughtering them "to avenge the death of the whale". We might see their actions with a different perspective six or seven decades later!

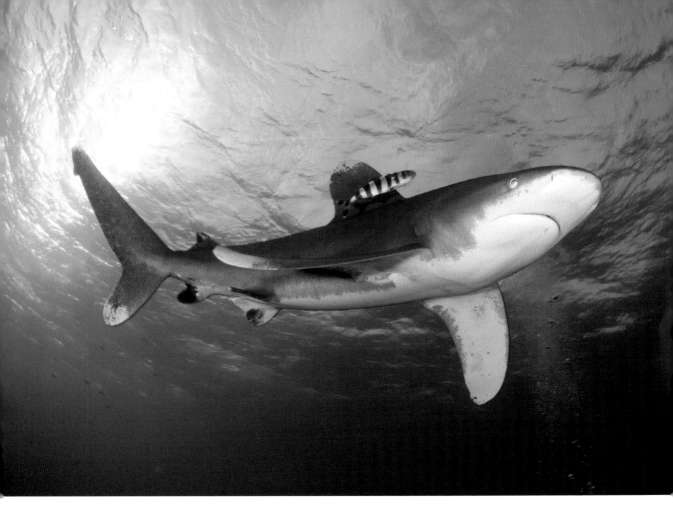

Oceanic whitetip sharks are ocean scavengers that usually feed near or at the surface. They wander the ocean constantly looking for a meal and investigate anything they notice that might be easy meat. They are constantly in feeding mode. The narrow yet very busy sea-lanes that form the central section of the Red Sea are thick with vessels making their way from the Indian Ocean towards the Suez Canal. Ship crews have made it a habit to toss anything unwanted off the sides, including kitchen waste. The wakes of these vessels form rich hunting areas for these sharks, which feed on anything suitable. As such, they are catholic in their taste. The oceanic whitetip sharks have learned this behaviour over more than a hundred years of such Red Sea traffic.

By the first decade of the 21st Century, the Egyptian scuba diving industry was booming and encounters with these sharks were becoming common. It didn't mean people didn't get hurt though, although it is significant that (to my knowledge) no diver has been bitten.

In 2010 there was an unfortunate sequence of events that happened in the waters close to the by now burgeoning holiday resorts along the coast of the Sinai in the Gulf of Aqaba. The coastline there enjoys deep water off the reef that abuts the shore and resorts afford their guests access to this water via floating pontoons in order to swim. It is also an extremely popular area for scuba diving and any dive guide resident along that coast will tell you that it is extremely rare to see any sort of shark, let alone one close up.

On the first day of December a shark seriously injured three Russians and a Ukrainian within minutes of each other while they were swimming on the surface of the water from these pontoons. Injuries included lost limbs. These attacks were unprecedented and resort operators did not appreciate the danger and failed to warn other resorts of what had happened. Four days later, a German woman tourist was bitten while either wading or snorkelling close to the shore and died from consequent loss of blood.

A couple of rival shark experts arrived from Florida and came up with all manner of theories as to why these 'shark attacks' had happened. Probably unaware of the unique relationship between the sharks and vessels in the busy but necessarily narrow sea-lanes, they came up with a variety of ideas. The most plausible theory had been that a vessel carrying live sheep had jettisoned some dead sheep carcasses and attracted sharks to the shore. Since the Red Sea often hosts vessels carrying livestock and it is common practice to jettison those that die during the passage, this theory does not impress me. Other theories offered at the time included focussing on over-fishing in the Red Sea that promised to reduce fish stocks and the illegal or inadvertent feeding of sharks by scuba divers near the shore.

I have a more logical theory but I hasten to add it is no more than that – a theory. Oceanic whitetip sharks have made it a habit to follow in the wake of freighters that frequent the busy yet constricted sea-lanes of the Red Sea and the majority of these ships travel to the West of the Sinai, along the Gulf of Suez to the Suez Canal and then Europe. A similar number of vessels travel back in the opposite direction. They represent a reliable food source for scavenging oceanic whitetip sharks.

Imagine, if you would, a shark following such a freighter that instead turns right at the Sinai and travels up through the Straits of Tiran towards the ports of Aqaba or Eilat in the Gulf of Aqaba. These ports are more than 120 miles from the Red Sea proper. Once the freighter arrived at its destination, the source of food for the shark would have stopped abruptly. Crews are not allowed to throw galley or kitchen waste into the water when in harbour. The shark would have cruised around for a while before gradually making its way back south. The coasts of the Gulf of Aqaba are desert on both sides and there would have been few opportunities for the animal to feed. By the time it got back to the busy holiday resorts that abound along the tip of the Sinai on the Eastern side, it would have been extremely hungry, even starving.

The combination of starving shark and swimmers splashing at the surface like so many injured or dying fish would have been totally seductive. It would have initially bumped the people just as those sharks bumped the injured sailors from the USS *Indianapolis*.

The first attacked, Olga Martynenko, suffered injuries to her spinal area and wounds to her hands and legs. Seventy-year-old Lyudmila Stolyarova lost her right hand and her left leg. Another victim, a Russian man, suffered serious leg wounds requiring partial amputation. While the fourth, a forty-nine-year-old Ukrainian man, suffered leg injuries. That fact that some of them lost forearms and lower legs bears testimony to the fact that the victims were trying to fend the shark off in the only way they knew how, by pushing and kicking.

The first incidents had happened near Ras Nasrani and a few days later a German woman lost her forearm to a shark attack further south in Na'ama Bay. She died from loss of blood. It had been the result of an unfortunate sequence of events, culminating in tragic life-changing circumstances for several people. The shark, sustained by whatever it had swallowed, probably then swam on into the Red Sea proper and continued with its practice of following in the wake of ships.

Often scuba divers, with strong views against shark baiting used in order to get a close up experience with sharks in other parts of the world, will tell you how they have had plenty of interaction with oceanic whitetip sharks in the Red Sea without resorting to feeding them.

Sharks basically do three things; they procreate, they allow other smaller fish to clean them, and they feed. These Red Sea oceanic whitetip sharks are perpetually in feeding mode. They come close to divers because they are investigating whether they are carrion or easy prey and usually turn away at the last moment when they decide they are not.

Oceanic whitetip sharks in the Red Sea have learned that the sound of the engines of ships, the hum of their generators and the seductive splashing noises that emanate from vessels signal an easy meal. When diving vessels were small and seldom had generators, scuba divers rarely saw sharks of any kind save for the very occasional whitetip reef shark in the northern part of the Red Sea. Today these vessels have grown to accommodate up to two-dozen paying passengers in hotel-like luxury. Instead of being on average 20m in length, today the average length of a typical liveaboard dive boat is more like twice that size. They have generators that constantly hum to supply electricity for the air-conditioning and freshwater-making machinery, and they make provocative splashing noises as divers leap off their sterns into the water. It is no surprise that at deep water reefs such as the Elphinstone, the Brother Islands and Daedelus Reef, oceanic whitetip sharks are drawn to such vessels and can often be seen passing by close to the surface.

Returning from a two-week trip to Sudanese waters in a search for sharks that was mainly fruitless, I was among a group of divers travelling with Royal Evolution, one of the largest of all the liveaboards operating in the Red Sea. We were finally rewarded with an encounter with two fine specimens of oceanic whitetip sharks at Daedelus Reef.

One of the lady passengers had contracted an ear infection and opted to snorkel at the surface instead of diving. Meanwhile the scuba divers marvelled at the sight of these magnificent looking beasts with pectoral fins outstretched and pilot fishes at their nose cruising up past them, disappearing for a time sufficient to allow them to cruise round in a large circular route so that they always approached with the sun behind them.

I was happy that the intention of the trip to see sharks was at last being fulfilled but was very concerned about our lady snorkeller. I could only watch helplessly as several times she had what was for me a heart-stopping moment as one or other of the sharks investigated this 'object' floating at the surface. Both she and the divers returned to the boat highly amused by the incident but I was not so sure. In my own opinion, formed from watching events unfold, I think she had had several lucky escapes from what might well have been an investigatory and possible fatal bite.

Nowadays, every time I scuba dive from a liveaboard somewhere like the Brothers, Daedelus Reef or the Elphinstone, you'll regularly find me doing a shallow dive around the moored vessels, hoping that the sounds of their generators and the splashing of divers entering the water will ring the dinner bell for one or two of these magnificent creatures. That said, you wouldn't find me swimming at the surface or snorkelling with them.

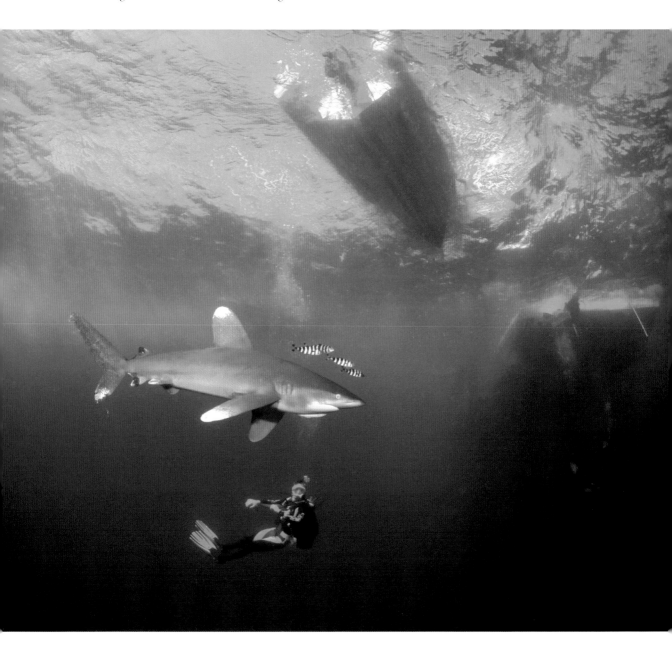

Chapter 11

Photographing Oceanic Whitetips

Oceanic whitetip sharks were among the stars of Peter Gimbel's 1971 classic film *Blue Water, White Death* when a massive school of them was recorded at night feeding on a dead whale that had been previously harpooned and awaited collection by a factory ship. Ron and Valerie Taylor, Australian shark experts and filmmakers, together with cameraman Stan Waterman, broke with contemporary taboos and left the safety of their shark cage to swim with the feeding sharks. At the time it was thought to be either a very brave or very foolish thing to do. An apparent attack on the cage at the end of the film is said to have inspired Peter Benchley, a friend of Waterman, to write the novel *Jaws*. Meanwhile *Blue Water, White Death* remains the finest natural history film of sharks ever made.

These sharks are easily identified. Rarely bigger than three metres in length, they feature a large distinctively rounded dorsal fin and those long pectoral fins, along with tail fins, tipped with white that contrasts strangely with the grey to brown upper body colour.

Always approaching a possible prey with the sun behind it, an oceanic whitetip shark swims around remorselessly, never stopping. Like most requiem sharks, they need to constantly force water through their gill slits although they have been known to raise a snout for a moment to smell the air to give them a better sense of direction for a possible carrion meal. They are not averse to taking the occasional seabird either and are regularly witnessed picking up galley waste discarded off the sterns of ships in passage.

Recently these sharks have been making a comeback in the Egyptian Red Sea and examples can often be seen at places where deep water abuts a dive site and is close to a sea-lane. It is probably because they have been following ships and are drawn by the noise of the dive boat engines and the splashes made by divers entering the water.

If you want to see one you must be patient, hanging out in the blue but near the surface. Encounters tend to be fleeting but repetitive, as the sharks will swim round in large circles investigating the sounds of regulators and the rushing bubbles of exhaled air from divers in the water. An animal will suddenly appear out of the sun, the perfect strategy for an open-water predator. It is quite daunting at first and gives an insight into how those beleaguered sailors from the USS *Indianapolis* must have felt and reminds me of my first such encounter (Chapter 10), but it is different if you are there of your own free will and armed with a camera intending to get close-up pictures.

Although you will rarely see more than one at a time, these animals usually hunt in small groups but well separated from each other. Oceanic whitetips are often accompanied by a host of black-and-white striped pilot fishes such as juvenile jacks. So how do you make good photographs of them?

As with all wildlife photography, extreme patience is needed. Knowing that the sharks like to hunt for food around boats, I prefer to position myself at around 6m or 8m deep in the blue water between the dive boats that are moored. It's helpful if your buddy does the same thing but at some considerable distance from you. This gives two sets of eyes to spot approaching sharks. A buddy can often see an animal if it is approaching from behind you and give you the nod, and you can return the favour.

With all good underwater photography, you need to get as close as possible to reduce the amount of water between you and your subject. This doesn't mean swimming towards the shark but waiting until it swims towards you. Since the sharks are usually shallow, you can get reasonable results by natural light, adjusting the colour in Photoshop on your personal computer after the event. If you shoot in RAW mode you have the option of an incredible adjustment range later.

Compact cameras usually take a long time to write a RAW file but with oceanic whitetip sharks you usually get plenty of time between photo opportunities so that is of little consequence. The main problem with natural lighting in deep water is that it all comes from above and none is reflected from below. Thus it does little to reveal details of a predator designed to be difficult to see on its approach. For good quality lighting you will need to use an external flashgun to light up the subject in natural colour rather than the rather flat monochromatic lighting available naturally.

A quick pulse of light combined with a fast shutter speed also helps do away with any lack of sharpness caused by subject movement and camera shake.

I use two flashguns and an extremely wide-angle lens. Most of my pictures are taken with a fisheye lens on a digital Nikon. This allows me to include the whole of a large subject from a very close distance. The problem is simply to get close enough.

It is no good chasing after sharks. They can swim a lot faster than any of us. The successful photographer has to become the ambush predator that outdoes the shark.

Swimming gently to maintain my station in a soft current, I keep my eyes continually peeled. If I see a shark coming my way I might make a small adjustment to my depth and position in order to put myself in its path for what could be a collision course. I keep very horizontal in the water making shallow fin strokes so that I present as small a frontal area as possible to the oncoming animal. Divers grouped together form a big and daunting shape. Once I know I have a possible target, I hold my fire. The shark sees me as a possible target too.

A premature pulse of light can make the shark turn away too early. I hope for a near impact at best, firing my camera at the last possible moment. Often the shark turns and the photograph is less dramatic than I would like. The secret is to stay calm and patient. My rule is that if the animal is beyond arm's length, it is too far away for good photography. There will always be another opportunity and the secret of success is to spend as long in the water as is practical.

It usually results in dives with long periods of boredom punctuated by a few moments of high excitement. Exhaled bubbles can spoil a good shot but if a shark passes over your head, do not be tempted to chase upwards while holding your breath. That is more dangerous than any shark encounter.

Of course, there are many other places where a scuba diver might encounter an oceanic whitetip shark because they are a pan-tropical species. At Cat Island in the Bahamas, dive operators lure them in for cameras using cuts of bonito as bait. Because there are no busy and

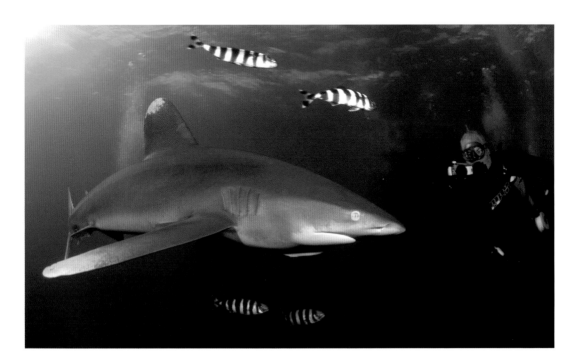

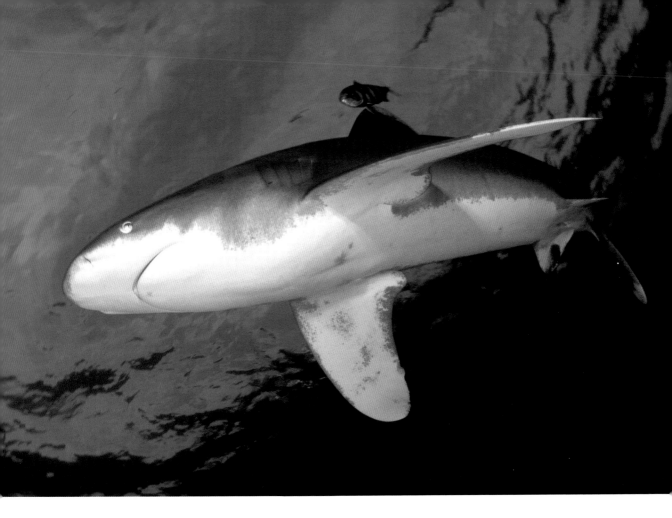

confined sea-lanes nearby these Atlantic sharks tend to feed more on the live fish they hunt. Besides eating carrion, they eat pelagic species of fish and that is the type of bait required. There is a theory that the function of the splashes of white on the fins of the sharks could be to confuse smaller predators into thinking they were prey fish, drawing them nearer to the shark so that they too become prey.

They may have once been the most numerous large predators on Earth but the shark finning industry has hugely reduced the numbers of oceanic whitetip sharks.

In 2012, I was at Daedelus Reef in southern Egyptian waters courtesy of the liveaboard dive boat *Grand Sea Serpent* and was soon in the water, waiting for such a shark to come and investigate me. A close investigation results in a good close-up picture, and I was prepared to wait for up to two hours just for one glorious moment.

The other divers on our vessel opted to do a reef wall and then come back later to the boat in the hope of their own chance encounter. None of us would be disappointed, but I spent most of my two hours alone in the water.

Two small youthful-looking sharks started circling, and because there were only two boats moored there at the Lighthouse jetty, their attention was not distracted and they returned to me again and again.

I was getting good close-up photographs from time to time, but was disappointed to note that one of the animals had a large hook embedded in its mouth, and was trailing a length of line. I tended to hope for more photographic interaction with the other one.

The second vessel moored behind *Grand Sea Serpent* was called *Heaven Freedom*. I was appalled that its crew chose to empty their sewage tanks over the dive site and me when they might have done it in the open ocean. I had to put up with the degraded quality of water, but the sharks seemed undeterred.

Suddenly, one of the sharks became highly agitated. At first I thought it was attacking some prey, as it writhed around and hurtled down to the depths. Then it returned to circle in the shallows, and the awful truth dawned on me. The crew of *Heaven Freedom* were fishing from their vessel, and had hooked the shark.

Once it was back in shallow water, frantically circling, I could see that it was trailing around 20m of monofilament fishing line that tangled around and cut into its body, and was restrained by a lead weight at the end of one section, and a second hook.

A fellow diver, returning to the boat from the reef and seeing me still trying to get more shots, observed that she thought I was going to be 'taken out' by the lead weight, because it bounced off my head at one point. What a shameful state of affairs!

While I was back on *Grand Sea Serpent* complaining to our dive guide, that the crew of *Heaven Freedom* were illegally fishing in the Marine Park, those same people set off in their RIB to fish some more, further up the reef.

Their return later was greeted by loud ironic applause from the passengers on our boat, and someone I assume to have been *Heaven Freedom's* captain came aboard our vessel to complain to our own captain about this rude behaviour.

When it was pointed out that I had photographed the previous hooking of the shark, *Heaven Freedom's* captain pleaded with ours to persuade me to delete the pictures. Me? If you're going to break the no fishing rules so blatantly, you'd best be sure there's nobody with a camera loitering underneath your boat!

Chapter 12

Bottlenose Dolphin

Unlike sharks that have evolved almost unchanged over millions of years, warm-blooded mammals, like dolphins, are relatively recent additions to the spectrum of animal life on the Blue Planet.

A casual observation of a shark will reveal an animal that cruises in a relaxed manner or even lies about lethargically until the moment comes to chase and strike a prey, when its demeanour changes to one of explosive action. The most obvious thing a diver notices about a dolphin is its exuberance for life and the energetic way in which it constantly conducts itself. It reflects the efficiency of the body of a warm-blooded mammal. Maybe that is why we seem to have such an affinity for these cetaceans; that together with their perpetually smiley faces.

Dolphins are one of the few animals in the sea that have time for leisure and actually enjoy sexual intercourse beyond the need for procreation. There are many incidents recorded of solitary dolphin befriending men and these have usually been outcasts from dolphin pods due to their proclivity for sexual deviance. This has occasionally been to the cost of those that have played with them in the sea and found that matters have taken a turn for the worst. One unfortunate man was even prosecuted in Britain when a group of boat-bound sightseers misunderstood what was going on and thought the man was stimulating such a solitary dolphin sexually when in fact he was actually fighting off its advances.

A brief interaction with a passing school of dolpins is not uncommon among scuba divers. For example, I once managed to get into the water at Jackfish Alley, near Egypt's Ras Mohammed,

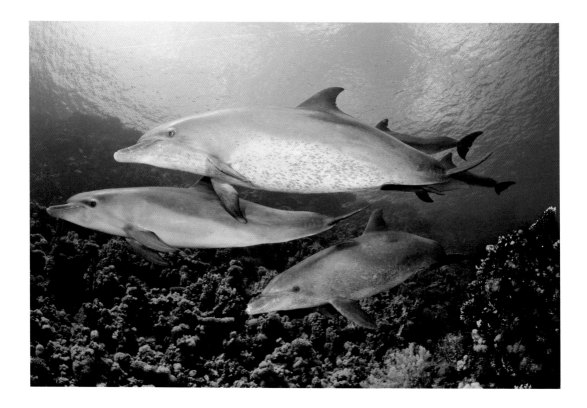

ahead of any other divers despite it being one of the world's most visited dive sites. My reward was a group of pan-tropical spotted dolphin that felt completely unthreatened by my solitary presence. Five of them circled closely around me, eyeing me curiously. They obviously knew that I was using a super-fisheye lens on my camera, so they came obligingly close to me each time they passed.

I had time to see that one was noticeably more spotted than another and was even slightly pinker in her coloration. Perhaps she was blushing precociously for the camera. I'd swear she fluttered her eyelids or gave me a knowing wink with that expression that only a warm-blooded mammal could muster. Then came the sound of other divers hitting the water, and the dolphins quickly discovered that they had business elsewhere.

Bottlenose dolphins are large and powerful animals and the largest and most powerful is the Atlantic bottlenose dolphin. Of course they don't actually have a nose in the way we terrestrial breathers do. They breathe through a hole in the top of their head but the nose-like rostrum is used for manipulating prey and even items pressed into service as dolphin toys.

Atlantic bottlenose dolphin have been proved to be the best survivors in the unfortunate world of dolphinarium and aquarium and at Sanctuary Bay, on the island of Grand Bahama, there is an on-going effort to rehabilitate dolphins rescued from such odious wet prisons. The problem is that these dolphins have mainly been in captivity since they were young and have

been fed on small herring. Although they are free to swim out in the ocean, they would never be able to catch sufficient quantities of such small fish to sustain themselves. The only wild dolphin to have been studied properly was JoJo, one of those solitary dolphins that lived off the beaches of Providenciales in the Turks and Caicos Islands. The young JoJo became stranded in a newly formed backwater after a storm had deposited him there and was rescued by men to whom it appeared he was eternally grateful.

Dean Bernal, a champion swimmer who lived on the island and regularly took to the ocean with JoJo, was able to observe the animal catch large fish such as grouper, after which the dolphin regurgitated the bones. Rehabilitated dolphins have never learned to do that.

Although they are free to swim off into the ocean, ironically, the offspring of the Atlantic bottlenose dolphin that live in Sanctuary Bay suffer from this same inability to consider large fish as prey, so that both parents and offspring are eternally bound to the food supply provided by their land-bound wardens. However, this does provide an amazing experience for scuba divers prepared to pay for the privilege of spending forty minutes or so with a couple of dolphins out in the open ocean. I've been fortunate enough to experience this more than once:

Two skiffs leave Sanctuary Bay and head out to sea. The first skiff includes a few lucky scuba divers while the second skiff has only a driver and a helper who tosses herring into the sea from time to time. The dolphins follow the food source, enthusiastically catching the herring and alternately leaping high in the air, higher than any wild dolphin would do and betraying their circus-like history. That show alone is worth the money we have paid.

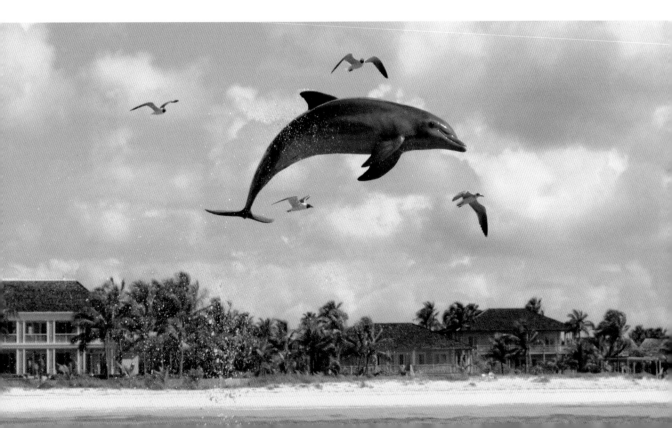

Eventually we arrive at the predetermined dive site. It's about ten metres (30 feet) deep and there is not more than the gentlest of currents flowing. We divers hastily don our kit. We've been thoroughly briefed on what to expect before we enter the water. The dolphins are big strong animals with a degree of intelligence that we are perhaps unused to in the animals we normally meet underwater. In a way, it's quite daunting.

These dolphins know their business and have a routine. They quickly take control and we are merely there to take photographs and participate in their games should we be invited to do so. Their manoeuvrability is astounding. They are never completely still, appearing to hurtle round in a state of high excitement, overwhelming we underwater photographers with Kodak moments that we could only have previously dreamt of.

Chris Allison, the now sadly deceased boss of the *Dolphin Experience*, once told me that he wanted the centre's dolphins to act as ambassadors, but added that they can be frisky, so divers needed to be experienced and to sign liability waivers before they went out. I was given strict instructions not to touch a dolphin unless invited to do so and told that the animals may look lovable but it took little to lead their cunning minds astray.

During my first visit I was accompanied out to sea by one of the founder members of the dolphin team, a rescued animal called Robbala. She knew her stuff and went through a regular routine, spinning divers around effortlessly, posing upright in the water and even giving my buddy what looked suspiciously like a tender kiss. She would line up and pose for my camera with that

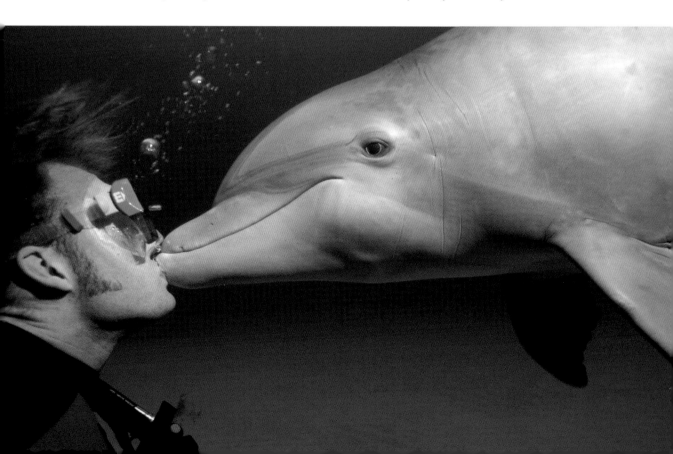

enigmatic dolphin smile always in place. Occasionally she would pop up out through the surface above us to take breath.

It's a strange feeling when you suddenly see a 200kg animal disappear out through the surface in a rush and into the air above, knowing that almost immediately it will be coming back down again. Every time the dolphin did this, the animal came to an instant and precise halt exactly where it had been immediately before heading off. It was also amazing that once around forty minutes of high adrenalin activity (on our part) had passed, the animals would position themselves vertically in the water and sidle up to you, inviting you to pat each of them by way of a thank you, before heading off back to the open pens that were their home.

Dolphin Reef in Eilat, Israel, is another place where divers can pay to swim with similarly rescued dolphins. They used to be kept in a netted enclosure but, enlightened times have meant that the animals are now free to come and go as they please. This had some repercussions once when we were doing a deep-water regulator comparison test for *Diver Magazine* a few miles south at Taba, in Egypt.

Five of us were down at 50 metres-plus where we were concentrating hard on using and comparing the performance of different breathing regulators. We made written notes on plastic slates and were so focussed on the job in hand and we were fairly oblivious at this time to what was going on around us. I was supervising the other four. Suddenly I felt myself shoved in the back. I assumed it was one of my fellow divers, maybe having a problem and needing help. Instead,

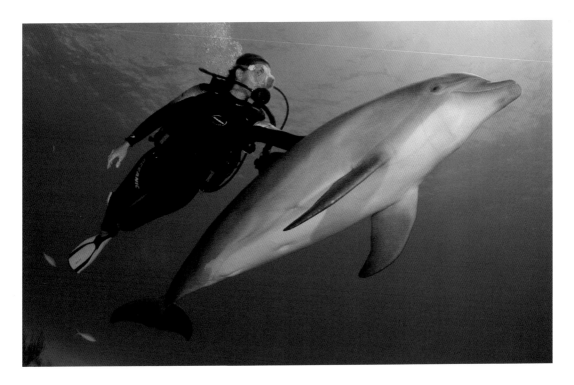

I turned to face three mischievous-looking dolphins in a tight group, grinning infectiously at me. The three then danced around us, giving the full repertoire of their former circus act while we all looked on in amazement.

It's quite surreal to be at that depth, breathing air and on the edge of the effects of nitrogen narcosis, and to have this experience. None of us, all very experienced divers, had ever seen dolphins so deep before.

Again, these were Atlantic bottlenose dolphins; far off their natural beat in the Red Sea. Further south at Nuweiba lived a Bedouin boy (later a man) who had made a friend of a solitary pan-tropical spotted bottlenose dolphin. Oline, as he called her, was a female, which was unusual among solitary dolphins, but the Bedouin village subsidised its income by charging a fee to divers who wished to enjoy a dive with her.

I once went there with the intention of writing a magazine feature on the dolphin and was accompanied by my wife, herself an excellent diver in her own right. Oline enjoyed being rubbed down with half a brick that the Bedouin kept handily for the purpose on the seabed, in a sunken truck tyre. After some welcome attention with the half-brick, I decided that photographically it didn't look too sympathetic towards the animal. It could have looked as through my wife was attempting to club it with a brick. Instead, I elected to get her to rub its flanks with the open palm of her hand.

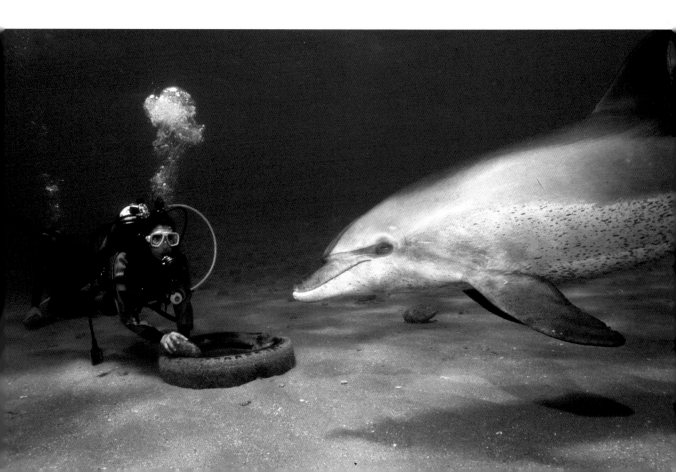

When the pictures were published we received the inevitable letters of protest from well-meaning but ill-informed readers. They assumed that her fingernails might have damaged the dolphin's skin to which my wife retorted, "Well, they obviously have never touched a dolphin!"

Unlike cartilaginous sharks that have very thick skin, these air-breathing mammals are exceedingly muscular and, when touched, their flanks feel as hard as concrete.

The question is often asked, if a dolphin and a shark came into conflict, which would be the victor. In fact, as you may have read elsewhere in this book, sharks and dolphins often have a symbiotic relationship in which the sharks clean up after the dolphins. If the truth be told, dolphins have such speed and mammalian stamina that it is unlikely one would ever fall prey to a shark and the sort of shark that would be big enough to disable a dolphin would be such as a tiger, which is quite a ponderous species. Not only that but dolphins normally operate in large cooperative family groups.

From time to time, different locations become known for their dolphin encounters. In the Red Sea, these inevitably become known as *Dolphin House Reef* although the actual location may vary as the dolphin tire of the attention of humans and the entertainment humans in the water apparently give them, relocating elsewhere.

One such reef has been Sha'ab el Erg, not far from Hurghada. For a long period, every morning a pod of dolphins entered a short channel between the main reef and a satellite reef. Finding scuba divers present, they would rush about excitedly, swimming down to meet them and often rushing round in a spiral of enthusiasm. Day boats will bring snorkelers out from the nearby resorts in which case the dolphins will put on a show at or near and above the surface, leaping out of the water only a few inches distant from the swimmers. Nobody knows why the dolphins do this. Maybe they think we poorly manoeuvring animals need help. Maybe they are just trying to show us how to swim properly.

Chapter 13

Silky Sharks and Dolphins

Dolphins are not sharks. They are air breathing warm-blooded mammals like us and, like us, they need fresh water. Where do they get it from, in the sea? They get it from the fish that they swallow whole. To this end they have blunt peg-like teeth that they use to grab their prey without tearing them. They then use their tongues to position the fish in the mouth before swallowing it but in order to avoid swallowing seawater, they use their tongues to press any water they took in with their meal out through the smiley part of their mouths first. Of course, this means that they can be messy eaters and many prey fish get away damaged or dying before they can be dealt with. Silky sharks (*Carcharhinus falciformis*) are generally associated with pods of dolphins in the open ocean and tend to travel with them, picking off the dead and dying fish so abandoned by the dolphins.

We were travelling by panga from our mother ship at Cocos to a dive site when we passed over a pod of false killer whales. These are effectively like big dolphins. Naturally we divers did not wish to miss the opportunity to dive with them and hastily donned our scuba equipment and slipped over the side into the water. We had travelling with us a non-diver, a young man who worked in the office of the boat company in San Jose, and he decided he would like to swim with the cetaceans and dived in, swimming free-style over to where we were.

Our hearts were in our mouths when we saw a huge mass of silky sharks rush up in a moment from the depths where they had been unseen, attracted by his splashing and ready to investigate what they assumed to be an injured fish.

The boy from San Jose was completely oblivious to the danger he was in, whilst I was calculating in my head how we might distract the sharks and rescue the poor clueless swimmer. Lost in my own planning and scanning to see what the sharks were doing, I noticed the boy stop splashing whilst he surveyed the depths beneath him. A non-diver, I guess he either didn't see the danger he was in or didn't recognise what he was looking at. The silky sharks, now disinterested with the whole affair, swam away.

How he did not suffer an investigatory bite, we'll never know but I don't recommend anyone to swim on the surface in the open ocean with dolphins for this reason.

We have heard stories and read reports of swimmers injured by sharks and saved by dolphins. Usually these are over-enthusiastic divers travelling on dive boats out at sea who cannot resist the temptation to get into the water and snorkel on the surface with those ever-smiling dolphins. Of course, the dolphins have not saved the swimmer from a 'shark attack'. The sharks make an investigatory bite and, finding the swimmer not to their taste, retreat. However, an investigatory bite on someone swimming in the sea can be fatal either through loss of blood, or shock, or even drowning. Once the sharks have returned to the depths, the dolphins continue to cavort as ever on the surface giving the illusion that their presence alone has scared off the sharks.

Silky sharks are so called because they do not have the abrasive skin featured on so many of the requiem sharks. As a species, it is a quick and agile swimmer. Along with the oceanic whitetip shark it is probably the most prolific of all the sharks but appears less aggressive or less bold to divers because it has a more restricted diet than the long-finned cousin. Silky sharks have long and slender bodies, can grow to more than three metres in length, and can be encountered in open water almost anywhere in the tropical and sub-tropical zone.

In the early days of scuba diving as a leisure activity, we were taught by early dive training manuals that should we see a shark while underwater we should position ourselves back to back with our buddy and, rotating round, ascend slowly to the surface. We were taught to have a fear of sharks.

Whilst a dive guide on a liveaboard dive vessel in the Red Sea I made it a habit to dive the plateau at Sha'ab Rumi reef in the Sudan where around two hundred sharks would be attracted by the dead fish that I used as bait. Among them were a great many silky sharks that moved swiftly in to take a bite at the bait before disappearing off into the blue of the ocean.

I might add that on one occasion after a freezer had been accidentally disconnected, we had a supply of chicken no longer fit for human consumption. I tried feeding the sharks, even wiping carcasses over the mouths of passing sharks, without success. It seems they have not evolved to feed on poultry. They prefer fish.

Jeremy Stafford-Deitsch wrote a best-selling book about sharks in the 1980s that established him as a shark expert. He reinforced that innate fear of sharks fostered among divers when he later told in an article in *Diver Magazine* how he was chased up on to a reef top in the Sudanese Red Sea by a some feisty silky sharks that got too close for comfort and got the story of his scary experience published in a number of periodicals.

By the summer of 1994, the sharks of Sha'ab Rumi reef in the Sudan were virtually cleaned out by Yemeni poachers but thankfully, by the following year, the grey reef sharks had returned in force. So did a number of silky sharks.

Jeremy Stafford-Deitsch arrived one afternoon and did a dive. He had been diving with a group of other divers at Sha'ab Rumi and was climbing back into the inflatable diver pick-up boat when four silky sharks passed by. This is what he later told me:

"Their supple bronze forms weaved fearlessly between the surfacing divers in the gloomy late afternoon light underwater.

One was quite big, approaching three metres long while two were much smaller. The fourth was an old warrior, heavily built of eight-feet long or more. Silky sharks are more typically encountered in the open ocean than close to a reef.

The silky sharks I have met in open water have generally been well behaved, impressive to look at, but not at all aggressive. The largest of these four sharks would sweep up towards the surface to investigate the divers. As it did so, all the rainbow runners in the vicinity would swarm around the great beating tail of the shark. Perhaps they were none too fond of this big old silky and were massing around its tail for safety, for it could not get them there.

The other schools of fish were clearly spooked by the approach of this impressive predator; the plankton-feeding fusiliers darting back and forth en masse and a dozen dogtooth tuna, usually seen swimming in the loosest of groups, swam past in front of the coral wall, densely packed together as if expecting trouble.

By now I was back on the dive boat but I grabbed my Nikonos amphibious camera and asked to be taken back to the sharks. My plan was to jump in and snorkel with them, fire off as many pictures as I could and jump back on the inflatable inside a few minutes. I instructed the coxswain of the inflatable to stay close in case I needed to make a quick exit.

We reached the point where we had previously seen the sharks and as we did a group of bottlenose dolphins swam around the inflatable. As I fitted on my mask I mused to myself that I was breaking some of my own safety rules. I was swimming with sharks when there were dolphins present.

Sharks can mistake you for an injured dolphin; I was swimming with large open water sharks on my own. No one had volunteered to come with me and I was swimming with sharks as dusk approached. Many species of shark are crepuscular in their feeding habits but I thought I could always jump back in the boat if things got out of hand.

I slipped into the gloomy water at the edge of the reef. As I did so, the smallest silky swooped past me and I was taken aback at this newfound pace, but it was only a small and overexcited youngster. I looked below into the gloom and gulped. The two largest sharks were powering up from below towards me at the same rapid speed. My instincts shrieked.

At the last moment the sharks stopped right in front of me. I nervously took a blurred shot with my camera as I tried to convince myself that they would calm down, circle and return to the gloom before circling again, but they didn't retreat an inch. Instead they worried their way ever

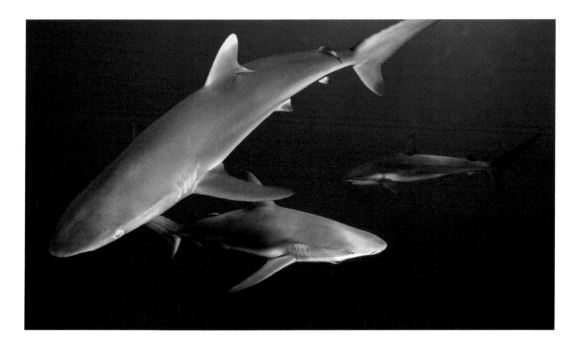

closer with their heads sweeping from side to side.

I decided that I needed to gain some respect and kicked the bigger one in the head with my fins. It shuddered, spun in an angry circle and immediately returned to its original position hovering inches from my fins, twitching and trembling in a mass of nervous energy. I kicked it again and it did not even bother to react. I kicked the second shark with another fin and it was similarly unimpressed.

I could hear the engine of the inflatable and judged it to be 20 or 30 metres away. I waved my free arm in the air hoping the coxswain would spot my alarm signal and race over to retrieve me. The sharks hovered, shuddered and twitched, working their way towards me, forcing me to backpedal.

I swam towards the reef crest. I planned to swim on the top of the reef where the water was about a metre and a half deep and signal and yell to be collected. I thought the sharks would surely not follow.

But they did, each positioning itself immediately behind my fins. I swam on my back so that I could keep an eye on both sharks and fired off a few frantic pictures as I retreated over the top of the reef. Now I was five metres from the reef crest. Now ten metres from deep water and the sharks were still glued to me, contemptuously ignoring my repeated kicks to their snouts. Disaster was surely only seconds away.

My only hope was to get back to the boat. The further I was driven over the shallow top of the reef the further I was from safety and yet if I stopped retreating the only thing left for the sharks to do was bite. At least if I could stay swimming they would have to swim with me.

I felt I was being tested. They were trying to find out what I could do to protect myself, what elaborate defences I had evolved from millions of years of life in the sea. Would I suddenly forge off into the distance with a spectacular burst of speed? Was I covered in venomous razor-sharp spines that would pierce their throats? Surely I had more to offer than a few pathetic kicks from my fins?

They had called my bluff and were soon discovering my defencelessness. I had to get back to the inflatable fast, but I was being forced to retreat even further from safety. I swam on my back waving my free arm in the air and hoping against hope that the man in the inflatable would see it.

I did not dare take my eyes off the sharks to see where the inflatable boat was. They were too close, too poised, too likely to switch from aggressive investigation into outright attack.

Then the large shark surged past my left fin and was alongside, fearlessly watching me with its yellow eyes. I clonked the shark on the snout with the butt of my camera. It ignored this puny blow and continued to glide parallel with me, watching, marvelling at how easily it had penetrated my defences. I was finished. One blow of the broad head and the inevitable would happen.

Then I heard the roar of the inflatable as it sped up to the side of the reef. The sharks distracted, retreated a little. It was the first moment of hesitation that had registered in the silkies since I had re-entered the water. That moment of hesitation meant that I was saved. The noisy arrival of the inflatable had broken the spell that bonds hunter to hunted. The sharks backed off enough to allow me to turn and swim for the boat.

Most sharks are not dangerous most of the time, but dusk is a special time. I got away with it this time, more sober, more respectful, more daunted than before and with more grey hairs."

Everyone who read about the experience later nodded in agreement that he had got away without being bitten. At the same time things were very different in the Bahamas.

*

In the Tongue of the Ocean, virtually the only really deep water to be found abutting the islands of the Bahamas, there used to be an AUTEC buoy moored in several hundred metres of water. The US Navy used this enormous structure to haul down equipment to depth to test it for viability for submarine operations. It has been taken out of service from time to time but when it is installed, this flat-topped buoy, more than 50 metres in diameter, effects a shadowy haven in the open ocean for all manner of pelagic or ocean roving fishes. Predominantly among these are great schools of mahi-mahi or dolphinfish together with almost as many silky sharks. The mahi-mahi is greatly prized for its good eating and often the buoy can be seen surrounded by the boats of anglers attempting to hook as many of these golden fish as possible. They also hook silky sharks in the process.

Local Bahamian dive centres also take advantage of the AUTEC buoy, which they call 'the Shark Buoy' in order to take their client divers on spectacular blue-water dives with massed schooling fish. Divers have to be careful to pay rigorous attention to their depth because there is

no visual datum with which to judge how deep you are and there have been documented cases of divers going too deep. In fact on one notable occasion three divers went down to 120m deep, which might have been kept secret had not one passed out from partial gas poisoning during the ascent!

The dive centre's staff also take the opportunity to do conservation work with the silky sharks, using pliers to remove the fishhooks and line that many sharks may be trailing. How do they do this? Many years ago it was discovered that if a shark was grabbed by the dorsal fin and tail and inverted it became passive, in a state of 'tonic immobility'. Youthful Bahamian people out fishing would get used to silky sharks surrounding their boats and feeding on the fish cleanings they dumped overboard. Young people being what they are, it wasn't long before they would dare each other to get into the water and swim alongside the sharks, which the braver ones among them did. Once this became normal, they took greater risks, culminating in grabbing hold of passing sharks. Soon it became a game among young local scuba divers who made it a habit to go out to the shark buoy and grab a passing silky shark, putting it into tonic immobility, pointing it at a friend underwater and then releasing it like a missile. It is telling that nobody ever got injured by a shark.

During the mid 1990s, I went out to the Bahamas with famous cave diver Rob Palmer who had taken up residence on New Providence at that time. We went out to the shark buoy with shark-wrangler Stuart Cove and I photographed them doing the aforementioned conservation work, removing hooks from the mouths of sharks. During our lunch interval back on the boat, the silky sharks congregated around our vessel assuming that there would soon be a bountiful supply of fish cleanings coming their way. Rob Palmer, ever macho, decided he would snorkel with them and got into the water. Stuart Cove and I amused ourselves by tossing small pieces of tuna at him as he swam and watched happily as the silky sharks lunged competitively for the free meal that bounced off him. Rob Palmer was not injured nor in any danger although he did suffer a sense of humour failure after a while.

Such was the attitude to sharks still prevalent at the end of the 20th Century that, when I wrote about this event in an article for *Diver Magazine* in the UK, the editor refused to print it in the belief that it was too far-fetched a story to be believable and it would only encourage readers to get into the water with such 'man-eating carnivores'. Sadly Rob Palmer was later killed during a dive, not by a shark but by breathing an inappropriate gas for the great depth to which he went.

More recently, near Cocos Island in the Eastern Pacific, about thirty-six hours sailing time from mainland Costa Rica, I had the very exciting privilege of diving with a bait ball. A bait ball is a phenomenon caused when millions of small fish gather together in a tight mass in order to protect themselves from the ravages of predatory open ocean fish. They swim in a circle that turns into a swirling vortex of silver bodies as each tries to hide behind another. Of course this makes a bigger target for the bigger fish that tend to be sharks plus dolphin and even seabirds that will plunge into the mass of bait fish as it nears the surface.

It's an exhilarating experience to be underwater as a scuba diver and witness the frenetic activity as sharks and dolphins and seabirds plunge into the mass of small fish, which rapidly becomes depleted.

At Cocos, on this occasion, the sharks were ocean roving silky sharks and they hurtled in and out of the silvery cloud, never once paying any attention to me. Things might have been different had I inserted myself amongst the bait ball since sharks tend to close their eyes when they bite and I could have sustained a bite by accident. However, I made sure to keep outside the perimeter even though the bait ball was moving through the water. I tried to be sure that it was always moving away from me rather than find myself engulfed by a silvery throng of panicking little fish.

Big schools of silky sharks can still be witnessed at certain times near the remote island dive sites such as both Malpelo and Socorro in the Eastern Pacific but they are certainly not as populous as they were. Just be aware that pods of dolphins travelling in the open ocean will almost certainly have an accompanying school of opportunistically feeding silky sharks swimming below them, so avoid swimming at the surface doing an impression of an injured fish or some other easy prey!

Chapter 14

Whale Sharks

The biggest fish in the sea, the whale shark (*Rincodon typus*), cruises the oceans filtering the water for small fish and planktonic life in the manner of the great baleen whales, hence its name. They are not territorial but simply follow seasonal concentrations of their food source, growing bigger and bigger as they do. Mature females can grow to a stupendous 18m in length yet their eyes tend to stay the same size, positioned as they are far forward on the head. Whale sharks are encountered both pan-tropically and in some temperate waters, and they frequent the open ocean as well as coastal waters. Most diver encounters with whale sharks are simply fortuitous. These animals can simply turn up almost anywhere.

That said, places noted for whale shark encounters include the Gulf of Tadjoura in Djibouti, the Seychelles, the coast of Western Australia, Mexico's Isla Mujeres and South Ari Atoll in the Maldives. They are often seen at places like Darwin and Cocos Islands and off the coast of Mozambique too, but generally speaking they are often merely passing through during long ocean wanderings. One individual, satellite-tagged in the Sea of Cortez, Baja California, was reported as turned up in the Marshall Islands in the Central Pacific proving it had travelled more than eight-thousand miles during a three-year period.

The female whale sharks of the Indian Ocean population are thought to give birth to their live young in the warm plankton-rich waters of the Gulf of Tadjoura, an obviously popular place where pregnant females congregate and newly born Indian Ocean whale sharks first arrive into

the world.

The Gulf of Tadjura is a partially enclosed body of water that opens out into the Indian Ocean at Bab-el-Mandeb, the Gateway of Tears, where ocean currents force their way past the six islands and headland of the Seven Brothers at the southernmost entrance to the Red Sea.

Most of these whale sharks head out southwards into the Indian Ocean in what is believed by some experts to be an anti-clockwise migratory pattern. A few, following an immediate food source such as a school of little fish or a cloud of plankton caught on the northernmost current, will head up into the relative confines of the Red Sea. Anyone who regularly scuba dives in the Red Sea will know that during a period in the hottest part of the summer the water can occasionally turn green with plankton and the visibility in the normally clear waters can turn disappointingly poor. I have travelled north the whole length of the Red Sea along the coastlines of Eritrea and the Sudan and only experienced the anticipated good conditions for photography by the time we reached Egyptian waters and even here, from time to time, the visibility can drop to a few metres thanks to a bloom of plankton.

It doesn't happen very often. However, it is these very conditions that encourage the whale sharks to head northwards instead of east into the Indian Ocean because the green plankton is like 'strawberries and cream' to these fast growing animals.

*

Back in the 1970s when Israel still occupied the Sinai after the two wars with Egypt, the southernmost town of Eilat was said to be like something from the American Wild West. Willy Halpert set up a diving business on the beach and, thanks to the activities of the Israeli tourist authority, Eilat became thought of as a trendy winter holiday destination. At the same time it attracted some colourful characters, a few of which were considered undesirable. Willy used to tell stories of how, without any proper police presence in Eilat, he and a group of other young businessmen would often make citizen's arrests of such people and transport them to the police station in far off Beersheba.

Willy's business boomed because this was the most northerly sea with a tropical marine environment while Israel was perceived to be a European-type winter sunshine destination when all around it were countries subject to political instability.

Intrepid divers from Europe flocked to the beaches and they either stayed diving the waters around Eilat or made their way down the coast of the Gulf of Aqaba by jeep safari, camping on the shore and diving in the crystal clear water, which effectively extended all the way to Sharm el Sheik at the southernmost tip of the Sinai.

Because the Gulf of Aqaba is an extension of the African Rift, the water is uncharacteristically warm for such latitudes. It is believed to be heated by submerged volcanic vents. In those days many European divers thought of it as the Red Sea proper although in fact it is not much more than a backwater. At the same time it was a perfect location for diving, with deep water accessed

directly from the shore and spectacular wall dives possible after only a short swim over the fringing reef.

The prevailing north-west desert wind may result in a choppy surface but it keeps the sea clear of plankton that might otherwise drift up from the south.

My first experience diving with a whale shark was brought to me courtesy of the Swedish skipper of a freighter who saw a whale shark near the surface in the southern part of the Gulf of Aqaba and managed to hook it with a small grapnel anchor and line. He towed it all the way to the port of Eilat, a distance not far short of 120 miles, and when the anchor lost its hold on the animal during the long haul. The Swede managed to hook it a second time and only released it when he reached his destination where it swam around aimlessly.

At the same time, I was diving with Willy Halpert's *Aqua-Sport* dive centre in Eilat and twice a day would stride purposefully across the scorchingly hot beach after donning my heavy scuba equipment before immersing myself in the relief of weightlessness afforded by the water. Divers would swim over a shallow sandy area that featured clusters of coral where the full gamut of Red Sea territorial marine life would be lit up in full colour by the bright desert sunshine. The few with underwater cameras would spend time hovering around these areas photographing animals as diverse as coral groupers, frogfish and yellow mouth moray eels, interrupted only by the occasional appearance of a turtle or maybe some pelagic jacks.

You can imagine my surprise when doing exactly that and photographing the young Israeli girl who accompanied me on such a dive, I noticed the huge dark shape of a whale shark pass leisurely by, directly behind her. I'd never seen one before.

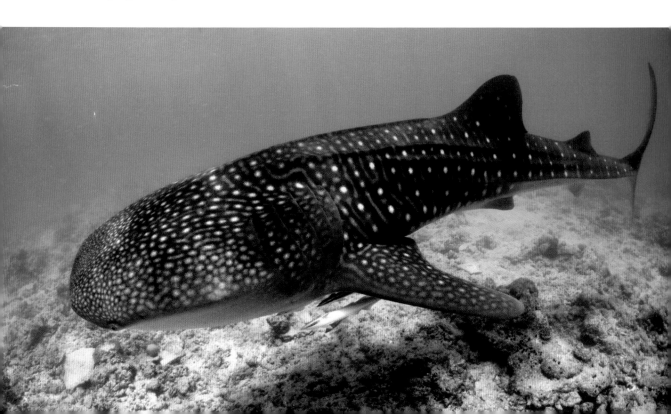

My heart raced and I swam after the beast, quickly using up the remaining film in my amphibious still camera. I then headed back to the beach, exhilarated by the experience and determined to quickly rinse my camera in fresh water and reload it with more film.

That done, I headed back to the shoreline and quickly submerged to re-join my erstwhile buddy who was by now swimming alongside the whale shark that in turn seemed to be swimming round in circles unable to decide which way to go. I shot off another thirty-six frames of film of her dwarfed by the animal. Some of these pictures revealed her holding on to its dorsal fin and being towed, a practice severely frowned on nowadays by conservationists.

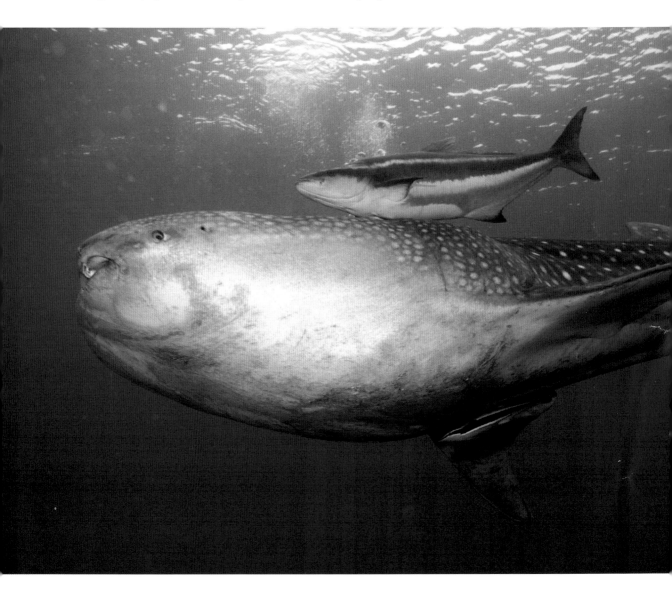

Whale sharks are obviously not the most intelligent animals in the ocean and it appeared to mind a lot less than the cobia, a dolphin-sized fish that accompanied the whale shark and which obviously took exception to this other animal that had seemingly attached itself to its giant friend. The cobia continued to mob the Israeli girl who in turn fended it off and resolutely stayed with the whale shark.

Film used up, I swam back to the beach, struggled across the hot soft sand, my feet sinking in more than I would have liked thanks to the excessive weight of my kit, and rinsed and reloaded my camera for a second time. By now I was running low on air so I asked for another full tank and swapped to that too. Soon I was back in the water and shooting a third roll of film of the whale shark that conveniently disappeared from time to time out into the deeper blue water offshore only to return as if it had simply run out of ideas as to what to do next. It was probably starving by now because there was little plankton and few schools of small fish for it to feed on.

Once again I returned to the rinse tank in *Aqua-Sport's* dive centre where one of the resident diving instructors casually observed that I seemed to be enjoying my diving, returning again and again to the water in quick succession as I was. It was at this point I stupidly revealed that I was in the process of photographing a whale shark.

Whale sharks were obviously rarely seen that far north and in that moment the beach emptied as the entire cast of staff and client divers of *Aqua-Sport* appeared to rush to the water. My interaction with that particular whale shark was at an end.

I didn't know it at the time but it is unusual to be able to spend so much time with a whale shark whilst equipped to scuba. The resistance of all the equipment in the water usually makes a diver unable to swim fast enough to keep up with the animal for long. It is much more normal to free dive since encounters tend to be close to the surface and, equipped with nothing more than mask, fins and snorkel, one has the freedom to sprint to keep up with an animal that appears to meander through the water so effortlessly.

Even so, and without the interference of any freighter skipper, whale sharks are encountered if infrequently around Ras Mohamed and dive sites at the tip of the Sinai peninsular during summer months when many species of fish are spawning. That's before they head back south in the Red Sea, following the food source.

Veteran shark taxonomist Dr Eugenie Clark told how, as a young woman, she encountered a whale shark on a dive off the coast of Egypt and, holding on to its dorsal fin, was carried along by it. Unfortunately she didn't notice it was taking her deeper and deeper and she didn't release her grip and head to the shallows until she was long past the safe maximum depth for a diver breathing air.

The majority of whale sharks make their way from the Gulf of Tadjoura out into the Indian Ocean and follow the plankton south down the east coast of Africa.

Exmouth, north of Perth in Western Australia, may be a sprawling town with a small population and a bit of a frontier feel but it has built a tourist industry around encounters with whale sharks at nearby Ningaloo Reef.

Whale sharks along with Ningaloo's other transients such as mantas and humpback whales are the town's meal ticket. Tributes to this are everywhere, from 'guaranteed success' whale shark-spotting notices to cuddly toys in the souvenir shops. There is a constant discussion of sightings.

Steve Weinman from Britain's *Diver Magazine* reported after a visit that dive centre and whale shark experience teams exuded an enthusiasm and pleasure in their work that would be hard to fake and were keen to share what they believe is Australia's best-kept secret. "So much emphasis is placed on protection of this golden egg that it feels less exploitative than an appreciative interface with the marine world."

Marine biologist Brad Norman is another scientist who operates a whale shark-identifying programme. He invites international visitors and divers to submit photos that reveal each individual shark's spotty 'fingerprint' because the pattern on each animal is thought to be unique.

The project complements his efforts to build a picture of the animals' global movements through satellite tagging. As the research reveals the most perilous parts of their route past the countries of the Far East, it is hoped that the evidence gathered will help to protect them from the voracious shark finning industry.

The whale sharks tend to be seen most often around Ningaloo during the months April to July and it is usual to snorkel with them rather than scuba dive.

Chapter 15

Tagging Whale Sharks

The Mafia Channel, formed between Mafia Island and the coast of mainland Tanzania, becomes a thick green soup at times, thanks to the plankton level. The plankton attracts large numbers of whale sharks that feed there.

Such is the reliability of whale shark encounters, scientific divers such as Matt Potenski, an American, spend large periods of the year fitting radio tags to as many of these animals as possible in order to monitor their movements and try to understand better where they go and what they feed on. Here is my first-hand account of a whale shark-tagging trip with him back in 2007:

"Tony, the boat captain, manoeuvred the Zodiac in his normally taciturn manner. We had been staring at the empty surface of the sea for two days. The equatorial African sun scorched us incessantly. Our hands were badly reddened with the effect of its fierce rays. I had developed an interesting tan in the shape of an oval that was left where my hood exposed my face. It was hot. Hotter than a very hot thing, but we were not tempted to discard our wetsuits and burn further parts of our bodies to a crisp. Our eyes smarted from the inevitable sea spray that showered us with every wave that met our onward progress. Our backsides ached from hours of bumping about the choppy channel. Finally we saw what we had come for.

"Go now," he said almost under his breath.

Tony had discreetly given me the nod. Mask on and snorkel in, I dipped my camera into the water at arm's length and did a less than elegant duck dive quietly over the side sponson of the

inflatable, trying to make as little splash as possible. My legs and fins, straightened high in the air, provided me with enough thrust by gravity to send me down into the murky green water. I swam as hard as I could in the suspected direction of my target, breath held, camera still outstretched those precious extra 60cm ahead of me. My finger on the trigger, I was shooting five frames a second at nothing. Well, nothing yet. It was like swimming in the soup that my mother used to make when I was a kid: full of nutrients, luke warm, and slightly unpleasant. A sudden rush of tiny fish and there was what I'd come for.

It knew I was there before I saw it. I was within a couple of metres or even less before it turned swiftly away, a tantalising glimpse of that massive spotty body, brushing me with a pectoral fin, washing me with the thrust of its tail. First time lucky! It was a small and immature female, too small to tag but large enough for me to be able to capture a reasonable image of her in the plankton-laden water using my super-wide-angle lens. Instantly she swung away. Of course I wasn't to know that one picture of many was a success until I pressed the playback button on my Nikon, but it gave me something to do while bobbing back at the surface, waves breaking over my head. Meanwhile Tony attempted to do my fellow passengers in the Zodiac the same favour he'd done me.

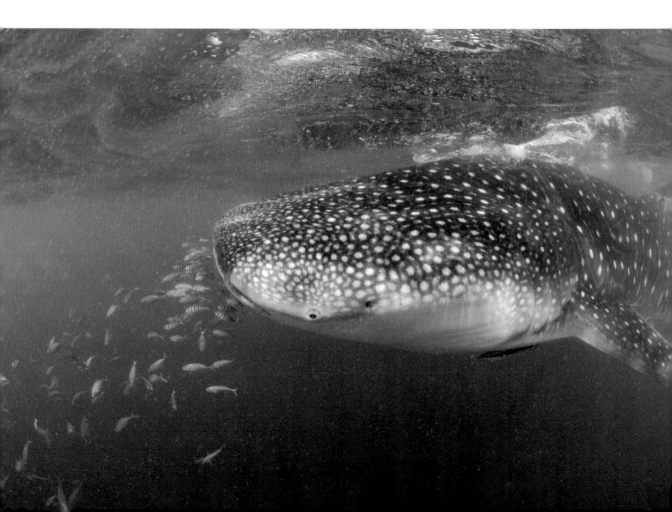

There followed several encounters with much bigger specimens of whale sharks. They always sensed my presence underwater before I could see them; turning away so that I tended to get only views of their massive flanks passing. I often had to content myself with shots of the pectoral fin, or a few remoras or a cobia improbably balanced on the pressure wave at the whale shark's nose.

What interests marine biologists like Matt Potenski of the Shark Research Institute are the known aggregations of whale sharks, and this is what we had come for.

Despite their grand scale, whale sharks feed on tiny plankton and the smallest of fish. They follow the plankton as they roam the ocean, mouths agape, filtering the water as they go. Because plankton is encouraged by bright daylight, it thrives in warm shallow seas and for this reason, the spotty monsters that whale sharks are, feed near to the surface and are thus often sighted by seafarers. It is remarkable that so little is known about them.

Although being endangered by the demand for shark products in the Far East, there has never been any true commercial fishery for whale sharks so little baseline data has been collected. Life spans and growth-rates can only be guessed at. Whale sharks cannot be caught on conventional long-lines, as are other sharks. Unlike most other sharks, they cannot simply be lifted out of the water to be measured and weighed. They present special problems when it comes to serious study.

Scientists from the Shark Research Institute have been attempting to study distribution and abundance patterns in the Indian Ocean by tagging whale sharks since 1993. In fourteen years, visual ID tags have been attached to over 200 whale sharks in areas off South Africa, Mozambique and the Seychelles. The shallow plankton-laden waters of the Mafia Channel form a more recently investigated area where whale sharks tend to aggregate and I had attached myself to Matt's SRI expedition to see how he worked. It isn't easy!

There are two types of tag. A large visual tag with a number that can be clearly seen and reported by any opportunistic snorkeller or scuba diver, and a satellite radio tag that finally comes unattached from the shark at some later date, bobs to the surface and downloads all the data it has collected via a satellite to SRI researcher's computers. These last cost around US $9,000 each so are used sparingly. But first you have to find your whale shark!

Along with a few other interested holiday-divers, I had joined the handsome young American giant Matt Potenski aboard *Kairos*, a diving expedition ship, out of Dar es Salaam. It is French-owned and registered in Panama. The first evening he briefed us on SRI guidelines of what we were allowed and not allowed to do. This included not causing the whale shark to deviate from its normal behaviour and not getting in front of one causing it to change direction, nor getting within four metres of it. It was easier said than done.

At four metres distance underwater in the Mafia channel, a full-grown whale shark could pass you by without you ever being aware that it was there. In fact the only successful technique was to drop into the water at a point some way ahead of an animal and swim furiously on a head-on collision course if there was to be any chance of a visual encounter.

And how did Matt attach the tags? With a huge three-band spear gun at point blank range!

The skin of a shark in very tough and covered in tiny teeth-like denticles. Immediately adjacent to the dorsal fin it is exceedingly thick – from 10 to 15cm thick! Employing a spear gun represents the least disturbance to the animal. Matt deploys a tag attached to a detachable stainless-steel tip at the end of a shaft with a stopper that will determine the depth of penetration. I noted that the animals hardly noticed the impact of the spear but certainly reacted where Matt tugged the spear away once the tag was attached. On one occasion, with a tag that was more firmly fixed to the spear than was normal, I thought we might have lost him when a shark swept its massive tail hard across him as he pulled, before going into warp drive and disappearing over the horizon. On a separate occasion, trying a new type of tag deployment spear, an animal set off with the spear still attached and it took some time to relocate the whale shark and get it back.

More usually, Matt would slip from the Zodiac with his spear gun just as an animal passed by, hit the animal with the spear under the dorsal fin on its port side so that there was a consistency of tag position, wrench away the spear shaft, climb back into the boat, and then get back in with his camera to record visual details of the animal that was still feeding and apparently undisturbed. Of course, these animals do tend to shy away from another large animal in the water, such as a snorkeller, so we photographers tended to get side-on and rear three-quarter shots in rapidly receding perspective.

The other hazard we had to consider was that The Mafia Channel is busy with dhows sailing quite speedily between Killigali and the mainland. We often found ourselves shadowing an animal in the Zodiac or even bobbing at the surface waiting to be picked up, with one of these vessels bearing down upon us. We always made way for them when in the rubber boat but I wondered if the crew would give you the same cheery wave after they had split a head open on collision with their hull.

After the first two days of fruitless searching, the animals began turning up in numbers. The bigger they were, the harder they were to photograph simply because of what they were there for – the thick layer of plankton that reduced the underwater visibility at times to just a few metres."

*

Matt Potenski is not alone in his endeavours. Dr David Rowat has spent his life in the Seychelles studying whale sharks.

He and his wife Glynis have been running the *Seychelles Underwater Centre* for more than twenty-five years and during that time they have studied the spotty monsters that pass by the islands in their migratory route around the Indian Ocean. They have been using a micro-light aircraft for locating these animals far out to sea and have been satellite-tagging them since the mid-1990s. He too works in conjunction with the Shark Research Institute. I went with him to Aldabra. Alas, his liveaboard research vessel *Indian Ocean Explorer*, a tool that gave him access to the distant atoll, has since been hijacked by Sudanese pirates.

At Tofo, on the coast of Mozambique, another American scientific diver has been studying

mega fauna, mainly giant manta rays. I joined Dr Andrea Marshall for a Mozambique experience. The high point was the launching and recovery of the boat in the high surf that strikes the long shallow beaches:

"It was like an amphibious assault, a D-Day landing, only speeded up in the style of a time-lapse movie. But this was real. We thrust our feet into the straps fixed to the hull floor and grasped the grab-lines with the sort of determination only those about to do something that they consider extremely dangerous can muster. John, not very tall and slightly bandy-legged, stood at the big red RIB's console, right hand on the twin throttles and the other feverishly wrestling the wheel as he hunted among the waves for the right one. We heeled one way and another as he weaved among the white plumes of water, turning and looking across his shoulder from time to time, making the best judgment he could of a suitable peak that we could ride.

We knew he'd made his choice when he turned hard to starboard and gunned the twin outboards, climbing the big red boat up on to the crest of his chosen wave.

The sea dropped away below us and our grips tightened. I glanced around at the various hard objects within the boat that could end up hurtling for my head. The vessel flew forward with all the visible intent of a manned missile; only we were shooting across the surf, and heading for what looked like a rather uncompromising shoreline.

"Mind that hotel," I muttered under my breath.

"Hold on!" he shouted. It was a shout that was surplus to requirements as we hurtled onwards towards that sandy shore. I gripped my heavy camera kit and braced my legs for the impact. We came to a sickening standstill, high and dry on Tofo's white sandy beach. I'd wondered how we would get back when we'd launched the big RIB into that same surf a few hours earlier.

Then, we'd all held on to the RIB, pointing it out into the breaking waves, walking it forward a few metres at a time on John's command, and waiting for that moment when he felt he could jump aboard and fire up the engines. Breaking waves that were deemed unsuitable crashed over the bow of the boat, washing any loose kit down the deck and flushing away those of us not strong enough to hold on or without the presence of mind to momentarily ride up with the boat. That was the moment when we all had to heave ourselves over the tubes and into the boat. A heartbeat of hesitation risked you getting left behind. In the mean time we hung on for dear life. Several times I found myself washed under as my grip on the boat faltered under the stresses of an impossible force. I was ever mindful of the devastating effect of the hard hull crashing down onto any wayward limb. It was a hard way to start a dive and even once in the boat and under way we still had to punch our way out through more incoming breakers. On one occasion I managed to smash my face down on to my own tank valve, as we dipped into an unseen trough and came to an abrupt if abbreviated halt.

"You should have been here last week. It was flat calm then," someone offered less than helpfully.

Maybe so but that was then and this was now. It was a long and arduous ride, the ten miles out to Manta Reef, and we didn't get there too soon. It was a serene moment received gratefully

when the howling outboards were suddenly silenced as an announcement of our arrival. Just as we were contemplating which tank belonged to whom, prior to kitting up, Roy, our effusive Chicago-born host, sent us into a panic to find our fins and snorkels as a massive fin broke the surface next to the boat.

"Whale shark!" he had hollered, before leaping into the water with a splash sufficient to send whatever it was on its way to the depths. I never got to see another whale shark that week but Andrea told me they evidently see so many here that on one particular ten mile journey between the beach at Tofo and Manta Reef, they once spotted thirty seven in the water. I was unlucky never to see one during my short stay."

Chapter 16

Whale Sharks and the Thruster

In 2010, I travelled around the Camotes Sea by bangka boat, a giant canoe-like structure constructed with bamboo poles bound together with nylon fishing line and powered by a truck engine. The Camotes Sea is that protected body of water between Cebu and Leyte in the Philippines and it could well be another area where whale sharks give birth. The Philippines cover an area of 116,000 square miles so it is difficult to be precise.

Our main intention had been to travel to Malapascua to photograph the thresher sharks that frequent the reef there but we also dived around the small island of Limasawa, close to South Leyte. On one side, Gunter's Wall provided us with spectacular hard corals, schools of giant barracuda and green turtles while, on the western side, we were promised encounters with whale sharks, albeit juvenile ones.

True to his word, our dive guide had soon identified the position of the first spotty monster, and everyone was in the water swimming furiously with their snorkels towards where it fed in the plankton-rich water. We weren't the only people doing this. I was amazed to see that the entrepreneurial locals had painted the words "*Whale Shark Encounters*" on the sides of their boats and were capitalising as best they could on the habit of these animals to feed in the waters off their shore. This meant there were more people in the water, attempting to get close to a whale shark, than anyone hoping to get good pictures might have liked.

I'm not into competitive swimming, and felt sure that all the splashing was not conducive to

a quiet and productive encounter. So I hit on the idea of getting Markos, a bangka crew member, to paddle me silently over to where the whale shark was in one of the little outrigger canoes.

My plan would have worked well had my cox and I enjoyed a common language. He repeatedly dropped me into the water directly on top of the animal, when in fact I needed to be ahead of its route to get that head-on money shot. I just got endless close-ups with my extreme wide-angle fisheye lens as I struggled to get out of its way.

Eventually I realised the confusion between my instruction to 'go ahead of the shark' and 'the head of the shark', my cox eventually got the idea, and I eventually got my picture. Another diver travelling with me on the other hand, got a better photograph of me with a whale shark, attempting what seemed almost impossible at the time. By the end of the afternoon I was exhausted. There had to be a more effective way to get these pictures.

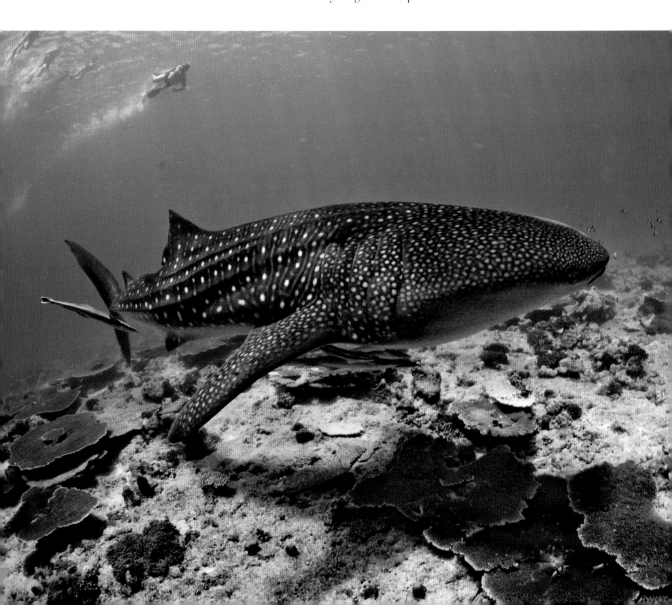

The same degree of difficulty can be said of snorkelling with the whale sharks encountered off the southern tip of Ari Atoll in the Maldives. Here the plankton on which they feed lies very deep but the whale sharks come up in clear water close to the surface from time to time where they tend to spend a few minutes and that is when boatloads of tourists attempt to snorkel with them, grabbing a few moments of this remarkable experience.

"Prepare to snorkel!" shouts Sartoki. He's a big strong Japanese dive guide and you can imagine him shouting orders on the deck of the *Nagato*, Yamamoto's flagship.

There's a scramble for masks, fins and snorkel and ten people, anxious to be first, scramble into the water. I wait more patiently, camera in hand.

"It's under the boat," one of the Maldivian crew quietly advises me. "Quick go now!" he whispers. I go headfirst into the water on the opposite side of the boat to the others just as the spotty monster appears below me. Another ten people left on the boat are behind me. I swim at a heart-busting pace, take a breath and head down so that I can get the important front three-quarters shot. Thank goodness for continuous shooting and the big digital buffers of modern cameras.

As a former advertising photographer, I knew the best angle to shoot a car at and this juvenile whale shark is rather bigger. I estimate it to be about four-and-a-half metres long, but that's just a baby.

Lungs busting, I head for the surface and fin like crazy in an attempt to repeat that trick but my short interval below has allowed the other snorkellers to catch up and I'm in a melee of thrashing arms and kicking legs. One of my co-snorkellers even attempts to pull himself forward by grabbing hold of my body and climbing over me, such is his determination to get ahead.

There's a distinct contrast between the relaxed tail-swishing cruise of the creature down below and those less at home in the water, thrashing at the surface. One more breath-hold dive and some over-the-shoulder (or should I say pectoral fin?) shots and I'm done. I felt there's got to be a better way to get pictures of whale sharks in the Maldives.

Two days later there's another whale shark trip. It's fully booked as usual. The dive centre on the island of Villamendhoo where I am based calls it 'Searching for whale sharks'. They don't like to make promises they can't keep. I suggest my plan to Mike, the *Euro-Divers* dive centre boss. As usual he bends over backwards to be helpful.

The normal format is to do a couple of dives and look for whale sharks during the surface intervals. I opt to take scuba gear but eschew the regular dives. I'll be wearing my scuba kit if and when we spot a spotty monster later.

Young Hussein is detailed to come with me, to see that I don't get into trouble. He doesn't know it but he's in for a 'cardio dive'! Few people can sustain the speed of a whale shark while wearing scuba kit, but I can. I have a secret weapon. I've got my *Pegasus Thruster* cam banded on to my tank.

A long slim cylinder culminating with a propeller in a shroud, its electric motor controlled by a switch in my hand at the end of a cable, can drive me along effortlessly. It has one speed. It's

the cruising speed of a whale shark!

These whale sharks spend only short periods at one time up near the surface. They spend most of their time in deeper water. Nobody really knows much about them, where they go or what they do there but it is assumed that they are feeding on deep-water plankton. We know that the ocean side of South Ari Atoll is a good place to encounter juveniles when the ocean currents are

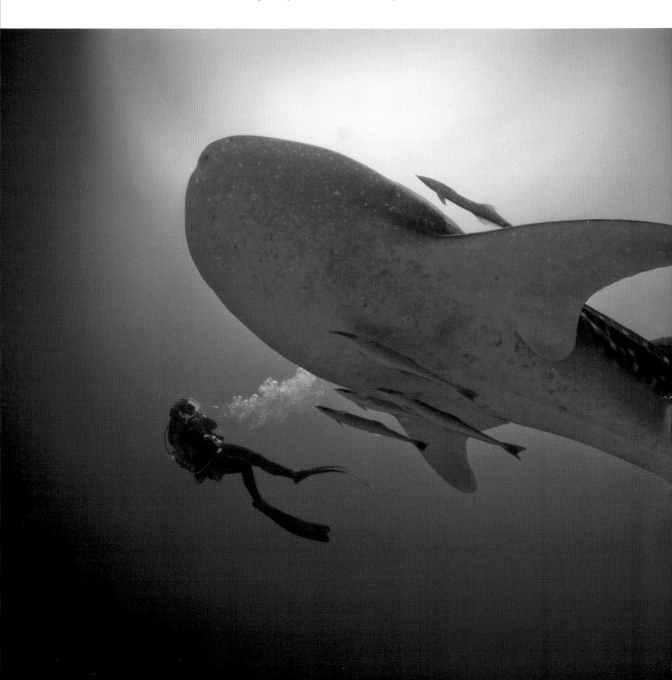

inward and the area around Maamigili Beyru has been designated a National Park with whale sharks in mind.

There are as always several boats hanging around with people ready to snorkel. The boat skippers communicate with each other and, like a safari in Africa, tell each other when they encounter the quarry. That means a lot of snorkellers and the whale sharks are often encouraged by the ensuing chaos at the surface to retreat into deeper waters.

Those on another boat have seen an animal and the shout goes up.

"Prepare to snorkel!"

I'm ready. The snorkellers go in. The shark starts to head deeper. Hussein and I go in. I'm almost instantly down at 3om, cruising alongside the animal. It's a small one, about 5m long. There's another diver with it. He's got a video camera and those long fins beloved of fit young men. I cruise effortlessly. He must be feeling a little envious as with stamina exhausted he soon gives up the chase. I cruise on.

I was a little concerned that the gentle whirring noise from the DeWalt electric motor powering me through the water would disturb the animal. Not so. I cruise alongside it, matching its speed. If I need to get ahead, I add a few fin strokes. My camera housing in my hand, unencumbered by flashguns and equipped with a super-wide-angle lens, I'm getting loads of pictures. I just need to keep the button of the remote control of the *Thruster* firmly depressed to keep pace.

The animal doesn't seem concerned. Far from it, it keeps heading over towards me, closing the gap between us. Too close! Too close even for my super-wide-angle lens. Some of the remoras detach themselves and reattach themselves to me instead. I've been accepted as another large animal sharing the ocean. The whale shark appears to like the company. Maybe it thinks I'm a cobia, a large fish that is often seen accompanying whale sharks. I edge a little further away.

In fact, in getting ahead to get the three-quarter-front shots, I inadvertently take the lead. I turn us both towards the reef wall and we start to head gently upwards and back the way we've come, following the coral to where the light is less monochromatic. "Oh, good," I think, "a chance for better lit pictures."

We cruise along the reef wall at around 15m deep and straight into a very surprised cluster of divers who weren't expecting such a spectacle. The whale shark scatters them as they break rank and their cameras are hastily refocused. A few get some unique and opportunistic close-ups. I don't think they even notice me. I hide below the outstretched pectorals of my newfound friend, still clicking away with my Nikon, secure in its waterproof case, and quietly whirring away with the *Thruster*.

We soon leave them in our wake. Few are athletic enough to stay the pace even for a moment. I've been twenty minutes alongside this juvenile whale shark. It's time to let it go. After all, I'll need to save some battery power of my *Thruster* for the next one! I let off the go-button and turn vertically in the water, stationary. The remoras, ever grateful for the ride, swap back to their previous host and I wave goodbye.

Oh look, there's young Hussein, my official dive guide and tasked with looking after me. He's looking out-of-breath! I told him he was letting himself in for a cardio dive. He grips the valve of my tank and I tow him back some of the way in the direction of the boat. He gets his breath back while the others are doing the next scuba dive and we get ready, rigging our tanks for the next surface interval.

"Prepare to snorkel!"

The shout goes up again and this time I'm in first. This whale shark is on top of the reef in shallow sunlit waters at around six metres deep. That suits me. Not only that but I'm already ahead of it and vector my course to let it catch up.

Behind at the top there is a group of snorkellers from another boat putting up one hell of a pace. The wakes from their fast beating fins scar the surface of the water. Sorry! We can't wait. The whale shark meanders onwards at a steady pace. We cruise together effortlessly. I'm getting good at this! I've set my camera to fire continuously as I hold down the release. It's easy once you know how!

Off the remote east coast of West Papua, whale sharks have learned to coexist with fishermen who believe that their presence brings them good luck. They allow the spotty beasts a proportion of their catch from their nets and recently scuba divers have taken advantage of the fact and obtained some well publicised pictures of the phenomenon.

Other places that are well known for whale shark encounters include around the islands of Utila off the coast of Honduras and the Isla de Mujeres near Cancun in Mexico. These are whale sharks from the Caribbean or tropical Atlantic populations but during the summer they are known to congregate in large numbers thanks to a thriving plankton level in the water and the eggs of mass-spawning grouper. New places where divers can interact with these harmless leviathans of the sea are being discovered almost daily and at the time of writing, the fishermen of Cebu in the Philippines are now augmenting their earnings with tourist dollars by taking visitors to snorkel with whale sharks.

Chapter 17

Safari or Circus?

Many divers nowadays, especially those armed with underwater cameras, want to get close to sharks and the most certain way to organise that is to offer some food in the form of bait. It's an emotive subject with many other people being vehemently against it, but those are usually people who have neither the actual knowledge nor experience and their judgement is based on prejudice rather than fact. A common reason offered against shark baiting is that it causes sharks to associate divers with food, with consequent risks to divers from the same sharks. In the last two decades around 100,000 people have attended shark feeds with probably only a couple of diver casualties reported although some feeders have sustained bites.

The shark-feeding industry has evolved as the knowledge so obtained has grown but it wasn't always like that. Back in 1997 I visited a number of shark-feeding operations in the Bahamas to make some comparisons as research for an article in *Diver Magazine* and discovered some startling differences in the way that they did things. This is my article from that time and it should be stressed that lessons have been learned and a different philosophy prevails today.

Safari or Circus? (*Diver Magazine, 1997*)
The dark shapes of half a dozen circled beneath the boat. I stood at the aft deck ready with my camera. Graham took the decapitated head of a grouper and wiped its bloody end over my wetsuit before slipping it into his BC pocket. The other divers aboard looked at us, astounded. We were

ready to dive.

This was not the height of diving madness. It just reflected how my own attitude to sharks had changed since I first started diving.

The Bahamas, situated in the Atlantic with more than 700 islands straddling the Tropic of Cancer, is the ideal place to see sharks. Several of the dive centres dotted about offer shark encounters and shark awareness courses. Each, however, goes about its business in a different way, reflecting their various and differing philosophies. This is nowhere more apparent than in the shark-dive briefings given by them before diving.

*

"Sharks are dangerous animals. We cannot predict nor anticipate their behaviour, or that they will even be there. There is a possibility you may be injured, even fatally. If you wish to cancel your participation in this shark dive, go to the front desk now, where your money will be refunded."
UNEXSO, Grand Bahama, 1997

The Underwater Explorers Society (UNEXSO) at Port Lucaya on Grand Bahama Island has probably benefitted from more publicity with its shark encounters than any other diving organisation.

Started in 1966, UNEXSO was a pioneer of diving tourism. Several famous names in the diving world, such as underwater cameraman Jack McKenney and photographers Dave Woodward and Kurt Amsler started their careers there as instructors and dive guides.

In those days, UNEXSO attracted many other diving stars, like Lloyd Bridges of *Sea Hunt* fame, and astronaut Buzz Aldrin.

The two people most responsible for putting UNEXSO on the diving map as it is today were probably John Englander, who headed the operation for many years (he later left to work with Jacques Cousteau) and Ben Rose, who also pioneered diving in the caves of Grand Bahama.

Remarkably, UNEXSO started by letting its clients dive with fibreglass models of sharks. That was back in 1987, when divers might have been more easily thrilled. By 1989, Ben Rose established a method that allowed them to dive with real sharks.

I turned up and confronted the bureaucracy at the front desk, insinuated myself onto three daily shark encounters – despite not being 'on the computer', and avoided having to do the obligatory check-out dive in the diving tank, even though I had not dived with UNEXSO before!

"Even if Jacques Cousteau came to dive with us, he'd have to do a check-out dive," I was told.

Shark dives are daily. On the first one I had to play the part of an ordinary customer, which made my job as photographer less successful than I would have liked. Most of my fellow divers were from the USA, had couch-potato bodies and were probably out of practice.

The pre-dive briefing took around an hour and the warning that heads this section was read at both beginning and end. It was read a third time before the boat left the dock but by then

nobody was prepared to opt out and take that long and lonely walk back to the front desk.

Once at the dive site, however, some of our number were so hyped up by the preamble, repeated yet again, that they almost walked on water like cartoon characters and tried to get back into the boat, declining to proceed further with the project. By now it was too late to get their money back!

Four staff divers entered the water with us. They were clad in chainmail suits that weighed more that 11kg and gave them the look of mediaeval warriors while some of the paying guests wore little more than their skimpy swimming costumes and T-shirts under their scuba gear.

The shark feeder was armed with the large-diameter tube with a neoprene cover at one end. This contained the fish to be used as shark bait. Another warrior was armed with a video camera in an enormous submarine housing. Two further warriors were armed with sticks, presumably intended to fend off sharks but more useful for keeping the human audience in line.

And in line we stayed. We had to kneel on the seabed, in around 14 metres of water, in front of an old abandoned recompression chamber that had been dumped there, with arms linked to prevent the possibility of any shark slipping between us.

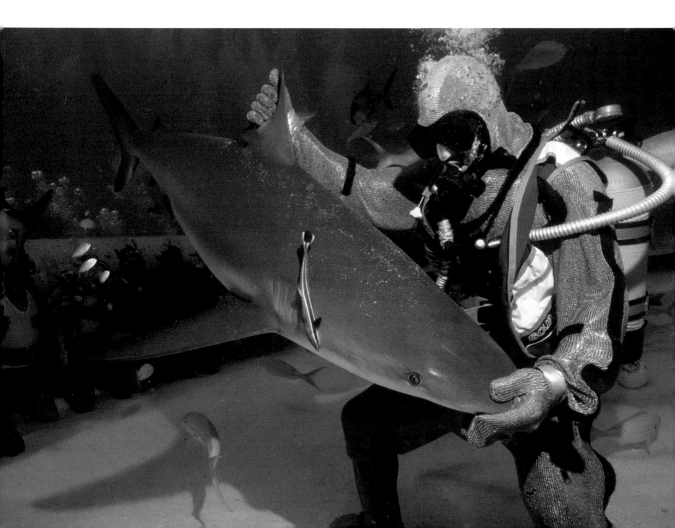

We each were instructed to hold our pressure gauges, both to fend off any shark that came too close and to help our steel-clad attendants monitor remaining air supplies.

As I wanted to use my camera, I was disinclined to do this. I put myself at the end of the line and tended to lean away from my co-shark-encounterers. My neighbouring diver obviously became upset at this and I clearly heard him call my parentage into disrepute during that dive.

Some fifteen Caribbean reef sharks turned up on cue and the feeder warrior fed them one by one. This made a good opportunity to get pictures of peripheral circling sharks together with the feeder once they came to the end of the line.

I noticed that some sharks were prone to bite at the chainmail. The effect was impressive if a tooth got caught in the tiny links causing the shark to panic for a moment.

Otherwise the sharks behaved impeccably. They swam round looking the business and the feeder was able to grab the slower ones, which lay still while they were stroked, nictitating their eyelids as they did so. The human audience kept remarkably still too, their own eyes remaining noticeably wide open!

All the staff divers on this occasion were women, the actual feeder a Japanese girl. My second dive with UNEXSO was more conducive to photography as she allowed me to move around. This concession is available to anyone provided they pay for their own private warrior-minder. Mine appeared to doze off while I did my thing. This time the feeder put on a bit of a show for me, picking up occasional sharks, balancing them on her nose and so on.

On my third and final dive with UNEXSO I dispensed with the minder. I gambled that I would be able to get my pictures before I was dragged out of the water. I certainly found out what the attendant's sticks were for but I persevered and got my job done.

I found the UNEXSO shark dive to be the ultimate underwater circus act using wild animals, with the audience effectively inside the cage with them. Most customers went home pleased to have survived this 'the most dangerous experience of their life' and marvelled at the death-defying feats of the UNEXSO warriors at Shark Junction. Naturally they were sold a video recording to show their friends and prove how brave they had been.

*

"Get up and swim around with the sharks during the feed. Touch them if you like. They will not harm you. They see you only as another big predator, there for a meal. If you stay bonded to the sand you might as well have stayed at home and watched it all on video."
Gary Adkison, Walker's Cay, 1997

Walker's Cay is a tiny island at the northernmost end of the Abaco chain in the Bahamas. You can get there from Grand Bahama or Fort Lauderdale by Piper Aztec. It is primarily a game-fishing location and there is a small marina for private yachts, most of which appeared to be from Florida. Beside the landing strip are the solitary hotel and a diving centre run by Gary Adkison and his

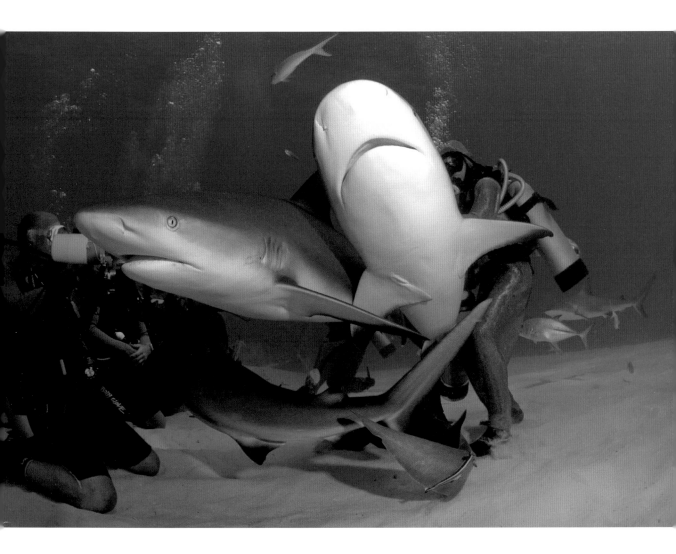

wife Brenda. Gary also acts as bush doctor having delivered several babies during his time on the island but the real babies are the hundred or so sharks: Caribbean reef and nurse together with the occasional bull and hammerhead, that turn up for twice-weekly shark feeds.

Originally Walker's Cay had the benefit of twice this number of sharks, but unscrupulous American fishermen took many for the shark fin soup industry and Gary could do little to stop them. Forty went in one day.

Gary and Brenda have been lobbying the Bahamas government to sanction this area as a national marine reserve. At present the reefs north of Walker's Cay to a depth of 5om form a voluntary reserve. The couple also favour tagging their sharks as a defence against illegal fishing.

Every major aquarium in the USA seems to have sent someone to Walker's Cay to study the sharks. Tagged reef sharks have been hooked by fishermen in up to 650m depth of water over a 23-mile circle, and some of the reef sharks have even been found in the open ocean feeding on tuna.

Gary and Brenda started shark-feeding in Walker's Cay in 1991, and run shark awareness courses too. It has been especially important to engage the support of local fishermen in their quest for a marine reserve.

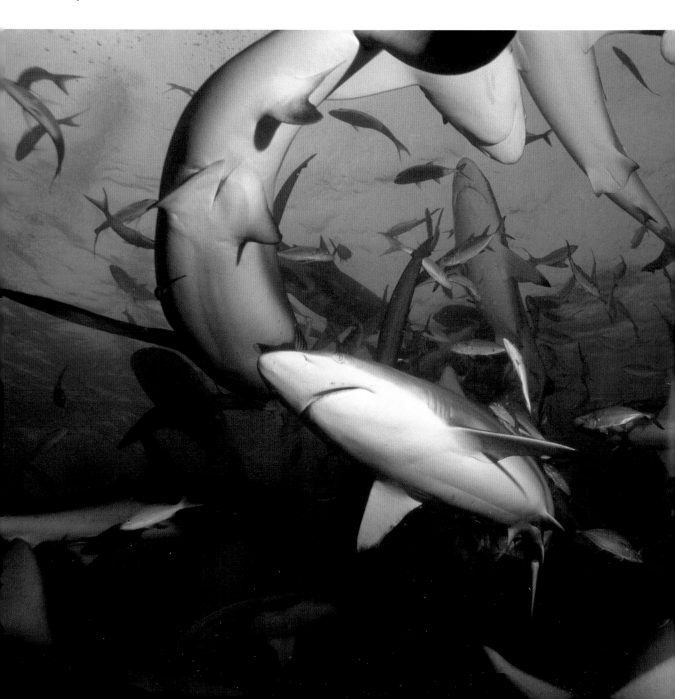

At Walker's Cay the feeding process is very different from that of UNEXSO. Gary and Brenda were quite happy that I did whatever it took to get my pictures, except that Gary thought my white knuckles might be too inviting to an excited inquisitive shark and sold me some black gloves to wear.

The chosen site was a flat arena of sand surrounded on all sides by reef outcrops and very close to the deep water of the open ocean. Once the divers were settled on the seabed, a frozen 'chumsicle' of fish was lowered from the boat. This was a barrel of fish heads and guts from the Walker's Cay fish-cleaning room, frozen into a giant fishy ice-lolly.

About the size of a large trashcan or dustbin, the chumsicle is tethered by a steel wire to an anchor at the seabed and a large buoy at the surface. This causes it to float mid-water and as it defrosts the sharks know exactly what to do.

Despite Gary's exhortations to swim with the sharks, few opted to take him up on the offer. Most preferred to stay anchored firmly to the sand as the chumsicle was hammered by the hungry fish. There were twenty-five guest divers and I recorded the sharks outnumbered them four-to-one. For my own part, I did not pass up the opportunity to swim alongside these magnificent creatures. There were hundreds of other fish too including a large grouper that seemed to have fallen in love with its own reflection in the glass front of my underwater camera housing, but the sharks were easily identifiable. They were the guys in the grey suits!

It took about twenty minutes for the food to be gorged, the last fragments breaking away and being energetically competed for in what Gary called a shark rodeo. Like Gary with his video camera, I got within a metre of the bait without getting involved. True to his word, these impressive animals merely treated me like another predator there for a meal.

Once the bait was finished I enjoyed the unexpected spectacle of all the divers searching the sand for shark teeth. Sharks lose their teeth during feeding, but can replace them instantly from a new row growing behind. As the divers searched, about fifty magnificent specimens circled metres above their heads but were ignored. The show was over.

*

"We only feed the sharks once a week because we don't want them associating food with divers. Kneel on the seabed with the reef to your backs. Stay together as a tight group. When the feed is over you are expected to ascend in pairs to the boat, back-to-back."
Stella Maris Resort, Long Island, 1997

The Stella Maris resort on Long Island, far to the south of the Abacos is where it all began. In the late 1960s three German friends set up a hotel according to their idea of an island paradise. Stella Maris has its own airstrip and light aircraft service, and its own small marina.

Shortly after arriving, the partners learned to dive. Before long they were feeding sharks in ten metres of water at their own 'shark reef', but from the safety of a cage. A year later they dispensed with the cage.

Because they started twenty-five years ago and still go about things the same way, they appear a lot less enlightened about sharks than their competitors. This was revealed when one of the owners, Peter Kuska, told me how they expected the divers to enter the water.

It was just as advised in old diving manuals. The diving however was in the hands of two charismatic Long Islanders, Smitty and Delbert. Apart from asking divers to kneel on the seabed, the other strictures of the briefing were ignored. They told me I could do what I liked.

I asked where the bait was. They replied that they were intent on doing some fishing during the journey to the dive site and duly caught a single barracuda on the way, although I could see as shark-bait it wasn't going to last very long. Once at the dive site, I opted to get into the water as quickly as I could. There were around fifteen Caribbean reef sharks waiting to greet me, but they seemed to be in a state of hungry agitation.

The other divers came hurtling down to join me, one of them apparently trying to sit on my head. It seemed both divers and sharks were on edge.

The two Long Islanders jostled the other divers into a tight group while the sharks awaited the big event. Fifteen sharks seems quite a lot when they are buzzing around like so many bluebottles in a jam jar.

Suddenly a bucket of bait was lowered into the water from our boat and the feeding frenzy began. Fifteen seconds it was over, one shark disappearing from view with the orange plastic bucket jammed over its head. Eventually floating to the surface, this bucket was picked up later.

The sharks continued to race around searching for more to eat, so in an effort to keep them interested one of the brothers produced a long spear and a Hawaiian sling and, against all the rules, speared a grouper.

This provoked a second feeding frenzy, the first shark getting the dying fish complete with the long spear. The other sharks gave chase, and we were faced with the additional hazard of a crazy game of tag, the leading shark now armed with a long spear protruding from its mouth! Film all used up in two cameras, I headed back to the boat and the other divers followed.

*

"The other dive guides will show you where to kneel on the sandy seabed to wait for the feeder to arrive with the bait box. Make sure you are negatively buoyant and comfortable and be sure you can see your pressure gauge without reaching for it. Cross your arms. Don't flail about or you might inadvertently drag your hand across a passing shark's mouth. Not good. When you've had enough, simply swim slowly back to the boat ever mindful of a sensible ascent rate."
Shark feeder Graham Cove, Stuart Cove's Dive South Ocean, 1997

New Providence is the island that hosts Nassau, the capital of the Bahamas. It never sounds quite as glamorous as the outer islands but, because it has a lot of deep water in the form of the Tongue of the Ocean, it provides, in my opinion, the best diving.

There is one dive centre I can recommend – Stuart Cove's Dive Bahamas. Canadian-educated Bahamian Stuart Cove and his wife Michelle Berlanda Cove are the Beckhams of the shark diving world. They are quite well known in the film world too, because they so often provide facilities to film and TV programme makers.

The village in the movie *Flipper* was their dive centre with a few added buildings and props, and Stuart drove the Sheriff's boat – one of his dive boats in fancy dress. They have left their mark on a number of other movies too, including various James Bonds, *Cocoon*, *Splash* and *Jaws IV*.

I like their operation because they always make my job so easy, and nothing seems to be too much trouble.

Besides the shark diving, Stuart Cove's provides a shark awareness course for those who want it. The centre bustles with business yet everyone gets the impression that they are special among the customers.

I arrived without warning and within minutes my gear was loaded onto the shark-diving boat, which had been held waiting while I assembled my camera gear. Without ceremony I was off shooting a shark encounter. In two days I got more work done here than I had done at any of the out-island dive resorts.

The shark feeder and video-maker both wear long chainmail gloves and feed from a box, offering the bait with a short spear.

The dive centre uses the four different sites at which shark encounters can be almost guaranteed – the Shark Wall and the Shark Arena, which are about 45 minutes by fast boat from New Providence; the Shark Runway, almost directly outside Stuart Cove's front door; and the Shark Buoy, some 35 minutes away.

The first two feature about thirty hefty female Caribbean reef sharks while the third, Shark Runway, attracts smaller, but faster, males.

The Arena is one of the several flat, sandy areas on the reef-top above deep water. It is about 12m (36 ft) deep. Often during this dive I was jostled and nudged by large sharks and several times felt the power in tail colliding with my camera housing. Exciting stuff.

The Shark Buoy is a blue water dive in about 2000m of water. Here all manner of fish enjoy the shade of an enormous US submarine-testing buoy, including lots of small silky sharks.

Dive guides take time out to do conservation work, removing fishing hooks from the sharks. They do this by grabbing each animal by tail and dorsal fin and inverting it so that it goes into tonic immobility while they get to work with the pliers.

On another occasion when I turned up without warning at Stuart Cove's, the scheduled shark dive had been cancelled by the customers because of a threatening tropical storm.

I went out with Stuart's nephew Graham Cove on an ordinary dive, but we improvised with the severed head of a grouper. The other divers on the boat viewed the prospect of diving with sharks rather dimly, but when they returned to the boat after watching our antics underwater universally pronounced it to have been the best dive of their lives!

The New Providence dive centre offers the most variety in shark encounters, and when I was there in July 1997, Stuart Cove, in an effort to add even more spectacle, was beginning to experiment with his first chumsicle feed.

*

Which Bahamas shark feed is best depends on you. UNEXSO offers controlled spectacle with a lot of hype along the lines that Billy Smart's Circus would appreciate. Walker's Cay gives you total freedom to do whatever you like during the feed with a huge number of sharks. The New Providence dive centre offers a greater variety of shark dives while Stella Maris offers the excitement of the unexpected.

Postscript

Fifteen years later, the hotel and dive centre on Walker's Cay was no more. It was shut down after the original owner passed away and the new owners felt it was too much of a financial liability to keep it open. The UNEXSO operation is a shadow of its former self and has changed its attitude to its customers. Although the feeder, exalted shark expert Cristina Zenato, still does the feed in the same way, the centre is much more enlightened in the way it briefs its customers and there is less regimentation of the guest divers in the water. No longer do they feel unsure or even scared as they enter the water in nothing more than their swimming costumes or maybe a wetsuit while they are surrounded by chainmail-clad dive staff telling them how dangerous the sharks are.

Cristina Zenato is noted for her stunningly beautiful shark ballet that progresses the Caribbean reef sharks she feeds to a different dimension – or some would say a different degree of foolhardiness!

I wrote this after a more recent visit to Stella Maris:

"Peter, one of the original founders, now retired and failing to remember my visit fifteen years previously, tells me how, a long time ago, a German film company made a documentary about sharks and filmed them close by Stella Maris in a staged feeding frenzy. He had reservations about it and thought the resulting television programme would scare divers away but it caught the imagination of their then-predominantly German audience and the demand was self-generating.

They became the first dive centre anywhere in the world to offer shark-feeding dives to leisure divers, and Robbie, the chief of the diving department still carries out these dives from time to time, though over the years he's had to modify the way he goes about it.

Fifteen years ago I visited as part of a comparison of shark-feeding operations in the Bahamas and then they put the wind up me. Instead of taking a bucket of dead fish as bait, the guys went spearing live fish during the dive and, as you can imagine, the sharks, alerted by the vibrations from dying fish, went crazy. It seemed to me to be a shark feed that was on the edge of loss of control. Not only was it a feeding frenzy, but also the sharks often hurtled around unpredictably with the speared fish, complete with the long spear, sticking out of their mouths. 'One could take your eye out!' Today things are very different.

It seems that it wasn't just me that thought the old routine was too risky. Robbie told me that they had to change things because the sharks were getting too frisky and people were reluctant to get into the water with them. He said that he only had to bang a weight on the side of the boat and he'd have sharks nearly jumping out of the water. I can imagine that.

Nowadays, the boat stops over a sandy patch near the old shark reef. It is only around ten metres deep. Divers are instructed to kneel on the bottom a safe distance away from the stern of the boat. The deckhand waits for ten minutes to pass to allow everyone to settle and by this time up to a dozen Caribbean reef sharks have gathered under the boat in anticipation. He then drops a bucket of bait into the water and the sharks make short work of the contents.

Of course, we are too far away to get good pictures of the sharks feeding from the bucket but as each one gabs a mouthful, it swims away in order not to have to share it. It's as these sharks circle round that you get the opportunity to get a clear view, but the sharks are not interested in the divers. They only want to get back to the bucket for another morsel before their mates have grabbed the lot. Eventually some bits of bait get into the possession of little groupers competing for a free meal. This is the most hazardous time, because these little fish will dart away and look for somewhere to hide and too often it can be under the stationary body of one of the divers. Robbie is ever vigilant and has equipped himself with a long pole for pushing these little grouper and their pursuing sharks away from where they are unwanted. No one wants to get bitten by mistake during such a tussle.

Once all the bait has gone, most of the sharks lose interest and disappear from view but two or three hang around on the off chance that some more food might magically appear. It is these sharks that come close enough for good pictures and by then the action has become less frenetic and things are more relaxed. The sunlight reflecting off the white sand gives perfect conditions for photography.

The whole event is so safe, it will appeal to those who have never seen a shark close up before but it will probably be a bit too tame for anyone who has seen shark feeds elsewhere. The most dangerous bit of the whole exercise was rushing back up to the boat and climbing on board. Robbie didn't want anyone hanging around doing safe ascents and safety stops because of past experience with sharks being interested in what's happening around the stern of the boat."

Meanwhile, Stuart Cove and Michelle Berlanda Cove may no longer be an item after so many years but their jointly-owned operation has gone from strength to strength. Film-makers continue to beat a path to their door although several minor accidents involving the shark feeders themselves has meant that they now use full chainmail suits and football helmets on routine shark-feeding dives conducted for the benefit of leisure divers.

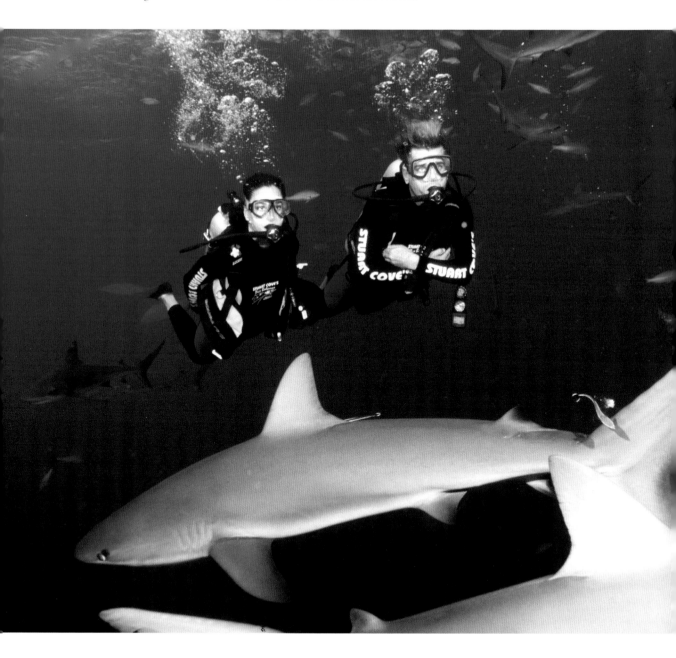

Chapter 18

Bull Sharks

Bull sharks were unlike any shark I'd seen before. The Caribbean reef sharks that I had become so used to diving with in the Bahamas could be quite bulky, especially the mature females. So bulky in fact that when shark feed dives first started in the archipelago they were misidentified as bull sharks. On the other hand the sharks we were looking at had a massive girth in proportion to their length, with mean-looking little piggy eyes. There were quite a few of them too and they circled around in expectation, trying not to get in each other's way.

A lemon shark that turned up for a moment looked very skinny by comparison. It quickly decided that it was going to need to fight beyond its weight and made itself scarce almost as quickly as it had arrived. These really were bull sharks, the real deal, not large Caribbean reef sharks, and at that time photographs of them were comparitively rare.

I lay at the surface, breathing from a snorkel tube and keeping out of their way until a suitable moment came for me to duck-dive down to grab a photograph before retreating not unhastily back to the surface. Jeremy did the same.

It was 1999 and I was photographing these bull sharks (*Carcharhinus leucas*) in the shallow waters of Walker's Cay in the Abaco chain of the Bahamas. I'd been told about the phenomenon of bull sharks aggregating there by shark book writer Jeremy Stafford-Deitsch. He'd discovered it and summoned me from the UK. I rendezvoused with him there.

The water off Bull Shark Beach, as he had so named it, was very clear and shallow enough

for me to take a breath of air whilst standing on my fin tips. Jeremy, another six-footer, could do the same, which is why we opted to snorkel with the sharks rather than endure the hassle of scuba equipment.

I was repeatedly struck by the massive breadth of each of the more than half a dozen big sharks that cruised around menacingly. These were by no means elegant creatures. They were ugly and they meant business.

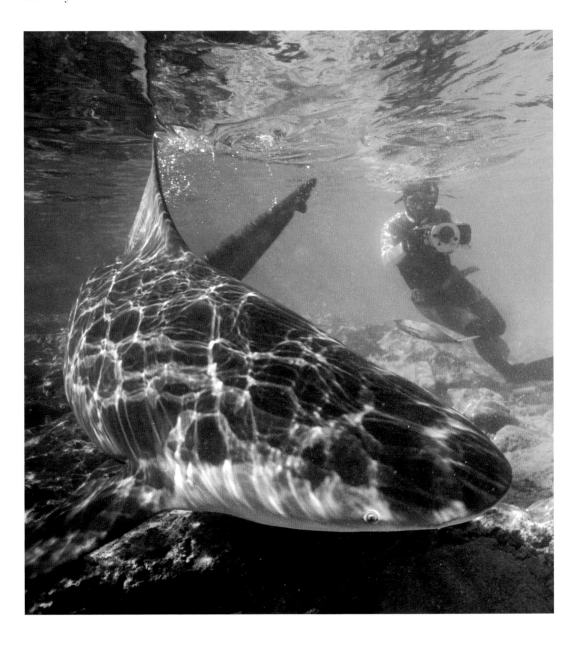

We kept them interested by getting Gary Adkison, the manager of what had been the dive centre then, to toss scraps of fish into the water. Seeing the fish scraps fly through the air to land in the water, Jeremy and I would take it in turns to duck-dive down following the bait, getting close to it with our cameras just as a shark gobbled it down. It was quite daunting, coming head to head with one of these monsters, but in this way we both got several 35mm films full of close-up images of bull sharks, something that was unprecedented at the time.

Our excitement was palpable and after a few days of successfully achieving hundreds of images, we decided that we should try to get a proper shark scientist to join us. Dr Erich Ritter, a shark behaviourist, was in Miami so Jeremy contacted him and persuaded him to make the short journey over to Walker's Cay.

Dr Ritter is a Swiss-German with what I thought were some unusual ideas about sharks. Whereas Jeremy and I were careful to swim down behind the bait and get the pictures of the sharks grabbing it, Dr Ritter took a different approach. He would get to the bait before the shark and deny the shark the food by standing on it. Jeremy and I both thought this action to be extremely risky. Dr Ritter wore a heart-rate monitor and claimed that he could drop his heart-rate so low that the sharks did not see him as prey, although I pointed out that the dead fish they were gobbling up so enthusiastically had little in the way of a heart-rate. Anyway, each of us continued in our own way and nobody got hurt – that time.

Dr Ritter became very proprietorial over these bull sharks. Based in Florida as he was, they were only a short plane ride away and he started regularly taking escorted groups of divers to swim with what became his sharks. He certainly appeared to me to be a colourful character.

I don't tell these anecdotes of my diving adventures with sharks to prove that they are safe, nor that they do not bite. I don't retell the stories in order to give the impression that I am particularly brave nor that I am foolhardy. What these experiences indicate is that sharks are not the undiscerning predators of the popular media. In fact, they're quite choosy.

They live a long time, breed only in small numbers and take care of themselves. They manage to feed without damaging each other and they try not to bite any other large predator, such as a scuba diver, which they assume also might be present for a meal.

Even the ultimate undersea predator shark, the great white, attacks its prey by making a sudden rush from below followed by a single bite, returning later to feed on the animal after it has bled to death. It won't risk damaging itself by joining battle with typical prey, such as an elephant seal. Of course, if a person gets bitten, that is very serious, even if the shark does not return to feed.

So they tend to be reticent if not timid. Sharks hang around to be photographed only if there is something in it for them. Working as a dive guide at Sha'ab Rumi in the Sudan back in the day, we used to tie a large lump of fish to a coral head and watch them come up from deep water following the scent trail. There were hundreds then, grey reefs, silkies and silvertips, but we would rarely see any on the reef in the shallows unless there was bait to attract them. I have seen the same thing done in the Maldives, although shark-feeding is now illegal there. The fact of the

matter is that these bull sharks would not have continued to stay with us at Bull Shark Beach if we had not encouraged them.

*

Media hysteria has successfully driven moves to outlaw shark-feeding by divers in Florida, following a number of attacks on people, most noticeably the little boy whose arm was severed in 2001 by a bull shark in shallow water off a beach in Pensacola.

The story is unclear in that various versions have been told by witnesses and further extrapolated on the internet by those that were not there.

Anyone who has seen a shark feed first-hand will know that the moment a shark gets a meal in its mouth, it hurtles off into deeper water, where it can deal with it without hassle and not have to share it with other sharks.

In this tragic case it seems the eight-year-old boy, Jessie Arbogast, was in shallow water on a boogie board with his uncle, when it seems he felt something touch his hand. He pushed away from it and inadvertently thrust his arm down the shark's throat. This caused the shark to react violently, severing the boy's arm.

Whether the uncle was actually fishing or not at the time remains unclear. However, he saw the bull shark and instinctively grabbed it by the tail to try to drag it away and in fact managed to drag it up on to the beach where a Park Service Ranger, Jared Klein, dispatched it with a shot to the head. Although the arm was recovered in order to be stitched back on at Pensacolas's Baptist Hospital, the boy lost most of his blood before he received medical attention and was tragically left with severe brain damage.

Bull sharks have been implicated in more attacks on man than any other shark species, but that is because they tend to frequent shallow water, harbours, the brackish water of river mouths and other places frequented by people enjoying the water.

In fact they've baffled scientists for years with their ability to enjoy both seawater and freshwater but in doing so they can be found in the river Ganges in India, more than 2000 kilometres far up the Amazon in Peru, in Lake Nicaragua, in the rivers of Malaysia, western and southern Africa, North America, Iraq and in lakes in Papua New Guinea and in Guatamala, as well as the Panama Canal.

Pensacola Chief Park Ranger Tomasovic told in an interview with CNN at the time of the attack on Jesse Arbogast that shark activity in the shallows was normal, that the previous shark attack had only been two years before and bull sharks were known to feed on the turtles that used the nearby sandy beaches to nest.

It seemed at the time to be politically expedient to blame the single dive centre that fed requiem sharks although they did this around 150 miles away from Pensacola, on Florida's east coast. Three other dive centres fed bottom-feeding nurse sharks only. So what caused this attack?

The crucial factor here would seem to be that people were fishing from the beach nearby.

Florida's beaches are often crowded with fishermen free-baiting the water to attract sharks in.

At the time I contacted shark behaviourist Dr Rocky Strong who drew a distinction between the effect on sharks of feeding them dead fish and that of fishermen (anglers) hauling in live fish.

He told me that a shark may spend hours following a scent trail and will generally do so at a leisurely to moderate pace. In contrast, that same shark will rush at full speed toward the source of low frequency vibrations such as a hooked fish. Thousands upon thousands of fish are hooked all day, every day, bleeding as they struggle violently, emitting smells and telltale sounds that bring sharks rushing in like a ringing dinner bell. The threat posed by shark attack on people from recreational and commercial fishing is colossal compared to the impact of a few dive operators who feed sharks once or twice a week.

At the same time, George Burgess, curator of that shark attack file at the Florida Museum of Natural History, added a word of caution.

"It appears that the pendulum has completely swung. A newly restructured shark image has emerged in the shark-feeding dive communities and sharks have been transformed from being bloodthirsty man-eaters to playful puppies. As is often the case, the truth lies somewhere in between these two extremes."

When I asked Michelle Cove why there had been so many sharks around Florida in the first place, she told me that, because of new controls on commercial fishing, stocks of pilchards and other baitfish had boomed and come inshore to the beaches:

"You can see tuna feeding on bait-balls in the very shallow water in the cuts left by the outgoing tide," she said. "There are many sharks and other big predators in attendance too. Don't be tempted to swim with schools of feeding dolphins either, for the same reason."

I took it upon myself to tell wildlife television presenter and producer Nigel Marven about Dr Ritter and his attitude to sharks. After the spate of shark attacks in Florida the previous summer, Nigel hit on the idea of making a documentary featuring some of those that had been injured by sharks, with Dr Ritter walking among the sharks and proving that they were not at all dangerous.

The original concept for the film had to be abandoned when, during filming, Dr Ritter got unexpectedly grabbed by the lower leg and dragged out to sea by one of the bull sharks. He owes his life to a brave member of the crew who swam out and retrieved him literally from the jaws of death. Meanwhile, one can only imagine what those amputees were thinking during their own mad scramble to get out of the water.

Dr Ritter lost a calf to the shark but has since made a recovery after being airlifted to Florida for medical treatment. The resulting film material that captured the moment of the 'attack' was rescripted and re-edited and was later shown on national television in the UK.

I wrote this when I later reviewed Erich Ritter's book *Understanding Sharks* in *Diver Magazine*:

"Sharks do not eat people. Despite the fact that the media continues to be fascinated by these 'monsters of the deep', few people are injured each year by sharks. Very few indeed, if you compare

the casualty figures from murderously falling coconuts. However, they are big animals with a large mouth equipped with rows and rows of exceedingly sharp teeth. If one chooses to feel you, in the way a baby feels things with its mouth, the results are inevitably catastrophic. The shark may not eat you but you have a good chance to bleed to death or you might simply drown.

It could be argued that dogs are just as dangerous but we are used to them. We spot when a dog looks aggressive and do not worry if we pass close to a pooch led by an old lady on the pavement. Sharks, on the other hand, have been usually portrayed as undiscerning and voracious predators.

At Walker's Cay, we attracted some very magnificent bull sharks to the shallows by baiting the water and then snorkelled with them as bits of dead fish were thrown in to keep them interested. I got some wonderful close-up photographs, but I was always careful not to appear to compete with a shark for the bait. I know what happens when you attempt to take a bone from a spaniel.

Erich, on the other hand, was intent on doing what appeared to me to be stunts, like taking the bait from a shark as it was about to eat it, or standing on the bait, thereby denying it to the shark. He gave me all sorts of reasons why he was perfectly safe. He did not get bitten. Not that time anyway.

Erich is a self-proclaimed 'shark behaviourist' but since it seems he is one of few this gives him leave to invent all sorts of technical terms that reveal his German background. 'Angstination' is an example. It's a combination of fear and fascination that people may have for sharks.

Now Erich Ritter is an expert and I am only a witness. He draws diagrams in his book that reveal the shark's Inner Circle. I translate that as 'get too close and look threatening' and the shark might warn you off. You don't want to be warned off by something with lots of teeth. He tells how a shark normally swims up and past you. Well, it would, wouldn't it? If it swims up to you and does not swim past, it would be very bad news indeed!

It is safe to swim with sharks, so long as you are sensible about it. Swimming with sharks that are chasing injured fish is very different to swimming with sharks that are leisurely sensing the presence of carrion. Do not threaten a shark and it will have no reason to threaten you. Do not compete with a shark for its food. Sharks close their eyes to protect them with a special nictitating eyelid when they bite which can make them less than accurate.

However, Erich Ritter continually puts himself in the firing line, so to speak, in his pursuit, proving that it is safe to swim with feeding sharks. He has only lost one calf and nearly his life once, but once is usually enough for most of us.

His book *Understanding Sharks* sets out to rationalise what he does. It does have some useful information including theories of previously recorded 'shark accidents'. He discusses exploratory bites. Erich Ritter's intentions are good. He wants sharks protected and makes a good case for saving them from extinction, which is a very real possibility thanks to a massive Chinese shark finning industry.

I still think that sharks that are feeding need to be treated with a healthy respect. It is OK to be a neutral observer but try not to get involved."

While I was writing that book review I was in Fiji, attending shark feeds orchestrated by Beqa Adventure Divers. I called them the BAD boys of Beqa. They went about their shark feeds in a different way to most other dive centres in that they tipped wheelie bins full of fish scraps and blood into the water so that divers are left swimming in a bouillabaisse with the underwater visibility similarly affected.

Up to eight different species of shark turn up for these feeds when the dive centre's feeder positions himself beside a strong post that ensures the sharks approach from one direction only. He then passes out large pieces of dead fish protected only by a chainmail gloved hand.

Not only is the visibility impaired for good photography but the feed tends to take place around thirty metres deep so the diver has to bear in mind not only what the sharks are doing but decompression requirements and long ascent times as well. If something were to go wrong, there would be no quick escape. After many years and hundreds if not thousands of thrilled divers attending these shark feed dives, nothing has ever gone wrong so far, apart from the lady who managed to trap her hand in the hinge of the boat's ladder, climbing up during a strong swell, and had her fingers severed.

It just goes to show that the most dangerous thing you encounter whilst scuba diving is probably your own boat.

It's a frenetic dive. First little whitetip reef sharks show up, followed by speedy little blacktip sharks. Then the more fearsome grey reef sharks are followed in by elegant-looking lemon sharks with their curiously coloured lemony-green skin. Divers are very much aware of the bait that is floating around freely in the water and the chaos of other fish such as snapper and jacks that are competing for it. It crosses the mind that one wouldn't want a piece of such bait to lodge in the crevices of one's equipment.

Then the bull sharks turn up and all the other sharks retreat with due respect. These bull sharks are bigger and more powerful than any I have seen elsewhere, including at Walker's Cay, and take on an awe-inspiring appearance with their broad beams and unkind little yellow eyes. Cameras click and strobes flash as all the attending divers attempt to outdo each other with better pictures.

The bull sharks swim round, each deferring to the one that gets to the bait handed out first, never resorting to any rough stuff with each other, although we divers are aware that just one of them could demolish any one of us in a moment. It was an awesome experience in the true sense of the word. Then Scarface, the enormous resident tiger shark appears…and the bull sharks make themselves scarce.

Chapter 19

Tiger, Tiger

Tiger Beach is so named because it is a shallow sandbank about 25 miles from West End, Grand Bahama, where, unusually, there lives a large population of tiger sharks. A couple of American-based dive boats have been coming here since they were chased out of their own home waters by the Florida angling lobby. It is now illegal to feed sharks in Florida apart from in pursuit of the purpose of harvesting them. That means that fishermen are allowed to bait sharks in order to kill them but divers are not allowed to bait them in order to observe them.

Of course, the American-based boats bring nothing to the economy of the Bahamas since they depart from Fort Lauderdale. More recently, Stuart Cove's local Dive Bahamas operation has made occasional forays from the Old Bahama Bay resort out to Tiger Beach and I went with them.

Once we were securely anchored in the sand at Tiger Beach, the lemon sharks turned up, waiting expectantly. There were about thirty of them. A large number of them began to thrash about at the surface expectantly. They've obviously come to associate dive boats with a free meal. Their big sand-coloured bodies looked rather incongruous to those of us that expect sharks to be the guys in the grey suits. A couple of itinerant holiday divers that had casually joined us for a day's diving at the Old Bahamas Bay resort looked rather daunted by the prospect of getting into the water with them. In fact they looked positively scared!

We were lucky. The weather was very overcast but there was little current, which is unusual since Tiger Beach is fed by the Gulf Stream.

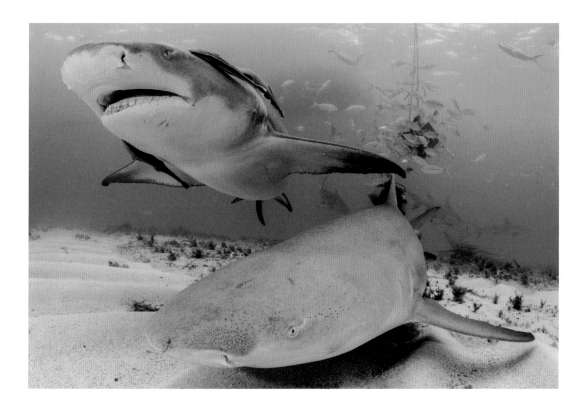

Lemon sharks are big, they're mean looking and they are in dire need of an orthodontist. Their teeth are spikey and very much in evidence. They're very much like the sharks in the movie *Finding Nemo*. Once we were underwater, they churned round continuously under the bait box that drifted up and past me as the boat swung in the wind. If you inadvertently found yourself under the bait box, you were in the centre of the action. Lemon sharks are also tricky and opportunistic. It seemed that you need to be aware that a lemon shark might bite you simply because you're there.

It was in the confusion of sharks under the bait box, that a sixth sense told me at one important moment that one intended to give my gloved hand a nip and I instinctively moved so that it grabbed the strobe mounting arm adjacent to it. There was a brief tussle before it gave up and let go. I managed to fend it off with my camera and came away with some teeth marks on one of the robust flash-mounting-arms. The scars on the anodised aluminium proved it.

Things were unusually chaotic down there. The lemon sharks seemed over-excited. Then several tiger sharks (*Galeocerdo cuvier*) turned up.

Tiger sharks are so called because they carry vertical stripes on their flanks that only fade away once they have reached the full size of maturity.

What have coal, shoes, car license plates, paint cans, a hat, a roll of tar paper, two tins of green peas, an unopened can of salmon, a 90g coil of copper wire, small barrels, nuts and bolts,

driftwood, a tom-tom, a wallet, boat cushions, the head and forequarters of a saltwater crocodile, hyenas, monkeys, chickens, pigs, cattle, donkeys, the hind leg of a sheep, a dog and rats got in common? According to Alessandro De Maddalena in his book, *Sharks, the Perfect Predator*, they have all been found in the stomachs of dead tiger sharks. They'll have a go at eating anything, it seems, whether it's a seabird sitting at the surface, or something lying on the seabed itself.

Tiger sharks are the garbage collectors of the sea. Notorious and often described as the "Great White of the tropics" they were once believed to be nocturnal hunters, although recent evidence reveals that they are quite prepared to hunt during daylight hours as well. They are long-distance travellers with a range that might typically include forty square miles.

The ultimate scavengers and opportunistic feeders, tiger sharks will try to eat anything including underwater cameras, scuba tanks and, as I was about to discover evidently, even me.

They seem to move around lethargically in mid-water but they are persistent. With no natural predator of their own, they don't need to hurry and their big black eyes are remorseless. They have huge mouths armed with rows of saw-like teeth so that they can swallow large chunks of their prey. Their stomachs have the capacity to match. They can chomp through the shells of sea turtles and in some parts of the world, they gather to feed on fledgling seabirds, even albatrosses, sitting at the surface unaware of the danger below. In fact there is little that might be in or fall into the water that they will not try to eat. There seems to be nothing they cannot swallow.

Stuart Cove tells me that during one movie shoot, they had experimented by offering the

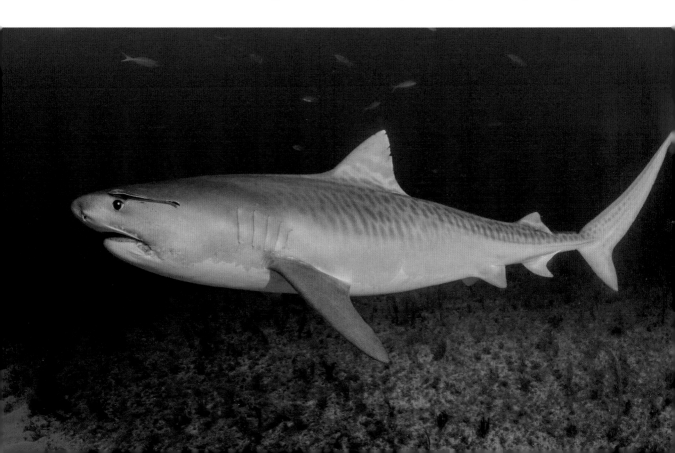

tiger sharks a wide range of food that ranged from frozen turkeys to pieces of metal, all of which seemed acceptable. Tiger sharks aren't vindictive. They'll just mindlessly eat whatever's put in front of them.

The small intestine of every shark is arranged in a curious spiral, in order to save space within its body. There is no way that any of these foreign objects could pass through. Veterinarian and shark expert Chris Harvey-Clark explained to me that the tiger shark eventually regurgitates what it cannot digest by eviscerating its stomach.

This small intestine of the shark is much shorter than those of mammals. Sharks have compensated for this problem by having a spiral valve to increase the absorbent surface. Keeping digestible material in the ileum for an extended period ensures the most efficient absorption of nutrients. For this reason, many species of shark feed infrequently. The food then passes into the comparatively short colon of the shark almost fully digested before being evacuated.

Tiger sharks are of potentially high risk to people although generally speaking they will swim lazily past divers, hardly giving them a second glance. Today was different.

We had a box of bait in the form of fish cuts and cleanings that was dangled on a steel chain from the stern of our anchored boat. By now there were more than a few dozen lemon sharks circling round in expectation and I'd already had a disappointing interaction with one of them so I was very much on my guard. It's important not to take your eyes off the tigers when you are in the water with them. They're particularly sneaky, but it gets difficult to keep track of them all when there's more than one of them. They are certainly massive and appeared to swim round lethargically, unlike the quicker moving lemon sharks.

"Thump!"

I felt the impact on my back but I wasn't sure which part of me was hit as I was accelerated away. I felt myself being carried through the water like a helpless ragdoll, the water rushing past my mask. I remember hoping that I wasn't losing too much blood although, after the initial impact, I felt no pain. It turned into a dreamlike sequence, an out-of-body experience. I became strangely passive, almost resigned to my fate. I was like a wildebeest in the helpless grip of an attacking lion, only I was underwater. Was I going to die peacefully? It certainly felt like it. I didn't panic. Panicking underwater is a precursor to drowning.

My breathing remained normal. My heart rate probably too. I couldn't see my attacker. I'd been expertly taken from behind. Luckily the enormous beast had grabbed me by my equipment and not my body. Doing nothing had turned out to be the right thing to do on my part.

One feels strangely detached when a huge tiger shark grabs you by your scuba tank and swims off with you but that was what had happened. It soon decided the metal was not tasty enough and discarded me. The whole sequence had probably lasted only sixty seconds but that's sixty seconds too much in my book. Beto Barbosa, the Brazilian master-baiter, chased it off and thankfully it dropped me from its grip.

I returned still holding my camera rig to where Beto had originally been with the box of bait, dangling as it was on a line from our boat at the surface. The problem had been that it was

becoming very breezy up above and our boat was now swinging wildly at anchor. The effect was to send the bait box in a wide arc so that it became impossible not to find yourself underneath it from time to time unless you stayed far away – and that's not what it takes to get good pictures of the sharks that are drawn to the smell of the dead fish within it like flies to a honeypot.

Then I got grabbed again. The same thumping impact and the same feeling of being carried

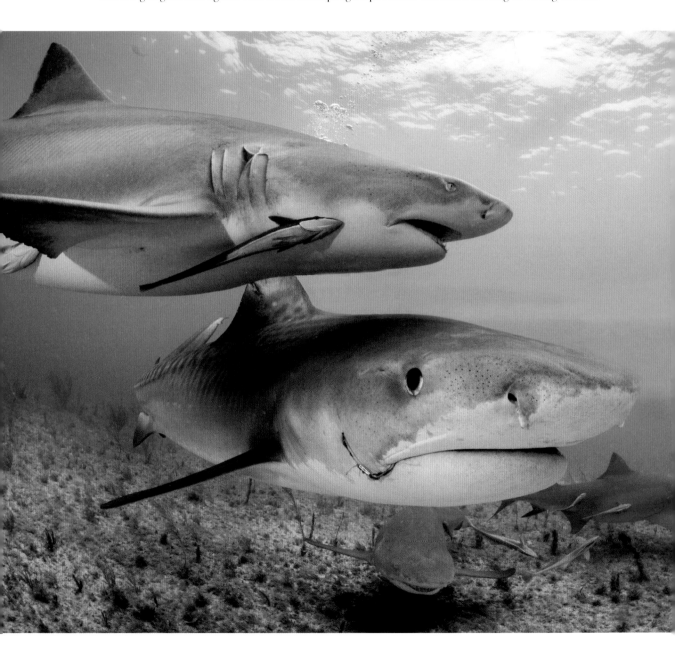

off by an invisible force. The helplessness as the water rushed past was followed by the same feeling of relief as I was eventually released from that dreadful grip.

After it happened to me twice on the same dive and I had started to think my luck was running out, I was only grateful that it hadn't grabbed me by a more vulnerable part of my body. Stuart Cove, shark-wrangler to the stars, obliged by chasing it off the second time. Under such circumstances you know who your friends are.

One of the tigers, 'Emma', as the American operators call her, has now made a habit of grabbing cameras and swimming off with them. If it's a tiger shark's idea of a jolly jape, she's probably got a tie-up with a regular eBay advertiser. My problem was that this tiger took my tank while I was still wearing it. What do you do when a big five-metre-long stripy fish with teeth grabs you? Well, there's not much you can do.

These are big striped animals with huge unemotional black eyes and a stealthy approach to eating. Their mouths are so capacious that they occasionally tried to swallow the galvanised iron bait box as it dangled from its chain. You don't want to turn your back on one of these animals or disaster might ensue. When there are several tiger sharks circling round, this requirement becomes more difficult to achieve. You find yourself focussing on one while another sneaks up from behind.

Normally, smaller sharks defer to larger ones but the lemon sharks were not impressed and continued to mob the water immediately round the bait box like lot of angry teenagers. The huge tigers came in slowly and determinedly like their grannies.

If I wanted close-up pictures, I needed to be close to that bait box. Several times I had to push an impressive yet persistent tiger shark away from me because it was simply getting too close. I was surprised to find that they felt quite squidgy in places, especially behind the gill slits. Stuart and Beto constantly needed to push them away too but the tigers were compassionless in a timeless and cold-blooded way.

The tiger sharks would swim around the periphery of the feeding lemon sharks, before heading in to the crowd and doing something unspeakable with those massive and unforgiving maws. They did this repeatedly. It was always necessary to keep an eye on where they were and twice I had failed in this. I don't know what the other guest divers thought when they witnessed my two predicaments with the tiger sharks, but they chose to abandon the idea of making a second dive that day and sat it out rather grumpily on the boat. However, just over one year later in July 2014, John Petty, American chiropractor and underwater photographer aged 63 years, went missing during such a shark dive at dusk. He was diving under the auspices of Jim Abernethy, an American operator from Fort Lauderdale, from the vessel *Shear Water*. At the time of writing, only the diver's mask and BC had been found. When divers go missing, many theories abound as to what happened. Maybe this man was also grabbed by a tiger which swam off with him, but unnoticed by the others in the dark. The result is that he might have panicked and drowned in the process, was unable to find his way back to the group of divers and was lost at sea or even sustained a fatal bite and died from loss of blood.

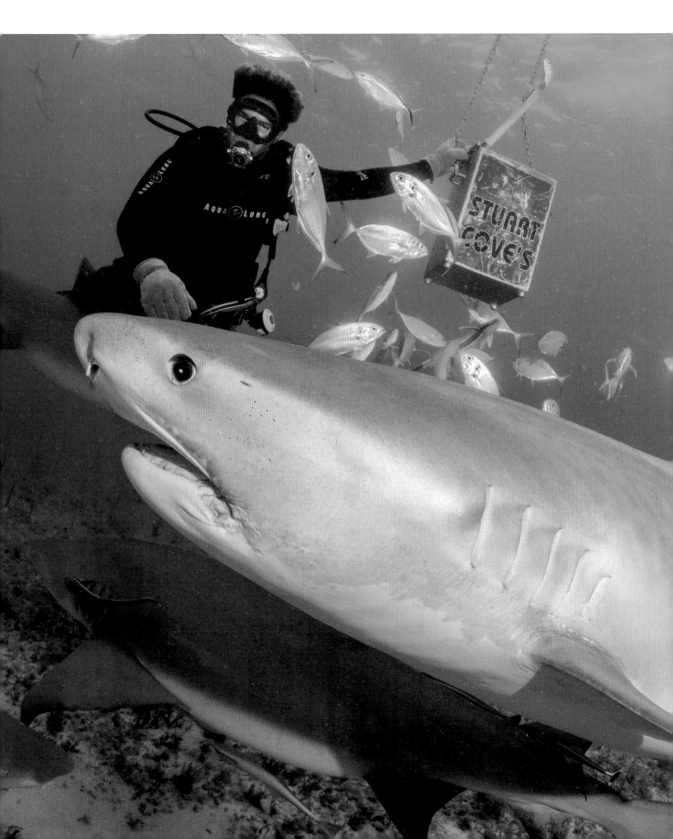

The buckles of his BC were found to have been released. Sharks can't undo such clips but if, like me, he was being carried by his tank, he might have climbed out of his kit to let the shark swim off with it. No longer with any air supply he would have struck out for the surface, but even had he got there, alone in the dark, on a current and probably no longer with any light, his predicament even then might have been hopeless.

On the other hand the shark might have grabbed his camera and pursuing it, he got separated from the other divers and was unable to find his way back. He may have simply been disorientated in the dark, swum off alone and got lost without a shark being involved at all. The ocean is a big place to look for a missing diver in, especially at night, and we will probably never know the truth.

Jim Abernethy himself has been accidentally injured by a shark during one such shark-feeding dive, resulting in him being hospitalised, and lost another client diver in 2008, 49-year-old Austrian lawyer Markus Groh, who was bitten on the calf probably by one of the competing lemon sharks or maybe a bull shark that was present at such a feed. Despite efforts to save him, he died on board the boat due to loss of blood caused by the injury. At the time of Markus Groh's fatality, Abernethy was reported as saying that in twenty-five years of running shark dives, he never thought this would happen. It was interesting to see the polarisation of opinion. The regular shark-diving community closed ranks behind the *Shear Water* operation while the mainstream press had a field day with shark attack stories.

Chapter 20

The Tasselled Wobbegong

Of the four hundred plus species of different sharks inhabiting our seas, the carpet shark or wobbegong has to be one of the most unusual. Found around the waters off Queensland, Northern Australia, Papua New Guinea and Eastern Indonesia, there are thought to be at least six and possibly as many as a dozen sub-species of which the tasselled wobbegong is the most frequently encountered by divers.

My first experience of a wobbegong was in the fertile waters of Raja Ampat, a small cluster of islands at the western end of the Bird's Head Peninsular, itself at the western extreme of West Papua, also known as Iryanjaya, that itself is the western half of the massive island it shares with Papua New Guinea.

Currents can often be quite strong in Raja Ampat and I was battling with my camera against the powerful flow of water at Cape Kri, a dive site adjoining Kri Island, and concentrating on photographing some animal that I have long since forgotten. It was a struggle, holding the unwieldy camera rig in one hand whilst attempting to maintain station in a steady manner, grasping the line of my current hook that was securely anchored in the rocky substrate, when the light above me was occluded as a large flying carpet passed over me. It was a carpet shark that was certainly as big as me and possibly as much as three metres long. I simply had not noticed it lying on the coral, it was such a master of disguise, but disturbed by my presence and possibly the erratic use of my fins as I fought to stay on even keel in the flow, it had decided to rise up and relocate elsewhere.

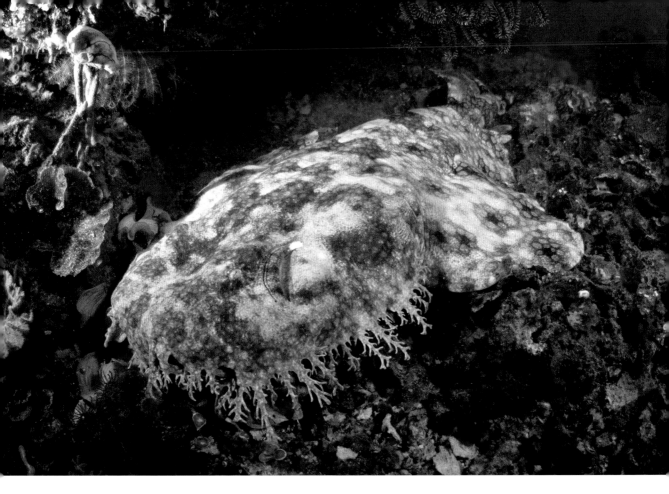

Wobbegongs, to use their aboriginal name that is variously translated as 'shaggy beard' or even 'living rock', either of which could be apt, are sublime in the way that they catch a meal. They are large flattened broad-bodied sharks with long aft sections and a tail that is often coiled up like a spring ready to launch the animal forward. Their jaws are strong and protrusible with enlarged teeth for impaling their prey. Their cryptic colouration is probably unique to each animal with blotches, spots, saddles and lines and really does contrive to make the animal disappear into its background despite its size.

They are experts at hiding in plain sight. Resting quietly on the bottom, they drape their flattened bodies over coral or rocky substrate in such a way that they are almost undetectable. The patterns of their variegated markings, usually brownish grey but often quite different from one another, breaks up the image of their bodies into irregular unrecognisable shapes that blend imperceptibly with the riotous irregularity of the surrounding coral reef. Even the eyes that would otherwise reveal its existence are rendered impossible to detect by being hooded and surrounded by eye-shaped markings.

However, what is really fascinating about the tasselled wobbegong are the many lobes around its frontal area and mouth that give it a frilly appearance almost like some aspects of the coral reef itself and belies the fact that a gaping maw is ready to swallow any fish that comes too close. Wobbegongs are the ultimate ambush predators.

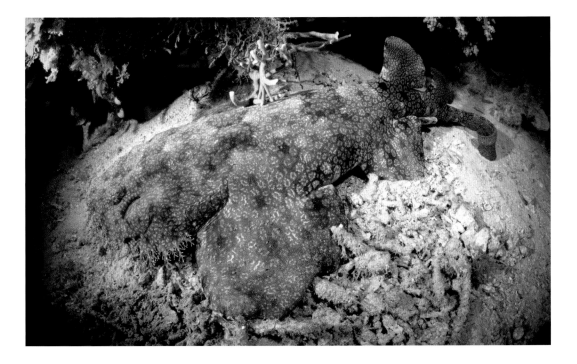

They will lie immobile for as long as it takes, tail coiled ready to propel the whole animal forward in a mighty lurch that will see an unfortunate fish, and quite large ones at that, dispatched and swallowed in an instant. Observers have noticed wobbegongs lying in the same spot day after day without apparently moving. Those that suggest that they go out and hunt after dark and merely return to the same spot each time that daylight strikes have been rebutted by those divers that state they have seen the same wobbegong lying in the same place during night dives too.

The wobbegong doesn't just grab its prey though. It opens its jaws and literally sucks the unfortunate meal into its mouth and the needle-like teeth found therein make it impossible for any such animal to make an escape.

At the same time as being lethal to passing prey fish, the wobbegong appears to be quite passive when it comes to divers. Because they tend to lie about passively in ambush, they can be found in favourite roosting spots that may be atop table corals or under overhangs. Local dive guides tend to know where to look and are often adept at lifting them and putting them out into the open so that underwater photographers can get an unobstructed shot although they are always careful to keep away from the frilly end. This action is not to be recommended.

An unfortunate Australian diver was reported to have managed to omit this caution and ended up with a small wobbegong firmly attached to his thigh after tampering with it and irritating it enough to make it bite him. There was no way the creature could be removed in the sea once it was fully locked on and the gentleman had to travel to the hospital with the shark still attached to his leg. The man survived but alas the shark did not.

Chapter 21

Shark Diving in the Golden Triangle

Cocos – Island of the Sharks

Divers can get a glimpse of hammerhead sharks almost anywhere in the tropics where there is also cold water, from Layang Layang and Sipadan in the Far East to the Sea of Cortez in the west, and even the Red Sea. But if you want to see hammerheads bouncing off your diving mask, go to Cocos Island.

Cocos is a lonely outpost in the Pacific, 36 hours' sailing from Puntarenas in Costa Rica. Always hung with thick cloud and continuously bathed in torrential downpours, the centre of the island enjoys more than 7 metres of rain each year.

Its steep cliffs and impenetrable rainforest inspired Michael Crichton to write *Jurassic Park*. It was also the island where they 'found' *King Kong* in the original movie of that name.

Robert Louis Stevenson based *Treasure Island* on a true story that has seen many entrepreneurs lose their shirts seeking gold in Cocos. When the army of Simon Bolivar threatened the cities of imperial Spain, the Spanish evacuated their treasures – some would say in a foolhardy manner – using an English ship. Predictably the crew stole the cargo, but they couldn't wait to get home to divide their booty. Each took his share and buried it somewhere on Cocos Island.

The event was well documented at the time but despite many efforts, including extensive use of modern technology, none of this treasure has ever been found. For divers, the real treasure of Cocos is under the water.

This could be described as among the best diving location in the world. Why? Upwellings of cold water mix with tropical surface water, providing fierce currents that can send you spiralling up or down without warning. One moment you are warm, the next you are chilled to the bone. One moment you enjoy 5om of visibility, the next you have problems reading your gauges.

A strong pair of leather-faced gloves for dragging yourself along unforgiving rock faces is essential. Neoprene gloves are torn to shreds within a couple of dives.

Look for respite from the flow by ducking into a hole in the cliff wall and you find it crowded with sea urchins. Skin being penetrated by their long spines becomes a familiar feeling.

It doesn't sound too good so far, does it? Yet, tough though these conditions are for humans, they are exactly what the fish seem to prefer.

The waters around Cocos attract wandering pelagics from all over the Pacific. They congregate here to mate and get cleaned, because this rocky outpost in the eternal blue is home to barber fish that like to eat parasites from pelagics' skin. None need this service more than the thousands of scalloped hammerhead sharks (*Sphyrna lewini*), which queue up for attention.

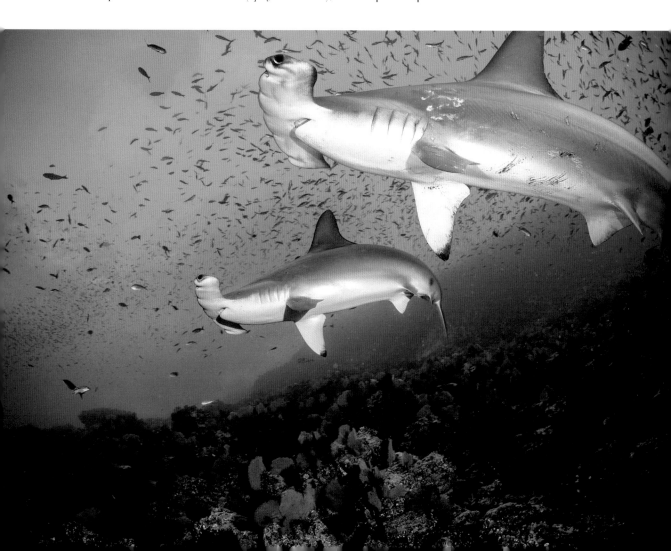

Hammerheads form an ever-present backdrop to every dive in Cocos. To get close, wait near a fluttering group of barber fish. Using a *Buddy Inspiration* closed-circuit rebreather, I had the advantages of almost indefinite gas duration and no stop times, and not a bubble released to alarm what are rather skittish creatures. Lying among the barber fish, I was able to get good close-up photographs even with my super-wide-angle lens.

I was in the best diving location in the world, armed with the best equipment with which to dive it.

Scalloped hammerheads are very timid. Now and then a great dark shape, made up of thousands of close-packed big-eye jacks, would make its way sedately past the cleaning stations and frighten away the predators. Life under water is a game of bluff and strategy.

Photography is not easy in the waters around Cocos, because of the continuously varying thermoclines. Water temperature can vary by as much as 10°C in a moment and this causes refraction in the water. The shapes of the sharks shiver and the divers shiver too. Many of my shark images ended up with deckle edges for this reason. Dive guides on *Sea Hunter* told me that photographers return time and again in pursuit of elusive perfection.

Because the currents are caused by cold upwellings, they come intermittently, like gusts of wind. Swimming in these currents feels like being outdoors in a hurricane. But the hammerheads and vast schools of whitetip reef sharks enjoy surfing in them.

The whitetip reef sharks (*Triaenodon obesus*) also like to hole up together in convenient spots on the cliff walls, like dogs exhausted after a long chase. On more than one occasion, lying in my own 'Royal Box' on the cliff wall, whitetips would come and huddle down with me.

At one time, at Submerged Rock, I counted more than 30 in a crowded dormitory of sharks, varying from 30cm to a good 2m long. Raising my camera resulted in an explosion of activity. If only I had been diving with another closed-circuit rebreather diver, we could have recorded the scene!

I always searched for an area that had an undisturbed sandy patch, indicating a sheltered spot. Located comfortably out of the flow, I was ready to ambush animals with my camera as they passed.

There were times when to raise it to my eye would subject the flashgun to the passing current and rip me from my hiding place. Once I watched a big old green turtle swimming hard towards where I waited. He battled round a headland for a full 20 minutes before giving up and allowing himself to be swept away.

As the only closed-circuit rebreather diver on the charter, I had to dive alone to use the equipment to full advantage. I often tried to re-join the group during its safety stop, cruising on the current out in the blue, but at other times would come up on my own deco-buoy and use a very large surface flag.

I promised that I would always be at the surface exactly one hour after submerging, and the *Sea Hunter* crew did all they could to accommodate me.

My descents were necessarily slow, too. Encumbered by a camera and the disciplines of

closed-circuit, together with the less-than-streamlined effect of the big yellow box that was the rebreather on my back, I inched my way down a buoyed line at a seamount called Bajo Alcyone (which was named by Jacques Cousteau after *Alcyon*, the vessel he was using). I was so slow into an almost impossible flow of water that I was in danger of meeting my fellow-divers coming back the other way, their open-circuit nitrox supplies exhausted.

The others observed my activities with amusement. I might be lying in wait, unaware that a whale shark was hovering over my head or a hammerhead almost lying on my back while enjoying the ministrations of the barber fish.

But fish interacted with open-circuit scuba divers, too. At Dirty Rock, flotillas of mobula (from the same family as manta rays) bathed in divers' exhaled bubbles, and large almaco amberjacks constantly tried to brush their own skin on the rough edges of the scuba equipment. Huge female marble rays cruised, pursued by numerous male admirers. Such were the numbers of spiny lobsters that there were places along the cliff walls where it was hard to get a handhold.

Our checkout dive was an easy, current-free experience on the sheltered side of the tiny island of Manuelita. It was a good introduction to Cocos. I must have seen fifty hammerheads, together with marble rays and countless eagle rays browsing on the seabed. Then, on the ocean side of the island, it was all action, with currents, hammerheads and shoals of jacks escorted by silky sharks.

Fishing is banned in the waters of Cocos but this doesn't stop the world's long-line fleet lying in wait for the sharks as they make their way to and from the manicurists. We pulled in a line that had drifted into the island's waters and found a dead silky shark attached. The week before the crew of *Sea Hunter* had pulled in a similar line with sixty dead sharks attached.

Many of the sharks I photographed had cuts and abrasions from close calls. One hundred million sharks are killed each year to fulfil the demand for shark fin in the Far East. The world shark population cannot sustain such slaughter.

*

Darwin & Wolf – Gems of the Galapagos

One hundred and fifty miles north from the main archipelago that is the Galapagos lie the isolated outposts of Darwin and Wolf Island. Wolf is virtually inaccessible by virtue of its steep cliff walls, home to thousands of blue-footed boobies and the frigate birds that plunder the results of their fishing, while unique-to-Wolf vampire finches peck at the feet of roosting birds, feeding from their blood.

Down in the water below steller sea lions swim, at night the phosphorescence caused by plankton disturbed in the water around them giving them an alien appearance. Nearby Darwin Island is a low lying plateau of rock surmounted by a huge edifice of rock that has been eroded away over time to look reminiscent of the Arc de Triomphe in Paris and is known as Darwin's Arch. Darwin himself never made it to the tiny island named after him but it provides the most

spectacular dive site of all.

The ocean currents rip around these two geological obstructions and attract those marine animals that enjoy such conditions. Scalloped hammerhead sharks are a common visitor, schooling in great numbers and breaking off to visit cleaning stations on the island's rocky undersea walls, inhabited by small fish that trade the job of manicurist in return for a free meal. The waters are thus rich with life. Most spectacular of all are the whale sharks. These ocean roving juggernauts follow the plankton on which they feed, huge mouths agape, insatiably filtering the water for the tiniest forms of life. They are also known to vacuum up great schools of small fish by approaching them from below, mouths open wide, so that they are scooped up helplessly en masse. They represent no danger to larger animals including man.

Whale sharks can be encountered almost anywhere in the tropical or sub-tropical zone but by the time they have reached the lonely outpost of Darwin Island in the Pacific they have reached maturity and their full size. They can measure up to 18m long. Can you imagine what it is like to meet an animal with the dimensions of the biggest intercontinental truck swimming majestically through the water with unhurried sweeps of its massive tail? Can you imagine what it must be like to come face-to-face with a group of them? At Darwin's Arch they are often seen in groups and I have been lucky enough to swim with three of these marine leviathans as they cruised together round Darwin Island.

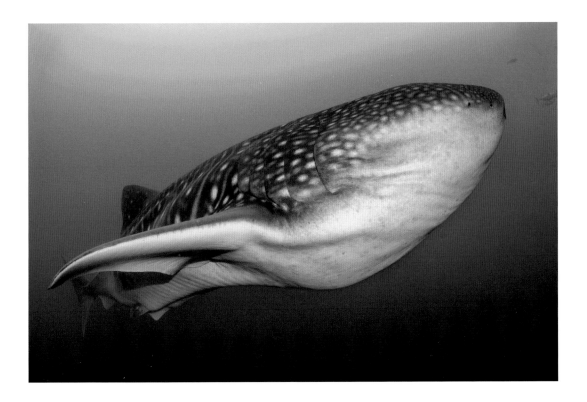

I told of one such interaction in my book *Amazing Diving Stories*. It was while I was away with Nigel Marven and a film crew from *Discovery Channel* intent on making a short film sequence diving with sharks that, unable to take any still photographs while filming took place for fear of spoiling the film crew's best chances, I asked to make what would be a special still-photography dive. Nobody is allowed to dive in the Galapagos without being accompanied by an official naturalist guide or Marine Park ranger.

"One such ranger was quick to tell the divers he escorted he was known as the 'Silver Fox'.

Whale sharks may look unhurried, but these spotty monsters meander at about two or three knots, which is as fast as a fully-equipped scuba diver can sustain for the briefest of periods. Divers leave the safety of the reef wall and take their chances with the current in exchange for a few moments with the whale sharks in the blue water. It is undeniable that it's a special experience to swim alongside a fish that makes a man feel like a minnow. One could only keep up for a limited amount of time before they sweep on past but luckily these animals circumnavigate Darwin Island several times allowing the superb experience to be repeated again and again.

It is tempting for any diver to try to grab hold of a passing dorsal fin and hitch a ride on one of these giant yet benign creatures but any modern and enlightened environmentalist would frown at the practice. Once I had signalled that I was finally out of film, it was, however, an impulse that this ranger, the Silver Fox, could not suppress. He grabbed a dorsal fin of a passing whale shark and rode the animal, Calgary Stampede style, for about three minutes as it circled in confusion round the incredulous audience.

That was not enough. Whale sharks are not the most intelligent organisms on the planet and are in fact very docile. The Silver Fox went on to do something that anyone who was not there to witness it would not believe. He dragged himself forwards along the top of the animal's head and tumbled headfirst into its openly gaping maw. For a moment he disappeared Jonah-like until with a great rush of water and the diver's own accumulated exhaled bubbles he was expelled in slight disarray, while the creature, with a gentle sweep of its mighty tail, unhurriedly swam on its way."

<center>*</center>

A Wild and Lonely Place – Malpelo

Leather bass are large and solidly built, but slightly annoying for underwater photographers in that they are quite gregarious yet do not school neatly like other fish. It makes them difficult to compose into a satisfying shot.

I spotted a bunch of them clustered around the top of a little seamount unimaginatively named 'The Aquarium' by our dive guides from our liveaboard dive boat *Yemaya II*.

I liked this spot because it's well away from the rugged cliffs of the main island and the water is less subject to the double surge as the huge Pacific swells rebound off the cliffs. Creeping forward with my camera to the leather bass so as not to fragment the group, I make a mental note of another rocky structure beyond them in the gloom as a place to head to next; only it isn't a

structure. It's a huge whale shark hovering stationary in the water.

One digital exposure on the leather bass, my original photographic prey, and I'm using them instead as cover to get the head-on shot of the spotty ocean juggernaut. Forget the babies you might see in the Maldives. This one's got to be at least fifteen metres long! No wonder I thought at first it was another seamount.

I get a few pictures, adjusting my camera to suit as I go, before it slowly turns away. I latch on to its right pectoral fin as it passes me and go for a ride. It may look flabby but it's hard as the rocks I've left behind. Neither does the gargantuan animal seem to notice me and I feel like I'm holding on to a branch of oak. My over-sized camera rig provides too much resistance in the flow and I soon let go. The leviathan meanders off none the wiser into the gloom and I head back to the seamount, elated. That was very big but then every experience you get at Malpelo is big.

You've got to consider where you grip these limpet-covered rocks. There are literally hundreds of free-swimming morays just gagging to grab an ill-placed hand. Put your hand in a crack and you don't get it back; that's a moray! Not only that but the tops of the rocks have numerous scorpionfish that don't take kindly to being disturbed either. These scorpionfish are fat and can be up to a couple of feet long and certainly appear different to those more usually seen in other parts of the Indo-Pacific, but they light up crimson in a photograph just like their warmer water cousins.

The whale shark had been hoovering up orange creole fish, of which there are millions. They seem to punctuate every available space in the water. A huge school of blue-striped rainbow-runner take it in turn at cleaning stations and pile up through the open water above us. As we ascend, hidden within this surging, circling pile of fish, we can look down at the otherwise skittish scalloped hammerhead sharks that mop up below them.

Malpelo is famous for its schooling hammerheads. They are the number one attraction. The island itself is nothing more than a huge windswept rock punctuating the ocean between the Galapagos and Cocos and 225 miles from our point of departure in Panama. It's a wild and lonely place. The sky is heavy with rain and the ocean enjoys an irrepressible surge that has been carried for thousands of miles across its surface. This is not diving for the faint-hearted.

With no sheltered anchorage, our liveaboard, *Jemaya II*, snatches and tugs at its mooring under the unforgiving cliffs. Only a million boobies and the frigate birds that bully them have residence, apart from a few unlucky Columbian soldiers that have to access the island by rope ladder from the sea.

There's no respite from the rough conditions. Our pick-up boats plunge and crash alongside the main vessel, and it's hazardous just to make the transfer. Even Sten, the not-so-gentle-giant Viking and one of our dive guides, is careful to get the timing right. We swing out on a knotted rope and then it's off to dive.

Underwater, it's just as tough. There's a heavy surge. The rocks appear grey in the grey water. Even the gorgonia are grey. The surface above us boils angrily in places as white water is churned up on impact with the steep cliffs. Little sunlight penetrates the clouds in the sky or the clouds

in the water. So why are we here?

Down in the murkier colder levels at around 35m deep, we gather near Sten as he gets to work with his plastic bottle, rubbing it noisily on the rocks. Soon, a dozen or so moody-looking Galapagos sharks are buzzing round, frenetically looking for where the action is and drawn by the vibrations. They keep their distance but occasionally one will break off and provide a lucky photographer with that Kodak moment. Each of us hopes it's our turn.

Far above us, the warmer clearer water appears to fill with the unmistakable shapes of the schooling hammerheads.

In shallower water, on a reef wall that tumbles down emulating the rock and shale slopes of the island, we take up position and wait. Sure enough, the hammerheads come in to be cleaned by the zealous yellow angel fish that are stationed near the rocks, or the blue king angels that wait further out in the deeper water.

We cling on, grateful for sturdy gloves. The rocks look grey but turn out to be pink in the light of the camera's flash, as do the Mexican hogfish that hang about us, ready to gobble up any small invertebrates revealed when a lump of limpet-covered rock inevitably breaks off in the hand. In fact, common as they may be here, the larger adult Mexican hogfish look rather stylish revealed in their pink and yellow garb.

The scalloped hammerheads take turns to run the gauntlet of the reef to be cleaned and then, with a sudden flick of the tail, they're gone back to open water. Getting a good picture is all about being in the right place at the right time and we all spend most of our time in the wrong place. Daniel, a young German underwater photographer, raises a fist in triumph when a hammerhead passes close by his head and he captures its image.

When it's time to come up, we head out into open ocean, avoiding that boiling white water churning close to the reef top. Out in the blue, it's time to watch for silky sharks. Richard, my cabin mate for the trip, is lucky. He gets one investigating his fins while the rest of us must content ourselves with close encounters of the rather unpleasant kind with an infestation of Portuguese Men-of-War.

Malpelo isn't just about sharks though. Eagle rays flit like giant demented moths around the rocks. The sea is rich with schooling fish of all types. There are slimline barracuda huddled in a mass; as tightly huddled as a ball of whipper snapper that try to look like a whale shark from a distance. Horse-eye jacks do the same. The ocean here is rich in both prey and predators. Only large evil-looking black jacks have the confidence to cruise these waters in pairs.

It's an arduous trip. We stopped for a couple of days at Coiba Island to do some diving on the way out. It's one of the extremities of the country of Panama, famous for its canal that links both hemispheres. Coiba itself is famous for its giant frogfish. The boat ride out to Columbia's Malpelo is not so bad but once the boat is moored, the continual rolling and snatching takes its toll over seven days. It's only really safe to take a shower without bruising once we set sail for home. Otherwise it's a bit like having an animated argument with an invisible boxer. However, if you've been to the Galapagos and Cocos, you've got to go. Malpelo completes the famous golden triangle.

Chapter 22

The Sha'ab Rumi Shark Club

Off the coast of the Sudan, not far north from Port Sudan, lies a number of reefs. Angarosh, Sanganeb and Sha'ab Rumi were made famous for their shark populations during the 20th Century, not least by none other than Jacques Cousteau, who led an expedition that blasted a route through the reef at Sha'ab Rumi to give a safe anchorage for his vessel *Calypso* within its large lagoon.

When we look back at the films he made, hindsight gives us the benefit of realising that Cousteau was more of a filmmaker than a conservationist. Times change and we no longer consider it OK for divers to ride the backs of turtles, nor for that matter to use explosives on the reef but, as he said in one voiceover at the time, "Sometimes, for reasons of conservation, it is necessary to use dynamite."

It cannot be denied that, despite changing attitudes to the natural world, Cousteau's contribution to the public awareness of the underwater world was enormously significant.

One of his films was about an undersea living experiment and to this end he built an underwater habitat at Sha'ab Rumi. It had living accommodation, a garage for the submersible transport, and garages for their diver propulsion vehicles. It all looked very impressive when the final production was cut together but he left a lot of the film set where it was underwater when he left. Nowadays divers can swim down less than ten metres deep to visit the remnants.

Jacques Cousteau also recorded a lot of shark action at Sha'ab Rumi and, bearing in mind

that his films were made in the days when sharks were believed to be voracious predators, which liked nothing better than to eat a man, his underwater cameramen filmed from inside shark cages.

Two of these cages can still be seen, left where they were abandoned and now covered in coral growth on the west and south sides of the Sha'ab Rumi reef.

They were very much in evidence when I first visited the place back in 1992 as a working dive guide aboard the *Lady Jenny V*. The British captain of our dive boat had done a shark feed there before and took it upon himself to show me how it was done. He chose to use one of the abandoned shark cages as a good place to tie the bait to and the guest divers were briefed to gather round it, at a distance of about five metres.

I went into the water with the other divers while he prepared some dead fish that he wrapped up with metal wire and swam down after us to attach it to the shark cage. I couldn't help noticing that he did this in a rather hasty manner, his body language revealing that he wasn't totally confident that the sharks would not attack him while he was in the process of tying off the bait.

Bait securely attached to the encrusted metal bars of the cage, he retreated back to the boat as hastily as he'd come, leaving me with the passengers to watch as hundreds of sharks made their way up from the depths, drawn by the smell of the carrion. There were mainly grey reef sharks but among them were the occasional whitetip reef shark and the much larger silvertip shark. All the sharks behaved impeccably, and circled round sedately, keeping out of each other's way. Only the odd little blacktip reef shark would dash in amongst them to see what food was on offer. I supposed that they themselves were concerned about being preyed upon by the bigger sharks.

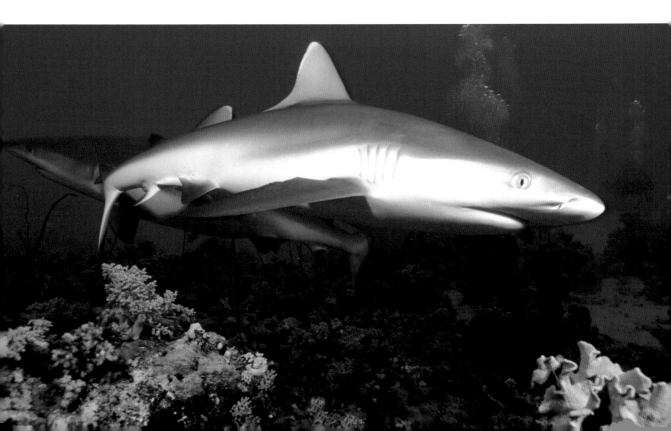

The whole show became so spectacular that I decided to go back to the boat for my underwater video camera. This raised a lot of criticism from the captain, in that I had left the guest divers to their own devices whilst surrounded by sharks. He may have had a point but had a shark attack have occurred, I don't think I could have done much to stop it happening. I returned immediately with the video camera to find the show continuing in a timeless and never ending way, and I don't believe that any of my charges had noticed my absence.

I then set up the camera and ran a good forty-five minutes worth of tape. By the time I had finished, all the guest divers had returned to the boat and crew members had joined me on their own dive. It was at this point that I realised I had incurred a lot of mandatory decompression stops and did not have sufficient air in my tank to do them. This was serious. I had to pass a message to one of my fellow crew members that ran along the lines of, "I'm out of air. Would you mind popping back to the boat to get another tank for me."

I will forever be indebted to Mike Archer for doing that for me and for not making a fuss about my page-one mistake. I was in much more danger from the water I was in than the sharks I was with. However, the video footage I obtained was used to market the operation successfully for a few years to come.

As one gets older, one begins to understand that there are precious few things that are truly new under the sun. At the same time others come along later and discover what has already been discovered and claim it as their own. We had been diving in Sha'ab Rumi following in the footsteps (or should it be fin strokes?) of Jacques Cousteau. Soon others would discover the place and become quite proprietorial about it.

Norman Temple, a Scot, was a retired Hong Kong police inspector who had invested in care homes in southern England. As such he was well heeled and had the time to devote to his private passion, which was scuba diving.

He started gathering acolytes together to go with him on diving trips to the Red Sea and it wasn't long before he was diving Sha'ab Rumi. His favourite liveaboard vessel was a retired Fleetwood trawler that had been converted to a dive support vessel. It was called *Sea Surveyor* and was owned jointly by an Israeli and his Salford-born female partner.

Temple invented the concept of the *Sha'ab Rumi Shark Club* and awarded membership complete with a certificate to anyone who had dived there with him and the sharks. The Owners of *Sea Surveyor* were unimpressed when he decided to make them honorary members. They didn't believe that these sharks were the sole property of one man!

Of course, several other dive boats visited the spot at that time and fed the sharks in order to get a dramatic encounter for their diver passengers. Two or three of these were Italian.

It is rumoured that during one of these shark dives, everything went horribly wrong when a large tiger shark turned up, scattering the smaller sharks, and grabbed one of the unfortunate watching divers, carrying him off into the depths never to be seen again. I didn't believe a word of it at the time and put it down to the sort of storytelling that comes from an activity that few people actually witness.

It was not until more than twenty years later that I myself got grabbed by a tiger shark (see Chapter 19, *Tiger, Tiger*) that I could see that it might have been true. Luckily for me, I was grabbed in the shallow waters off the Bahamas. Sha'ab Rumi is a reef that rises up from very deep water indeed and I would guess that any diver carried down to a depth beyond which it was safe to breathe air would have more to worry about than being eaten later by a shark.

Can you imagine being carried off by an unassailable force while your friends looked on hopelessly, with you taken over the edge of the reef plateau, constantly clearing your ears with increasing depth? Eventually, and with increasing depth, nitrogen narcosis caused by the air you were breathing from your tank would cause panic, even if you had managed to keep your composure until then. Eventually, the high partial pressure of oxygen in the air would cause spasms and finally blessed unconsciousness, before the shark decided you were a meal for the partaking of, or even simply abandoned you. Sha'ab Rumi Shark Club or not, that's one club of which I would prefer not to be a member.

It is quite easy to understand why the operators of the boat would have kept such an accident concealed. The Sudanese and Egyptian authorities are difficult to deal with at the best of times. It is said that when one of the passengers on *Sea Surveyor* died, probably of a heart attack, whilst snorkelling, the crew opted to store the retrieved cadaver in a freezer cabinet before returning with it to Egypt. For a long period afterward, all liveaboards returning from the Sudan to Egypt were subject to their freezers being searched.

Within a few years, the thriving population of sharks at those Sudanese reefs was decimated by the Yemeni long-line fishing fleets that cashed in on the Oriental demand for shark fin. Only a few sharks now turn up for shark feed dives at Sha'ab Rumi and sometimes none at all. So much for the *Sha'ab Rumi Shark Club*.

Chapter 23

Panic at Gordon Rocks

My wife and I first met through our shared interest in scuba diving. She had just returned from a trip to the Maldives and was looking delectably sun-tanned when I was introduced to her at a diving club's social night in London. Despite the fact that I was a lot older than she was, a trip to the Bahamas and a spot of shark-feeding confirmed that this was a girl with whom I could share the rest of my life. We were soon married and had a baby daughter.

She had been to the Galapagos with a previous partner but, at that time, I had never had the experience of diving in one of the world's premier diving locations. This was an error that needed rectifying so for my fiftieth birthday we celebrated by booking a trip aboard the giant trimaran *Lammer Law*.

The Ecuadorian archipelago of the Galapagos may be at the Equator but the islands are positioned at the confluence of three currents: the cold Humboldt from the south, the Panama and the Equatorial current. The Humboldt water upwells from the depths. The effect is to ensure the water is cold and this in turn brings an equable climate to what otherwise might have been the steamy tropics. It is a place where a diver is grateful for a warm semi-dry suit. The effects of wayward currents can make keeping buoyancy control of an even warmer drysuit something of a trial.

The sea conditions can be tough at the surface. On the one hand, the huge swells that have travelled for thousands of miles across the mighty Pacific are relentless, while the mixture of cold

and warm water can result in heavy mists that can mean divers can become invisible to the crews of their pick-up boats when at the surface. A good marker buoy or even a marker flag that can be held well above the waves can be significant to diver safety. Getting lost at the surface must be the most likely hazard to any diver, as well as getting washed on to the unforgiving rocky shoreline by the power of the ocean. So it's quite a tough place to go diving. Then there are the powerful currents.

Of course, the conditions that make it difficult for people underwater are exactly what appeals to the animals we go to the Galapagos to see. Great schools of smaller fish are fed on by sea lions, scalloped hammerhead sharks, Galapagos sharks, whale sharks and these bigger stars of the show are augmented by the smaller, quirkier members of the Galapagos cast such as various rays, marine iguanas and red-lipped batfish.

Gordon Rocks is at the north-eastern end of Santa Cruz island, about an hour's boat ride from Puerto Ayora. It is the site of what was once the caldera of a volcano, now long submerged by the passing of geological time. It is marked at the surface by three rocks. Underwater, you can still identify the lip of the caldera and the water tends to surge over this adding to the powerful currents that wash through the place.

Of course, it's exactly these conditions that make it so attractive to the schooling scalloped hammerheads and Galapagos sharks, and we were looking forward to getting into the water with them.

The boat ride from our liveaboard had been hard work. The sea was so choppy that waves broke over us on the way and it took a lot of effort to stay in the inflatable at times.

With us were some very experienced divers, all friends, that included Rob Bryning and Sam Harwood, owners and operators of a very successful diving business in the Maldives, and Kwok Lam from Hong Kong who, besides being incredibly experienced, was the sleekest diver in the water I have ever seen. Underwater he simply became a fish.

My wife and I got into the water and, with me pushing my big camera ahead of me, we fought the current whilst marvelling at the scalloped hammerhead sharks. They cruised around, their strangely wing-like heads obviously being used to surf on the flow of water that changed direction from depth to depth.

Gordon Rocks is a point at which various currents mix so there is wave after wave of thermocline that causes refraction of light and blurs your vision. It was hard to take sharp photographs. Below the water are submerged pinnacles and the channel between makes for very strong currents, surge, down currents and there is plenty of depth. So this is a very advanced dive site for anyone, no matter how experienced.

The scalloped hammerheads tended to approach us, moving their strange looking heads from side to side as if building an image from the two very disjointed points of view afforded by eyes that were so far apart and positioned on the outer edge of those unusual wing-like heads. Then, almost as if the sudden realisation dawned that we might be dangerous to them, they'd turn on the spot and with a flick of the tail, shoot off into deeper water.

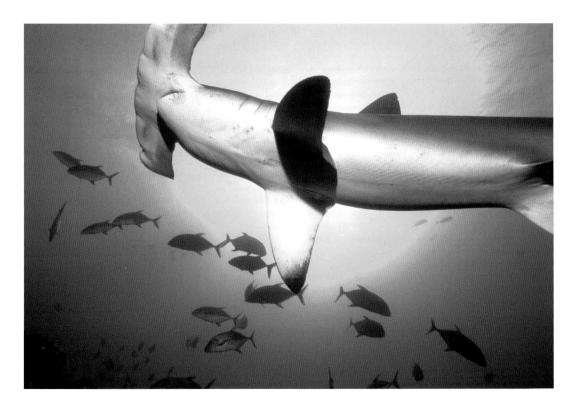

In amongst the scalloped hammerheads we spotted the graceful and streamlined forms of numerous Galapagos sharks. These tended to be larger and more shark-like whereas the scalloped hammerheads appeared to be nothing more than evolutionary oddities. The Galapagos sharks certainly looked more threatening.

We, for our part, were intruders in this shark's playground. The currents were so strong and so unpredictable, combined with the effects of the oceanic surge, that I found it was hard work and was breathing more heavily than I would have chosen to. Encumbered by our scuba equipment and cameras, it was brought home forcibly that we humans were not at home in this environment. The sharks simply moved effortlessly on the flow.

Being bigger and a lot older than my companions, I wasn't surprised that I ran low on air before the others. I knew from experience that my air consumption under duress was twice that of Rob, and Sam hardly breathed at all. As I already said, neatly packaged Lam breathed like a fish.

There were up currents as well as down currents. The site is often referred to as La Lavadora, 'the washing machine', and for good reason. The currents were intense and changeable, almost moment to moment. I found I needed to be aware of my position in the water column at all times. To become transfixed looking through the viewfinder eyepiece of my camera might result in me plunging to the depths or finding myself unceremoniously at the surface with all the hazards to health that might entail.

After about thirty-five minutes of hard finning and repeated adjustments of buoyancy, I knew I was sufficiently low on air that I needed to call it a day and head back to the surface. My wife on the other hand appeared to have plenty of air left and she signalled to me that she was going to join the other divers.

Soon I was back in the boat, the first of our group. I was surprised that it wasn't long before Rob and Sam also surfaced. It had been an arduous dive. Even Lam came up after a dive of forty-five minutes duration. That left only my wife to watch out for.

I scanned the surface from the Zodiac looking for her telltale surface marker flag but saw nothing. The surface of the sea was still very choppy and looking out into the direction of the sun, I became aware that, the waves were such, it would be impossible to spot her if she came up in the water on that side of the boat.

She was nowhere near as experienced as my companions and they had surfaced out-of-air and were now in the boat. Where was she? I kept looking. Another twenty-five minutes passed and I was beginning to panic. She couldn't possibly be still down there. Her air would not have lasted. She must have surfaced and we must have missed her.

I started to try to estimate what the surface currents were doing. Which direction would she have gone in? I squinted into the sun reflecting off the sea to try to spot the tiny shape of a diver's head. Maybe she had lost her flag.

Maybe she had been washed up on the rocks by the swell. We motored round the rocks in the boat in case she had surfaced on the other side of them, out of sight. She hadn't.

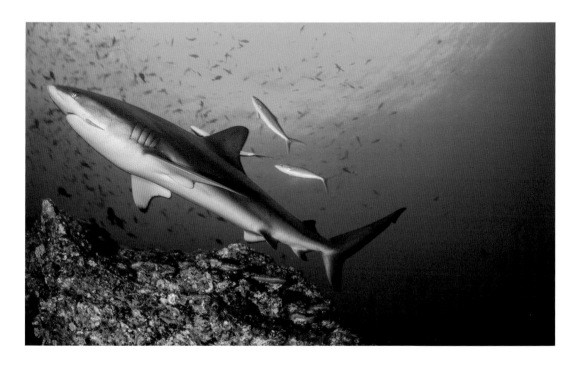

I started thinking about the menacing appearance of those Galapagos sharks. My wife was pretty fearless and I wondered if she had tried to interact with any of them, with fatal consequences. I started to think about our tiny baby daughter, at home in London with her grandmother and unknowingly left without a mother. I was almost breaking down in tears.

The others, it turned out on interrogation, had not seen her down there underwater although she had indicated to me that she was going to join them when I signalled I was out of air and going to surface. I had never been so frightened before. I wasn't used to being responsible for another person in the water, let alone the mother of my child. Just as the moment when despair was setting in, she surfaced next to the boat.

"What a fantastic dive!" she announced with a grin as we helped her over the tubes of the Zodiac.

"Where have you been?" I asked, trying not to shout at her, my exasperation mixed with relief. "How could your air have lasted for more than an hour?"

It seemed to be a reasonable question given the fact that the rest of us, Lam included, had only lasted a maximum of forty-five minutes.

"Gosh, the hammerhead sharks were incredible. They circled round me and came close enough, I could have touched them. Aren't they weird looking? Those wide flat heads with the inquisitive eyes at either end. Those flanks that almost show ribs if they had them. I suppose they must be muscles. I'm getting goose-bumps just thinking of it!"

She was babbling on about the dive and totally unaware of what had been going on in my head while I was waiting for her at the surface. I was simply grateful she was safe.

"How did you manage to stay down for so long?"

"Oh, I managed to find an eddy where there was no current whatsoever. I stayed there and watched the sharks. They were up close and really personal! Wow!"

Gordon Rocks is not a place for the faint-hearted. Some less well maintained or operated dive boats have sunk in the hurly burly of the sea conditions there. There were two deaths of divers in 2012. Although it is one of the most popular in the Galapagos, it is not a dive site for divers inexperienced in those sort of conditions.

Chapter 24

Australian Rules

The image of Australia and Australians in the wider world is often at odds with the reality of life on that subcontinent. Whereas outsiders imagine the land to be one of outback and adventurers, nearly all Australians live in suburbia and conduct very ordinary suburban lives.

With terrestrial wildlife in Australia said to be ready to poison, sting or bite, and hazardous sea life ranging from the almost invisible irukandji jellyfish to the giant voracious saltwater crocodile, you can understand people wishing to stay safe in their bungalows complete with Hills Hoist. The most dangerous encounter likely being an undercooked sausage on the barbecue.

Nowhere is more conscious of health and safety. Those that trek through the bush in the wild Northern Territories to get to some point of natural beauty such as a lake or waterfall will usually be welcomed by expanded metal walkways, safety railings and signs warning against swimming.

The Australian attitude to sharks is no less safety conscious. The fact that great white sharks patrol the colder waters off New South Wales has permeated the Australian subconsciousness in such a way that all sharks are thought of as man-eaters. True, great white sharks occasionally mistake a surfer for a sea lion, usually with tragic consequences. However, in a five-year period commencing 2010, tiger sharks gave swimmers off the coast of Western Australia a spate of investigatory bites causing seven fatalities. There followed a massive Government sponsored shark cull in 2014 which caused the destruction of sixty-three tiger sharks in less than six months and an outcry among conservationists worldwide.

So you could be forgiven for thinking that Australians have developed an inbuilt fear of sharks that is more apparent than the fear shared by any other nationality.

Ten years before that shark cull, I went on the diving liveaboard *Spoilsport* out to Flinders Reef in the Coral Sea to watch a spectacle they call the Scuba Zoo. It's a shark feed dive that mainly attracts grey reef sharks not unlike the Caribbean Reef shark feed dives undertaken in the Bahamas, only with a distinct difference. The procedure for attracting and feeding the sharks adheres to the Australian perception of safety and probably reveals the Australian innate fear of sharks.

Scuba Zoo was to be the high point of the trip that visited other points in the Great Barrier Reef. It was at the southern point of Flinders Reef where the shark-feeding dive was to be done. After a long briefing, extra liability waivers had to be signed. Some passengers were nervous, and one even declined to join in although I was confident that there would be no danger.

On the seabed there were two huge cages, the size of shipping containers, arranged at right-angles to one another with a large coral bommie forming the third side of what was a U-shape, with the open end facing out into the blue of open water. In the centre of the area that filled the U-shape was a large shackle fixed to the rocky substrate.

The passenger divers, once in the water, were ushered inside or on top of these cages according to their choice. The Japanese contingent, with their matching white fins and masks, and colourful wetsuits, opted to group together in one cage while the gaggle of other nationalities in more sombre diving attire chose the other.

Inside the cages, the bars were close enough together to make positioning a camera with a flashgun mounted quite difficult and as they were covered in growth this released much detritus into the water, so I opted to lie on top of a cage instead. Either way, we were told we would all have to go inside the cages later in the dive.

When I discovered beforehand how the shark feed was going to be conducted, I complained to Blake, the dive manager on board, that I would not be able to get good enough pictures for my magazine article working in this way. He answered that he couldn't force me to go into one of the cages, which I took to be an unspoken license to swim around freely with the sharks. It was not to be.

He approached me just before the dive and whispered that one of the crew had overheard our earlier conversation and ran to tell the captain of my intention to swim with the feeding sharks. The captain announced that he too was coming on the dive. It was something that was unprecedented. He was coming to make sure I went into the cage with the others when the time came, and once underwater I was constantly aware that he was always at my shoulder.

A line was attached to the shackle in the seabed and a large trash can-sized galvanised bucket, with a closed lid and holes puncturing its sides, was hauled down. It contained pieces of the tuna caught previously. There seemed to be a complicated rig of other lines that would allow the lid of this receptacle to be opened and closed at a remote distance from it. The water seemed to be littered with such ropes as far as I was concerned.

Obviously, the trash can was filled with cuts of fish that smelled good to sharks. The lid was opened for a nervous moment and that was enough to allow a scent trail to dribble out into the ocean. A few grey reef sharks responded and turned up, circling rather lethargically around the receptacle of bait that now had the lid firmly closed again.

I then noticed a diver, one of two of the vessel's resident dive guides, positioned at the junction of the two cages. The second dive guide controlled the height of the bucket using a line that passed through the pulley fixed to the shackle in the seabed and another at the vessel's stern. The first dive guide had hold of a long line that allowed him to drag the bait box from side to side.

The other had grip on another rope that was fed via a pulley to the lid of the bait can and was controlling it from a safe distance. In this way no diver was close to the bait that was to be the epicentre of the action.

He would pull on this rope from time to time to release more scent trail and just sufficiently enough to keep the sharks interested. A few more turned up. They looked very relaxed. It was as if they were patiently waiting for the main event.

It cannot be denied that the passengers were thrilled by this close proximity to a group of what they considered to be man-eaters, albeit most whilst safely inside a cage. In some ways I found the system and operation of it more fascinating than the sharks that turned up.

There was a vast difference in attitude between this Australian sanitised method of getting the bait accessed to the waiting sharks and, say, the method in French Polynesia where a diver simply cuts bits off a mahi-mahi head that he carries under his arm and offers them barehanded to passing sharks. With Australian rules, there was to be no such close proximity nor any chance of an accidental bite.

By the time you've read this far into this book, you'll appreciate that I have greatest confidence in the way shark feeds are done where the feeder wears a chainmail suit and offers the bait in a controlled manner at the end of a short spear.

Nevertheless I was watching the Australian method and, far be it from me to criticise, that's how they wanted to do it. My job was to write about it for the readers of *Diver Magazine* back in the UK.

The controlling diver fluttered open the lid of the bait box from time to time and a few more sharks appeared while some of the first ones got bored and started to drift off to look for food elsewhere. This went on for around thirty minutes until it was judged there was a sufficient number of sharks present and, like the bait box, they were appearing to be adequately agitated.

At this juncture we were then all hustled inside the cages. My view became rather restricted by the cage bars and the other divers squeezed into the cage alongside me. So there I was with my camera rig, squeezed inside one of the cages, in close proximity to half the other divers from the boat together with the bulky captain of *Spoilsport*, and looking out through the closely spaced bars at what was meant to be an adrenalin-fuelled experience.

I noticed by the amount of air being exhaled inside the cage I was in, that the other watching fare-paying divers were quite excited enough by the spectacle. Breathing-rates were significant.

The claustrophobia induced from being inside a closed container with no clear route to the surface probably added some tension.

The controlling divers pulled the bait can about in the space between the cages and the mainly female grey reef sharks and occasional silvertip were drawn in by the tuna oil and blood spilling into the water. More sharks turned up. This went on until some twenty sharks had been brought to a frenzy of frustration and were starting to look a little fractious, at which point the two crew members decided to squeeze safely inside the cages with us.

After what had been judged to be a sufficient period teasing the sharks with the chum trail, it was obviously decided to let the bait go free. On a signal to *Spoilsport* above us, the lid was released and the whole bin was tipped by remote control. The contents spilled out into the water. This was what the sharks had been waiting for.

A long period of boredom was punctuated by a few moments of high excitement as the sharks rushed about at high speed, competing for whatever they could get their teeth into. It really revealed the speed at which these animals could accelerate when the time came and, unlike a shark feed in the Bahamas, where the sharks circle round in an orderly manner, taking it in turns to get a helping of bait, these sharks went for it in a blur of activity. The sharks battled desperately for their share of the bait, biting the chain, the bait can and the ropes, the cages and anything else that was available to bite, adequately fulfilling anyone's preconception that these were mindless killers.

Alas, it was hard to manoeuvre and get any pictures from inside the crowded cages. True, I suppose at this point they would have easily bitten any diver unfortunate to be out there in the chaos of swirling grey bodies and flashing teeth. I was suddenly glad to be out of harm's way.

And then it was over almost as soon as it had started. The bait was gone and with it the sharks. I hadn't managed to fire off a single successful picture from behind the bars and was feeling that I had achieved little, whereas the other divers with me were obviously bubbling with excitement.

We were shepherded back out of the two cages in an orderly fashion, rather like people leaving an airliner, and returned to the surface to climb back on board *Spoilsport*. The other passengers were all very excited at seeing the spectacle, the sharks in feeding frenzy, and it had been an unusual experience, even for me, although I pointed out to the dive manager, Blake, that I had not managed to get off one shot of the sharks at the most important moment.

On other shark feeds elsewhere I expected to run out of film in my camera long before the dive was over. He understood where I was coming from but explained that it was a system they adhered to, that was dictated by the company, and that they'd never had an accident that way. I could believe it.

I suggested to him that he should visit places where shark-feeding was done more sensitively. Sadly, I felt this method did not portray the shark as the discerning predator it surely is. If you teased a group of spaniels with a bone in that way, they too would become aggressive monsters and that is what these sharks had become, if only for a moment.

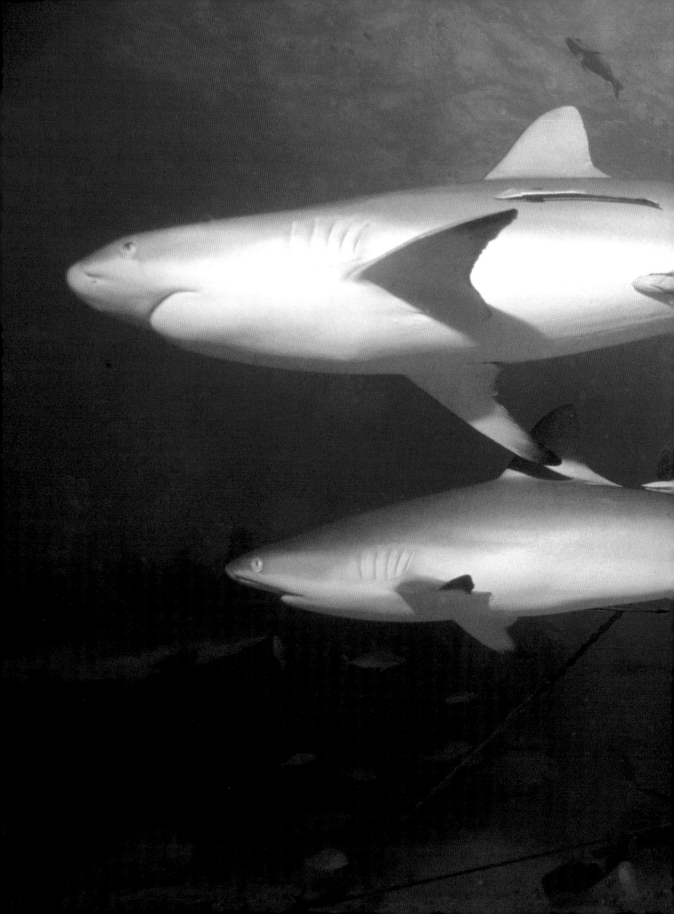

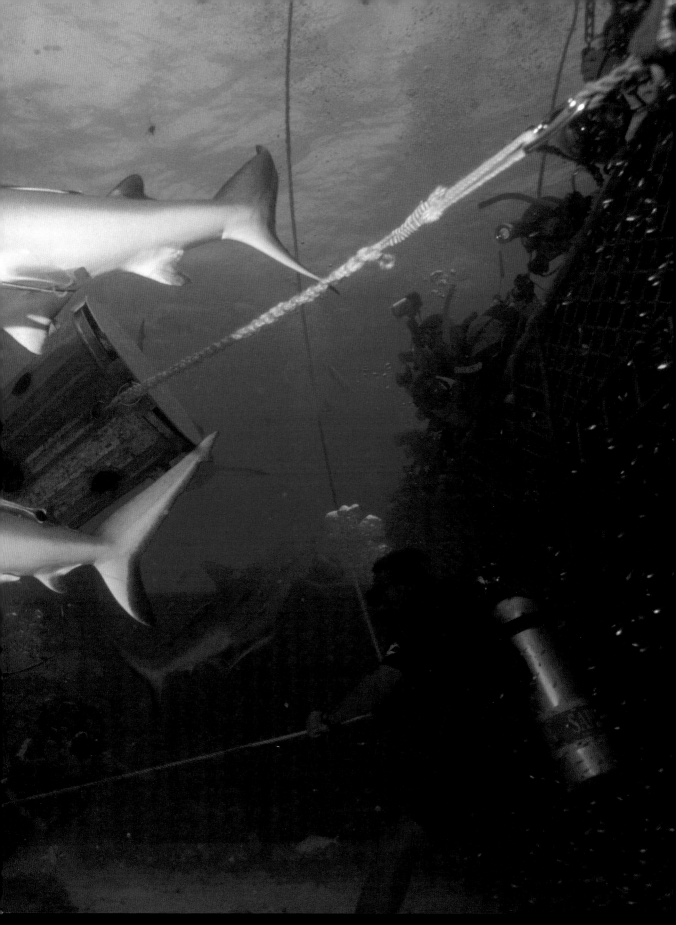

Chapter 25

A Dive on the Wild Side

"Agonistic behaviour among animals results in a contest that involves both threatening and submissive behaviour between contestants that are competing for access to the same resource, such as food or a mate. Sometimes it involves tests of strength or the contestants engage in threatening displays that make them look large or fierce, often with exaggerated posturing."

Killed tragically in a helicopter crash in Australia in 2012, underwater cameraman Mike deGruy knew about shark attacks. As a younger man, Mike lived for three years on Enewetak in the distant Marshall Islands. It was a pivotal time for Mike. His knowledge of the ocean and its fascinating creatures grew tremendously as he spent thousands of hours underwater.

I was lucky enough to meet him much later in his life at a conference in America. Mike was a handsome looking man and always appeared cheerful. I was surprised that he was physically so small after seeing him with Martha Holmes in the BBC Television series *Sea Trek*. I don't suppose he knew me from Adam but he was gracious enough to indulge me while I loomed over him asking him questions.

In conversation, he was very self-deprecating and approachable and, rather cheekily on my part, I asked him about what had happened to his arm. He appeared to have less use of one hand than was normal. He took off his jacket and I was shocked to see the state of his arm. It looked mangled. He then told me about the shark that violently attacked him.

It was April 1978 when Mike and a fellow researcher were diving in a remote area of the Enewetak Atoll. Mike was taking still photographs when, without any apparent reason, he was savagely attacked by a grey reef shark. It ripped the top off his right arm, leaving him bleeding profusely in the shark-infested waters of the lagoon. His diving partner was also attacked by the same shark but less severely. They were around ten miles out with no land in sight and there was nobody aboard their little boat to help. It goes without saying that things looked grim for the two researchers, each left alone to deal with a dire situation in the middle of a lonely ocean.

Mike thought it was a mystery as to why he was not eaten that day. The Marshall Islands were famous for their enormous population of sharks and Mike was bleeding heavily, a long way from an empty boat and his diving partner not in sight. He had rough seas surrounding him and he was severely injured. He told me it was the fact that he was totally convinced he was going to die that saved his life.

"I just figured, I was done," he told me. Spewing blood, deGruy paddled on his back to his boat through shark-filled waters for twenty-five minutes, speculating calmly about where the next one would hit him. "If I thought I might have made it, then I would have panicked."

When you think you are as good as dead, there is little reason to panic. Mike just rolled over on his back, used his left hand to clamp off the blood flow from his right arm, and slowly kicked his way toward the boat, waiting for the inevitable repeat attacks. He told me that he even imagined on what part of his body the next attack would hit him.

But a second attack never came and when Mike finally reached the boat, he saw blood on the gunwales. His friend had made it back. He called up and was helped into the boat and eventually to a hospital in Hawaii. After two years and eleven operations, he had recovered with a partially operating right hand and very ugly scars left as reminders.

"I still do not understand why I was not eaten," Mike said, making light of something very dramatic and life-threatening, only dulled by the passage of time. "I must taste like crap."

Other survivors of shark bites tell similar stories that feature a sudden, stunningly muscular attack, lots of blood and little pain, and a mind totally cleared by either adrenaline or possibly fatalism. Looking back, Mike reflected that he had not then understood the distinctive agonistic threat display of the grey reef shark (*Carcharhinus amblyrhynchos*).

When threatened, the grey reef shark lifts its snout, holds its pectoral fins stiffly downwards, arches its back and holds its tail sideways. It often accompanies this posture with an exaggerated swimming pattern in a yawing figure-of-eight. The speed and intensity of the display increases as the perceived threat increases and may be interspersed with quick slashing attacks followed by a hurried retreat. It indicates that the animal is on the verge of either attacking or fleeing. This action often causes the displaying shark to seize the opportunity to make good its escape.

"Know that only a very small percentage of attacks are fatal, so use this as confidence that you will get out of this mess with scars and a great story to tell down at the pub. Or, eat a lot of onion and garlic before diving – no self-respecting shark would like that taste!"

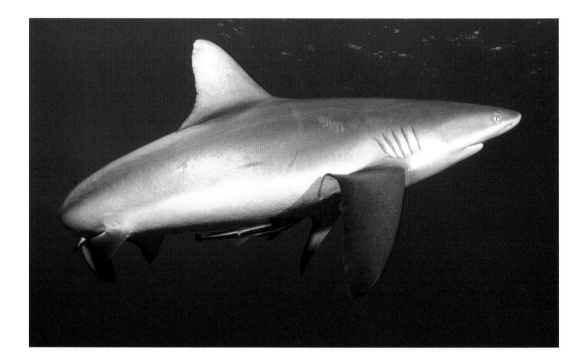

Palau is located east of the Philippines and a long way south of Japan. It is another of those tiny groups of dots that punctuate the vast expanse of the Pacific Ocean. At only 7° north, in the Western Caroline Islands, it is equatorial, and in an area collectively known as Micronesia.

It was in the 18th Century that Palau was originally settled by the Spanish, but its ties with the west stem from a friendship built between an Englishman, Henry Wilson, and a local chief. Wilson's ship, the *Antelope*, had been wrecked on Palau's barrier reef. At the beginning of this century Spain sold Palau to Germany, but it was soon wrested from them by the Japanese.

Palau came to prominence at the end of the Second World War due to the stubborn defence by the Japanese, with their underground tunnels and fortifications built under Peleliu. Thousands of Japanese and Americans lost their lives before the islands were captured.

Shortly after that fortuitous encounter with the great Mike deGruy I made my first visit to the island nation of Palau to go diving. Some of the outer reefs of Palau are no place for a beginner to dive. It is here that the roaring tide of the Philippine Sea, moving northwards, meets the mighty current of the Pacific Ocean, sweeping down in the opposite direction. I was at Peleliu Cut, hooked on to the reef to enjoy this exhilarating confluence.

The current was roaring. I needed both hands to keep my heavy camera aimed ahead, and I had already rigged the flash in such a way that it would not be bent back on its mounting arm by the force of the water.

My arms ached as my exhaled bubbles spun away horizontally. To turn and look at other divers caused my regulator to free-flow and my mask to dislodge and flood. Their exhaled bubbles

gave them the appearance of the steam expresses of my loco-spotting youth.

I was glad I'd selected a secure place to fix my reef hook. Now I was tied off by a metre-and-a-half of line, and the little bit of air in my BC gave me the buoyancy I needed to keep the line taut and the hook in place. I vectored my body so as to be as aqua-dynamic as I could. Below me, further down the wall, grey reef sharks did the same, but a lot more effectively, and they weren't tied off to the rock!

Peleliu Cut is a slash in the reef wall at the south-east end of Peleliu Island, where the tides of moving water meet the current working in the opposite direction. Where this irresistible force of the sea meets the immovable mass of the reef, the result is spectacular.

We were facing the flood tide from the south, watching for action out in the blue and knowing that we had a contrary current waiting at our backs, waiting to hurl us either up or down, but certainly out into the wide-open space of the Pacific Ocean.

It is not a place for beginners but it is a special place to see pelagic action. I had been told that big fish enjoy the current. Mantas, tuna, sharks (oceanic whitetips, threshers, tigers and silvertips) all pay regular visits.

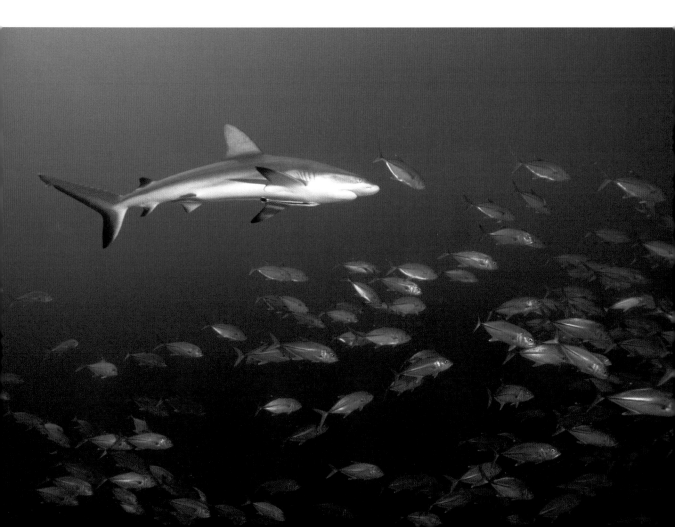

I soon was made aware that a few of the grey reef sharks had made their way towards me. They weren't very big but they were sharks nevertheless and they seemed to have taken an inordinate interest in me. There must have been a handful of them. Each in turn cautiously nosed its way up to me in a rather doglike fashion, but then apparently having second thoughts, would turn at the last moment and, with a flick of the tail, zip back in a sudden burst of speed over the reef wall into the blue outer space of deeper water.

This routine continued. They seemed to be getting bolder, like a gang of itinerant youths, each daring the next to get closer to this strange air bubbling creature that was flying in the flow but anchored by a line to the rock. I wasn't enjoying it.

I started thinking of Mike and the agonistic display he'd described. I'd attended shark feeds before where the action was always concentric around the bait, but this was different. Each shark would approach me head-on and go, head-on and go. It was getting repetitive and I was getting more uncomfortable with it by the moment.

Were these sharks mobbing me? Were they threatening me? Was any of that behaviour an agonistic display? I tried to tell if their pectoral fins were pointed down. I tried to ascertain if their backs were hunched. I attempted to see if their movements were erratic. I really didn't know.

I wished Mike hadn't given me the benefit of the sight of his injury. The imagination does terrible things. The sharks continued to swim up close to me before retreating hastily again.

By the time my tank was approaching empty, I noticed I was alone. My companion divers were by now making their safety stops, spinning along at the unpredictable will of the two opposing currents.

I pulled myself down my own tether to where the hook had been planted. It was not an easy job with one hand holding the camera. I began to wish I hadn't fixed the hook so securely and considered disconnecting it from where it was clipped to my BC, but that meant losing an important tool. Thankfully the sharks scattered as I flailed around in the flow.

It took me half of the air that I had left before I had successfully freed it and taken the hurdy-gurdy ride in the current at six-metres for a safety stop on my way to the surface.

Every diver goes in these waters equipped with a safety sausage and direct-feed whistle. It was a lesson learned the hard way. Some years previously, four Japanese divers and their local guide lost their lives here when their pick-up boat was unable to find where they ended up on the surface in stormy conditions. One of the women had written pathetically on her slate that she could see the boats searching for them but the people in the boats could not see the divers. The slate was found when their bodies were eventually located.

Thankfully, I climbed out into the pick-up boat and slipped my tank and BC off my shoulder. I felt in the pocket of the BC and found the little bit of fish from the previous night's dinner I'd discreetly stowed there, almost as an afterthought but in the hope of attracting the attention of a shark. I'd forgotten about its existence and the seductive scent trail it had obviously made.

Chapter 26

Maldives after Dark

It's dark, very dark. It's so dark the darkness hurts my eyes. There's no moon and the narrow beam of my lamp lights nothing more than a narrow section of plankton in my view of otherwise eternal blackness. I check my computer. I'm swimming hard across a strong current at about ten metres deep. I cannot see the seabed or anything else for that matter and need to check the compass function. It confirms I'm heading in the right direction generally but how much progress I'm making against the flow of the ocean is anyone's guess. Meanwhile I get the strange sensation that I'm looking through the wrong end of some binoculars with the lens caps still in place.

The briefing was that we were to be dropped up current and drift down on to the dive site that is said to be only a few metres deep. I assume the rest of our group understood the briefing and are safely floating on the surface and heading in the flow towards the island's jetty. My buddy on the other hand got things confused. She was last seen heading down to the seabed twenty-five metres below and in a futile chase after her, I lost both her and the main group and now here I am mid-water, swimming the swim from hell and hoping I'll get to where I'm going.

The standard instruction is to surface in such a scenario but the water above me is busy with dhonis and I'm concerned they might not see my single lamp, glimmering in a solitary way in the darkness of the night, and run me down, let alone would the crew of my own dhoni realise I needed picking up? No, instead I opt to get to the dive site or at worst make landfall on the beach.

It's not my first visit to Alimatha. I've been there before but never in such a strong current.

This is the mother of currents and promises to project me out into the ocean where nobody would expect me to be. I swim hard, my bulky camera rig making my work less effective than it might have been. I can detect the faint glimmer of divers' lights ahead so I believe that I'm pointing in the right direction.

My muscles are working harder than should be healthy for a man of my age. I feel an unexpected tug at my leg. Is it my buddy? No it's a huge tawny nurse shark, bigger than me and investigating what I am. It appears from nowhere like a phantom. I certainly didn't see it coming. It was just suddenly there.

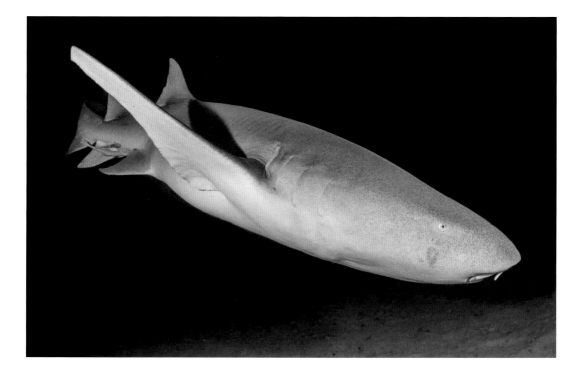

Instantly I'm surrounded by a mob of these creatures, many as big as I am, or bigger, and with poor eyesight needing to feel me with their nasal barbels, the whisker-like feelers they use to search out prey buried in the sand. Strangely enough, I find this experience disconcerting though in different circumstances I might have been thrilled. I go instantly from sensory deprivation to sensory overload.

Turning in an attempt to get pictures of my new and attentive companions is unsuccessful. My sudden movement unsettles them and they're gone as instantly as they arrived. They melt away, evaporated into the night and I'm back to eternal blackness, swimming blindly onwards. Panning round with my light reveals absolutely nothing. The beam simply peters out at a visual infinity. At least I know I'm near the place I'm trying to get to. It's the famous Alimatha night dive.

I decide to drop down to find the sandy seabed. I need a visual point of reference. I get lucky. It's only a few metres below me and I come across one of a maze of mooring ropes that are used to secure the dhonis that are anchored for the night around the jetty area in this powerful flow of water. They each head upwards at a gentle angle from where they are secured, to a massive block, capstan like.

Grabbing a thick rope with my free hand, the other hand holds my camera rig that's forced behind my back by the current. However, it affords a moment of respite. I can stop finning for a moment and struggle to see the compass on my computer. I lock an arm around the heavy mooring line and manage to press the right button. Eventually I get a heading and choose one of what has become a confusion of ropes forming alternative routes. It's one that heads in the right direction. I drag myself along and up it one-handed. I can neither see the surface nor the seabed now.

The dim glow of other divers' lights is getting more distinct and I'm working my way shallower. Eventually I reach a group of divers clinging to the same rope at six metres deep and watching a single juvenile shark circling round them. It's not my original group but my buddy is with them. The current is too strong to allow me to use my camera. The strobe mounting arms are simply forced back behind the housing.

We eventually get back to our liveaboard. Everyone is safe but has the same story to tell. It's basically along the lines of, "It was deeper than expected, in a strong current, and in the pitch blackness of night."

This is not how this night dive was meant to be conducted. A few weeks later I'm back with the crew and passengers of *Orion*, a Maldives liveaboard. The strong current is no more. It's a very different experience from the previous one.

*

Alimatha is an island on the mid-northern rim of Felidhu Atoll, in the Maldives. Its working jetty has attracted a lot of big animals. That's because returning fishermen have made it a habit to land their catch and dump the fish cleanings into the ocean. It's a bonanza, a free meal for any big animal that cares to turn up.

It's another frenetic dive for me but in a much nicer way. It's the animals that are working hard, not us. We confront a busy scene but we divers are relaxed and enjoying watching it. We've dropped together in a group from *Orion*'s huge diving dhoni on to the sandy bottom. It's about ten metres deep. There are around twenty of us and the combined lights of twenty divers reveals dozens of tawny nurse sharks circling round. A couple of sharks have discovered an octopus in a hole in a rock and are busy attempting to suck it out of its sanctuary. It holds on tight but the nurse sharks won't give up and keep returning to this little coral outcrop.

Nurse sharks have small mouths but an incredible ability to suck. They can suck a crustacean out of its own carapace. Some say they are powerful enough to suck the flesh off a man's thigh.

It's not something I want to discover.

This hunting activity gives us a point of focus and we gather round, those of us with cameras attempting to get pictures. The problem is that the swishing tails of these big animals, along with the ill-considered movements of the fins of other divers, is stirring up the sand and crucifying the visibility.

A pair of huge black trevally jacks hurtle about our heads relentlessly in expectation of some easy pickings. The whole scene is like something from the creative imagination of J.K.Rowling. We divers have to take care where we touch the seabed not only because of the danger of stirring up the sand, but also very large marble rays and fantail rays are swimming round excitedly below us too. It would be only too easy to kneel on one by accident, with disastrous results.

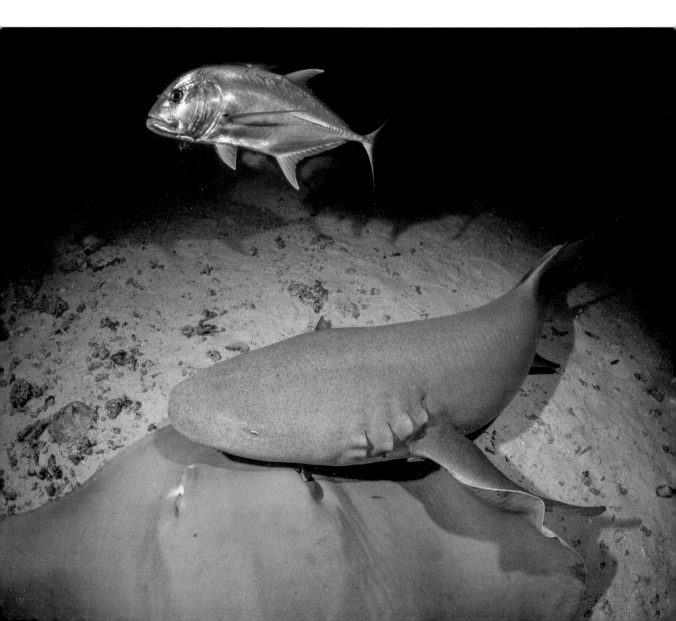

Above us in the darkness there's a veritable wall of nurse sharks schooling. All the books will tell you tawny nurse sharks are solitary beasts, but here they are not! They are like phantoms in the darkness. We may be used to seeing the occasional nurse shark lying lethargically on the bottom but there must be dozens of them swimming in mid-water. It's a very unusual sight if only revealed momentarily in the darkness of the night.

I swim up with my camera and fire off a few flash-lit shots blindly in the hope of capturing an image of this phenomenon. I'm not entirely lucky. I spray and pray, checking the LCD on my camera to see if I've managed a passable result. It's more difficult than I expect.

Meanwhile another boatload of divers has arrived. Their dive guide sets up a catering-size food can on the sand that obviously has some dead fish in it. Holes punctured in the sides of the can allow the smell out but deny the sharks the meal. It doesn't stop them from trying though and it has the effect of making the action concentric around one point.

All of this recently arrived group of divers kneel in a disciplined way around their can, watching the show, while the divers from our boat have no scruples about swimming around. Some of us return to see how well the octopus is surviving. Judging by the continued and persistent interest of a couple of sharks, it's still doing very well, thank you.

With their tiny myopic blue eyes, nurse sharks work by scent and feel rather than rely on their very imperfect vision. They can sense the octopus is there but it's not coming out simply to satisfy their appetites.

It seems to be the smaller younger sharks that cruise hurriedly around the divers. These are the tiddlers. The big ones stay aloof. They've seen it all before and can tell the difference between diving dhonis and a fishing dhoni with a crew that might be about to jettison a load of fish cleanings into the water next to the jetty.

Night dives are meant to last only forty-five minutes, or so we are told at the briefing. We've been in the water for more than an hour before some of us get bored and the thought of dinner aboard becomes more attractive. We head up slowly towards the surface, pointing our lamps upwards to make sure that we don't get run over by any errant boat driver. Our dhoni is there waiting. How do they know it's us? It's a mystery.

*

A few weeks earlier I'd done an equally interesting night dive while staying aboard *Leo*, one of *Orion*'s two fleet sister ships. We were moored in Fesdu Lagoon in North Ari Atoll and dived from the associated dhoni but it was still tied up to the mother ship. Big lights had been rigged at the stern of *Leo* to attract plankton and whatever might feed on it. Every diver was encouraged to take as much light as possible. The end result was that it was almost like daylight in the seven or eight metres of water under the boat.

We divers kneeled in a neat circle and waited patiently. Nothing showed. On a previous visit with a different boat our dive guide had promised us feeding whale sharks. He told us all to go to

bed and he would wake us when the whale sharks arrived. At first light he was found sound asleep on the swim platform. No whale sharks had turned up. I began to be afraid this was going to be a repeat performance only with us divers dozing off under water.

After an interval of maybe ten minutes with very little happening, our German dive guide, Katie, indicated that we were to follow her. She led us over the similarly illuminated stern of another liveaboard that was moored a couple of hundred metres away. There, two mantas cavorted like a couple of demented moths round a candle. The lights from the stern of this vessel had attracted so much plankton that we were swimming in a thick fog. Not only that, but the manta activity was stirring up the sand from the seabed too. It made cleanly lit photography almost impossible.

One of our divers, a resident of Hong Kong, had an over-bright Chinese-made lamp. It knocked out something like 10,000 lumens. The mantas loved it. They continued to make barrel rolls directly in front of his face and at times only inches from his mask. What a shame he hadn't invested in a camera too.

This was entirely different to insinuating oneself close to a manta cleaning station in order to get the close-up pictures during daylight hours. These mantas loved the light from the lamps and the tasty zooplankton that was attracted by it. However, while mantas on a cleaning station act passively to allow the cleaner fish to do their work, these mantas were enthusiastically hoovering up dinner and there was nothing passive or slow moving about what they were doing. When there's food available, wild animals act very differently and we were swimming in the planktonic soup that mantas love. When the time came to make our way back to our own boat, the plankton came along with us, the mantas too. The show would continue as long as the lights were on.

Chapter 27

Manta Mania

1993. I'm at Rangali, often known as Madivaru or Manta Point. It is at the southern end of Ari Atoll in the Maldives. I can see the light shading of the thilla against the darkness of deep water below me but I wait for the dhoni driver to tell me when to go. And when he does it's into the water and down as fast as I can.

As usual there's a strong current. The long reef passes me like an express train. I have a momentary encounter with a large hawksbill turtle but there's no chance to dally. I am still wiping away the bubbles that cling to the front port of my camera and sorting out my twin flashguns when the first spaceship hoves into view.

'Manta' is the Spanish word for 'cloak' and this animal is well named. One of the largest animals a diver will commonly encounter underwater, it is also one of the most spectacularly graceful. This one moves effortlessly against the flow and I am swept past it and onwards down the reef.

I look for a particular spot. I know it well. There's a trench-like indent across the top of the reef and I drop down into it, putting the brakes on by sticking my reef-hook like a dagger into a convenient hole in the substrate. Down here I can duck out of the flow and watch for oncoming mantas as they wait, like so many aircraft, out in the gloom.

Suddenly one is upon me. It hovers over me, blotting out the blue sky that ripples through the surface above. The gentle giant glides effortlessly against the current as dozens of tiny fish, all

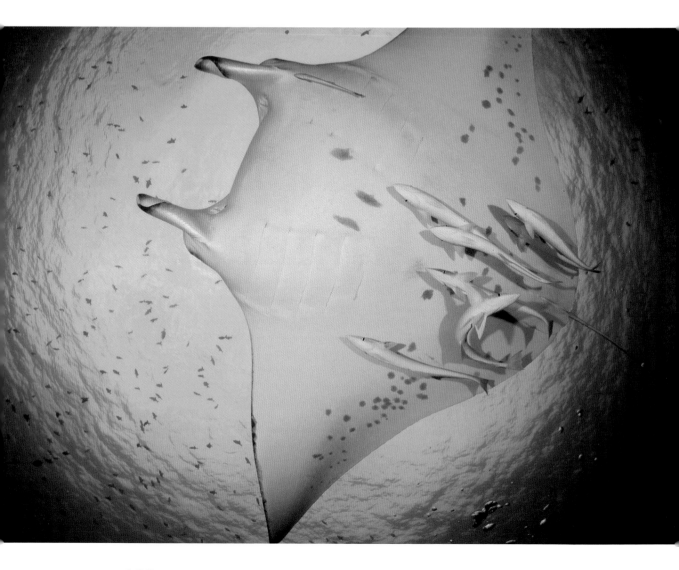

manner of different types of wrasses, gather up from the reef under its wings and dart in and out of its gill slits like so many service technicians under a great aircraft. This is a manta's cleaning station and I am lying under it.

Another great animal arrives and starts a queue. It patiently waits and contents itself by doing a few barrel-rolls, its mouth agape, feeding on the plentiful plankton that spoils the clarity of the water, guiding the food in with its unfurled lobes. The first manta moves off and the next is in place, this one adorned with twinned remoras; missiles under-slung its delta wings. Its big black eyes have a certain knowing look. These animals are used to meeting divers.

Then there is another manta and another. Trying for that elusive wide-angle close-up shot, I raise myself too far from the protection of my trench and get lifted by unseen hands. I'm taken

by the never ending flow of plankton-rich water that rushes from inside the atoll and am sent irresistibly onwards down the reef top.

I get the hook tucked in again and manage to stop before I'm sent off into mid-water at the reef end, and then I'm tethered, flying like a kite. But it's only for a moment while I pause to rethink my plan. Five, six, now seven cloaked behemoths have passed me and are queuing up at the cleaning station, but I'm getting nothing but rear views in the planktonic haze.

I drag myself down over the edge of the reef and laboriously pull myself back along it half a metre at a time, sticking my hook into solid rock where I can, like a dagger. I am careful to stay below the level of the mantas, my exhaled air bubbles swept away from me horizontally in a way that does not disturb them. And once I think I am far enough up current I swim the few metres that take me back on top of the reef and allow myself to be swept back down towards my quarry, camera ready for those important head-on shots. This exercise is repeated two or three more times until I am out of film, and then, as usual, something very special happens.

Two mantas wheel and roll, cavorting and pirouetting together, belly to belly, in a graceful synchronised ballet. It's as captivating to watch as it is to participate in. These two majestically sensuous animals are engaged in a mating ritual which I watch, mesmerised and shameless.

Mantas (*Manta birostris*) are the largest of the family of rays; elasmobranchs, part of the family of cartilaginous fishes that includes sharks. Mantas are plankton feeders, filtering the water through plates on their gill openings. Pan-tropical, the largest can weigh in at up to 2,000kg. Usually white on the underside but with dark patches often covering the upper side, the manta ray has large feeding flaps or lobes which it can carry rolled up so that they look like horns. It can deploy them in order to direct food into its cavernous mouth. The smaller but otherwise similar mobular ray does not have these large flaps. A true pelagic species, mantas are often found drawn in numbers to their food source at the entrances to underwater channels where plankton-rich water from an atoll's tropical lagoon empties into the ocean.

*

2012. Nineteen years later, I was back for one of a number of repeat visits that was probably by now in double figures. There are Madivarus or 'manta points' all around the Maldives but my favourite is the one that's famous as the Rangali Madivaru. It has never let me down for a manta encounter. Manta rays are intelligent and sociable animals that can gather in groups at places they favour where little fish feed on the parasites that frequent their skin and gill-rakers, and give them a good cleaning.

It's best when there's a strong current running and the mantas approach the reef like so many aircraft lining up to land at London's Heathrow. This time I go in equipped with my hands-free propulsion device, my *Pegasus Thruster*, strapped to my tank. This time it's Norwegian dive guide Hal from Euro Divers who's in for the 'cardio' dive, in attempting to be my official buddy and keep up with me, while I'm powering effortlessly in the powerful flow of water.

We reach the first known cleaning station and I'm disappointed to find around thirty divers gathered around, clinging on to the reef in the flow and watching the ballet of a single graceful manta. It's a circus. I don't feel I can get good pictures here and signal to Hal that we should move on to cleaning station number two and we are rewarded on the way with a close encounter with a couple of mantas that are happy to stay with us.

Once again, the *Thruster* proves its worth. The animals seem to tolerate it, maybe a bit more than they would me if I needed to move my legs and fin. They let me get big close-up pictures and come back for more. In fact I start to get buzzed by more mantas while Hal is left to watch from further down the reef.

They appear to think I'm just another big animal, merely present for the services of the busy little cleaner fish, just as they are. I don't like to persuade them otherwise. We cruise together along the reef and I am busy, clicking away, the flashes from my camera having no discernable effect on the symbiosis between us. We make our way to the third cleaning station. It's just the mantas and me.

They like to cruise above me, shivering and shuddering with pleasure from the Jacuzzi effect of my exhaled bubbles. I turn on my back as I motor, keeping a wary eye for any outcrops of coral that I might be guilty of colliding with. The mantas drop their feeding lobes. They look relaxed. I feel ecstatic.

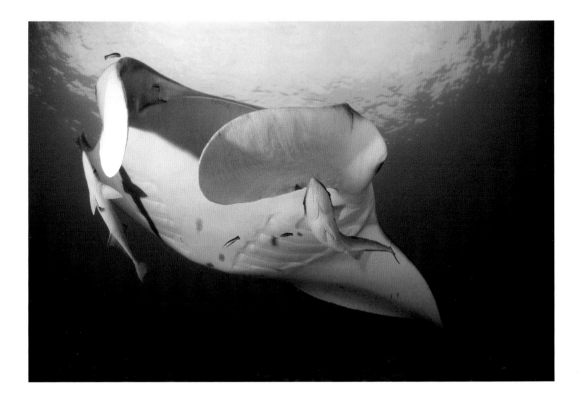

Some mantas slip away as others join the ballet. The cast seems inexhaustible, which is more than I can say for young Hal who has been trailing behind the moving show, finning his heart out into the current!

*

Of course, mantas can be found throughout the tropics, wherever there is a food source for them. When the north-east monsoon wind blows, a small indent in the reef at Hanifaru in Baa Atoll fills with trapped plankton and the mantas have come to learn of this. They aggregate in very large numbers towards the end of the year, feeding on this bonanza and, because the area is not much larger than a football pitch, a lot of mantas will squeeze in to get their share. It's now a UNESCO World Biosphere Reserve Core Protected Area and access by human visitors is strictly controlled but before that, the area became a magnet for divers too.

Can you imagine what it is like to be close to more than a hundred mantas, busy in the act of feeding? They swoop about in the plankton-rich water, mouths agape, demonstrating amazing spacial awarenes and never colliding with each other.

After graduating as a marine biologist at the University of Plymouth, UK, Guy Stevens moved to the Maldives to work as a marine biologist on board the *Four Seasons Explorer* – a luxury liveaboard dive boat. He fell in love with diving with mantas and now devotes his life to doing manta research at Hanifaru backed by the *Save Our Seas Foundation*.

He has expressed concern about the well-being of the mantas at Hanifaru. The Maldives are a perfect place for reef mantas to live. There is plenty of food all year round and few natural predators. Neither has there has ever been a significant commercial fishery for mantas in the Maldives. However, it is quite difficult to quantify the impact of the burgeoning tourism (with high numbers of people wishing to swim with them) on the animals themselves. They appear to be very tolerant of this human intrusion while they are feeding, the primary reason for them to aggregate in Hanifaru bay. As specific sites like Hanifaru become overwhelmed by tourists there will be an obvious need for effective management of such locations.

Of course, although Hanifaru might be unique thanks to the direction of the monsoon and the way plankton collects in the small bay, there are manta cleaning stations throughout the tropical world.

I've photographed mantas as far apart as Raja Ampat in West Papua, Tubbataha in the Philippines, Nusa Penida near Bali and off the coast of Tanzania close to Tofo. This was from the German Channel in Palau in 2012:

"The current was just a gentle push as we swam towards the small coral bommie known to be a regular cleaning station for mantas.

The channel was blown out of the coral by the Germans at the beginning of the 20th century, and provides the only access for ships entering the main lagoon. Now, the flow of water encouraged by its existence attracts masses of pelagic life, and the water above us was a bouillabaisse of fish.

Captain Kenneth from our liveaboard *Ocean Hunter* was with us. While we kept low to the sand, he flashed around using his long fins to cover great distances, and was soon excitedly pointing as a big black manta passed far above us.

We waited patiently. Soon the beast was swimming slowly a few metres above the seabed directly towards me. I held my breath and squeezed off a single shot at the last moment as it came up to me, then it was gone in the mist of plankton.

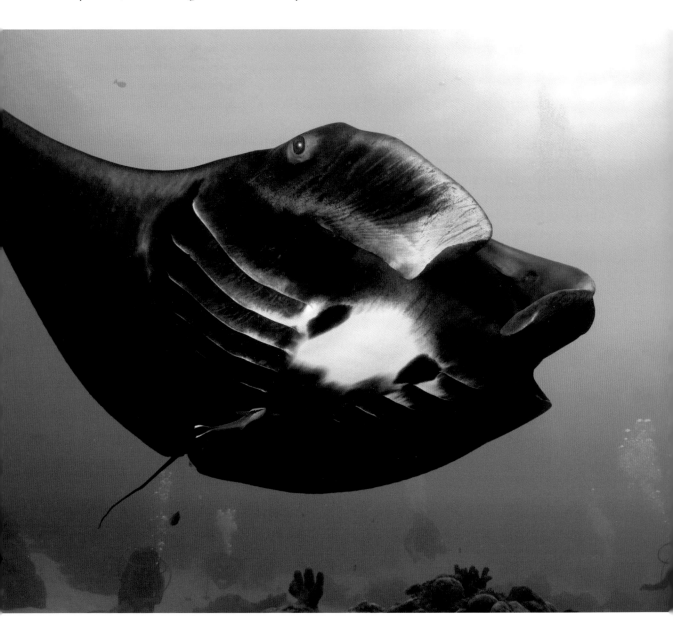

After 15 minutes or so, the other divers made their way up the channel to shallower waters. I stood my ground for a time but soon felt a bit lonely.

I let myself go with the gentle flow and soon could see the wraithlike figures of my companions, Kenneth hovering mid-water above them.

Visibility was not ideal, thanks to the nutrients in the water, but soon he was spreading his arms wide, indicating that this was a big one he could see.

I steered in the direction in which he was pointing to come face to face with an enormous white manta ray, as it materialised out of the gloom.

Again, I held my breath and hung motionless at the same depth in its path as the giant approached. At the last moment, I pressed the shutter release.

"Low Battery" came up on the viewfinder's display. The camera refused to function and the ray ploughed into me, nearly knocking it from my hand.

I turned the camera off and on again. It now worked perfectly, but too late. It must have been something to do with the extreme humidity as I sealed it into its housing.

Looking despondently towards my fellow divers, I made out the big black manta again, visiting a cleaning spot further across the channel unseen by the others.

I drifted over and ducked between two huge brain corals. The ray circled to make another pass.

By now the other divers had seen it, but they hadn't seen me. They started making their way towards where it was circling. As the manta passed over me, I popped up and got two extreme wide-angle close-ups. Black mantas are notoriously difficult to photograph, but this one had all its features helpfully delineated by white edges.

The other divers later expressed surprise at seeing me there, if not a little envy. How did I know to be waiting in that position?

That's the thing about mantas. You have to guess where they will be and let them come to you. The successful manta photographer must be a patient ambush predator."

*

I was still being thrilled by encounters with manta rays and wrote this during a trip to the southern atolls of the Maldives in 2013:

"It was little more than a bleak sandy channel, fringed on each side with high coral reef walls. Some way in from the ocean stood a lonely coral boulder, a solitary feature in what looked like a sandy runway. This was the place.

Reminiscent of an airfield, the underwater aircraft lined up in turn to come in from the ocean and approach this single servicing point, where tiny technicians set about cleaning the fuselage of each one.

As soon as one was satisfied, it would return back down the channel to the ocean, only to be replaced by the next waiting in line.

A handful of us divers clung to the coral rubble at the edge of the channel, watching the seemingly endless show like so many plane-spotters gathered at Heathrow.

I flattened myself and slid slowly across the sand towards the coral boulder, in the hope of getting a close-up of an underside as it passed over but was soon pulled back by airfield security in the form of one of our dive guides.

I chose instead to head out alone down the channel to get my close-ups as these magnificent creatures headed in.

There are many places in the Maldives where the rays come to get cleaned by small reef fish, and this was just one of them. The mantas allow access to their mouths and gills, and the little cleanerfish get a free meal in exchange for their efforts.

The channel seemed ideal for the mantas to manoeuvre. They didn't need to negotiate any coral obstructions until they got to the maintenance bay that was the boulder lying alone on the sand.

At the same time, the rather straight channel became a highway that allowed me to anticipate their route both in from and out to the ocean.

I found a handy outcrop on the coral wall that they would often pass over, and behind which I could conceal myself. Ambush-hunting is the best philosophy when attempting to photograph animals that can swim a lot faster than you can.

The visibility was less than clear. After all, mantas love plankton-loaded water, even if underwater photographers do not. It's what they feed on. To encounter a spa after a meal was a bonus as far as these gentle giant elasmobranchs were concerned.

I was able to photograph several rays without disturbing their relaxed approach, wings flapping in a leisurely manner, to their regular morning treat after a night of ocean roaming."

Chapter 28

Dugongs: Mermaids of Years Gone By

Swimming over acres of featureless sandy seabed at six metres deep for more than half an hour doesn't sound very appealing, does it? I was there in the hope of getting pictures of guitarfish, often referred to as guitar sharks, that were said to inhabit the area but I wasn't having much luck. Sometimes as an underwater photographer you have to persevere in such endeavors and sometimes perseverance goes unrewarded.

Marsa Shona is a large bay on the Red Sea coast of southern Egypt that some liveaboard dive boats nowadays come to, immediately before returning to Port Ghalib at the end of a charter. It has a small amount of very ordinary coral reef at its northern end, where it meets the sea, but otherwise there would appear to be little reason to dive there. It's shallow, and the visibility can be quite poor.

So there I was, thirty-five minutes into a dive in which I would barely have been able to keep any other members of my group in sight, thanks to the murky water, were it not for Nina's white fins, and I was getting bored. Nina was our intrepid guide. She'd promised me pictures of guitarfish or at least the occasional green turtle.

It was not as if there was enough sea grass to cause a passing green turtle to pause, although my boredom had been punctuated for a moment when I glimpsed such an animal making its way to the surface for a breath. Then it had disappeared, like the famous Roman Ninth Legion, into the mist.

Something caused me to stop finning, however. I had been pushing ahead in my impatience to find something worth looking at, and when I turned back I discovered a large dugong gliding gracefully up behind me through mid-water.

One lucky click with my camera as it passed a few inches from my head and I found myself swimming furiously to keep up with it. The dugong knew where the sea grass was, found it and soon settled down on the seabed to suck some up. I reflected that after many years of being unlucky and never finding the dugong, the animals had taken to finding me. It was not always the case.

A dugong is a marine mammal, a strange combination reminiscent of whale and elephant, with the grazing habits of a cow. When sailors from Europe first glimpsed them from a distance, carrying their offspring with the forward flipper in an arm-like posture, the encounter may well have given rise to the legend of the half-human, half-fish 'mermaid'.

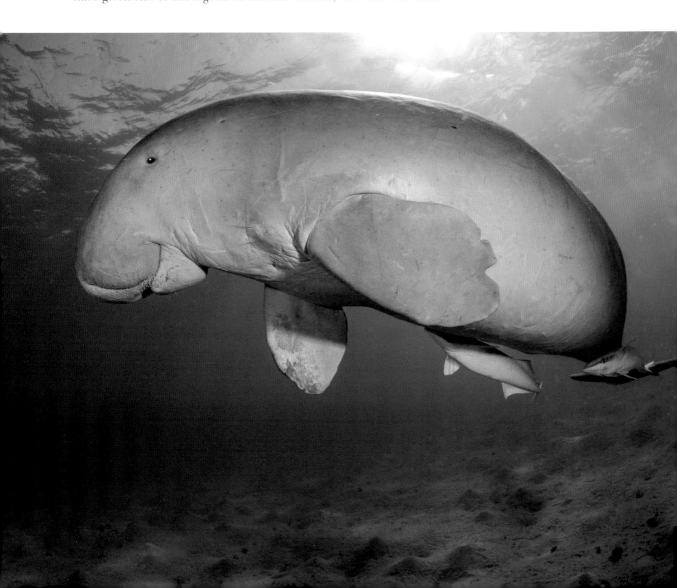

Many people confuse dugongs with the fresh water manatees of Florida. Although they are of the same order of Sirenia they look quite different, especially considering that incongruously large tail.

In fact the dugong looks quite absurd. Who in their right mind would have designed such a creature?

Dugongs are not sexy but they could be said to be beautiful in their own special way. I suppose if you've been at sea for months with nothing but the company of a lot of scurvy-ridden salt-caked men, misapprehensions could arise.

Of course, unbeknown to me, this dugong was acting rather like the Pied Piper. A lot of divers were chasing to keep up with it in the murk. It munched away while some fat and happy remoras cleaned up behind it. There were no cowpats in this field.

The other divers then arrived and cavorted around it with their cameras, me included. An inflatable even delivered a posse of snorkellers, who occasionally managed to swim down and momentarily touch the animal's back. It took no notice, ignoring the intrusion.

Feeding is a serious matter, and the patches of sea grass were so sparsely distributed here in this bay that the dugong obviously needed to consume a lot when it found it, to satisfy its hunger. From time to time it would lift off from the bottom and head up to the surface in a stately manner before returning to its meal, unperturbed by the gaggle of air-bubblers gathered to watch it.

*

That was at Marsa Shona. There was a time when Red Sea liveaboard dive boats would come into another little sheltered bay for the evening, prior to returning to Port Ghalib. It was Marsa Abu Dabab. They would spend the night there, often emptying their waste tanks into the sea, and divers would risk the opportunity in the water so polluted to make a last dive before the end of their trip.

There is an inauspicious little reef, but a lot of sea grass. It was only after divers, bored with looking at the coral, started to wander over the vast grassy areas that it was realised that a number of huge green turtles, complete with accompanying remoras, inhabited the place.

Not only that, but guitarfish habitually cruised the grassy underwater plain. Even a mimic octopus has been photographed there.

However, the star of the show was undoubtedly the resident solitary dugong. It grazed the area and occasionally another, its mate, had also been sighted.

Before long the bay, Marsa Abu Dabab, became one of the most noted sites for those diving in the southern area of Egypt's Red Sea. Every dive became a search for the elusive dugong.

Dugongs are said to inhabit sea grass beds in shallow tropical water throughout the Indo-Pacific region. The majority of the world's population of dugongs is to be found between the northern part of Western Australia and the corresponding part of Queensland. On the other hand, Red Sea dugongs are rare and solitary creatures. It must be presumed that many of the

shallow bays that dot the coastline this far south are grazing lands for these animals but dugongs are few and far between.

Dugongs use their whale-like flukes for propulsion, and their forward flippers for balance. Their movements are slow, and usually graceful. They stay underwater only for short periods because, unlike other marine mammals, they can't hold their breath for very long. This is probably another reason why they prefer shallow water.

They can live for around seventy years, but take some seventeen years to reach adult maturity. They are listed as vulnerable to extinction. For this reason the authorities eventually decided to ban boats from Marsa Abu Dabab and effectively, with it, scuba diving.

Alas, these political moves are often too little too late. By the time the ban came into force, a large holiday resort and hotel had been built on the shore at Marsa Abu Dabab and, of course, it has a dive centre and is popular with snorkellers. Bad luck for the dugong, one would think.

When I originally decided to make a special trip to Marsa Abu Dabab it was in order to make a concerted effort to find the dugong; I was prepared to spend all week if necessary searching for the elusive creature, but there was no need.

The shore was now a crowded holiday beach and it was suggested by my buddy Rami that we had only to sit on the shore in our dive kit and wait until we saw thirty or so Italian holiday-makers becoming hysterically frenetic, yelling and screaming and splashing above the dugong, to know where it was. He was right.

When we swam out, I could hardly believe what I saw. The animal was in only around three metres of water, and within easy reach of those prepared to hold their breath a little. Above it, dozens of flipper-clad feet bicycled frantically. Yet the animal seemed totally unperturbed, grazing on the grass in its bovine manner with its capacious, bristly snout.

Occasionally it would rise calmly through the melee to take a breath of air, before returning gracefully to the bottom to continue feeding.

It was me that was perturbed. Endless feet kicked my camera. My regulator was continually wrenched from my mouth by the wayward limbs of swimmers crashing into me. I got bruises in places I didn't know I had.

I was having a tough enough time and I wondered why we stayed in such shallow water, but the dugong didn't seem to give a damn.

It did have numerous old scars on its back, but before you assume that ladies' manicured nails or jewellery caused these injuries, be informed that male dugongs have tusks that they use during the mating season.

Not only that, but this particular animal appeared to be quite a clumsy swimmer when it came to manoeuvring. I'm told that when the wind gets up and waves form in the bay, it sometimes crashes against what coral there was at the reef.

Life seemed to be carrying on as normal for the dugong. If it didn't like the crowd, it would have gone somewhere else. But I was relieved when its path of uncropped grass

led it down deeper to nine metres where the raucous revellers above were less able to reach and interfere with me! I then got shots of the dugong in a more natural state.

It was only afterwards that I realised that the pictures of the animal accompanied by the madding crowd told more of a story.

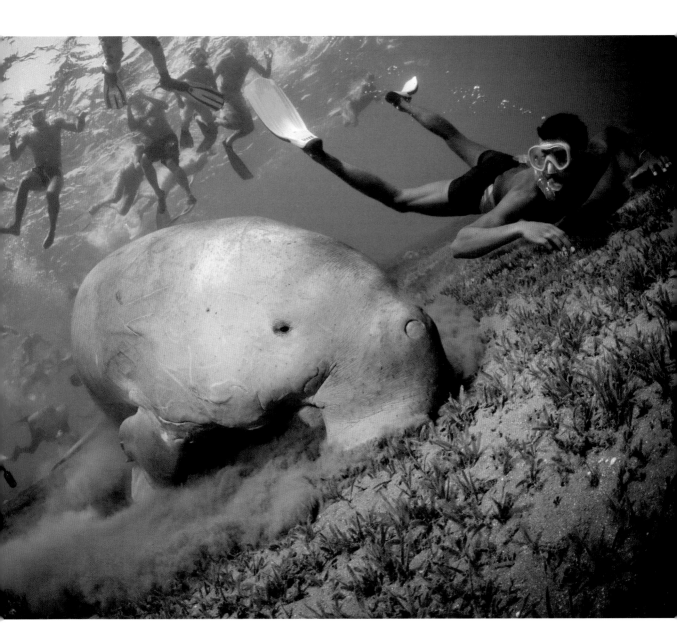

Chapter 29

British Sharks

We should not forget that sharks are also found in British waters. During the 1980s I did a lot of diving with a club based in London. As a busy professional, I needed to specifically allocate time to this activity and was often vociferous in my disappointment if, after all the effort, we didn't get into the water.

This happened more often than I would have liked due to the unreliable British summer weather and huge seas that rolled in from the Atlantic as the result of storms thousands of miles away. Then, if we did get conditions right for diving, our instrumentation for locating specific dive sites was little more than a rudimentary magnetic compass and a depth sounder. Instead we mainly relied on transits, lining up hard to see features on the sometimes featureless low-lying shore of Britain's south coast.

Too often I wrote in my diving logbook that I had been diving in the vicinity of some intended undersea feature rather than actually on it. Added to that, the strong tides experienced around Britain's south coast usually meant there was only a short window of opportunity to get into water that was not moving at a rate of knots.

My enthusiasm for club diving was certainly beginning to wane when Gerry, the club's diving officer, persuaded me to give up just one more weekend, to go with a group from the club to dive out of Weymouth. On occasion in the past I'd driven to Weymouth and waited at the roadside with other club members only to find that the member towing our club boat had met some unforeseen

difficulty and let us down. Luckily for me by then I knew enough divers from other clubs that I could hitch a ride with them instead. Otherwise, the sea turned out to be too rough and we ended up cliff walking or driving to some obscure pub that one of our number knew, that served an even more obscure brand of ale. It seemed that actual dives were few and far between.

This time Gerry insisted things would be different. We would be using a chartered fishing boat instead of the club's inflatable and this cathedral-hulled vessel cruised at no less than 18 knots, bringing all manner of distant wreck sites within range of a day's diving. Imbued with new enthusiasm, I drove to Weymouth on the appropriate Friday night.

There was no sign of any others among our number that evening in the prescribed bed-and-breakfast lodgings that we were all meant to be staying at, but undeterred and wearily wiping the sleep from my eyes at 05.30am, I was down at the dockside, loading my dive kit and relieved to see that I was not alone. A handful of other club members had reluctantly left their beds to do the same.

It needed to be an early start to take advantage of slack water over the wreck we intended to dive and we set off full of optimism, Mars bars and hot tea brewed in a rusty kettle by our skipper. Unusually, the sea swell was coming from the east and after an hour of smashing headlong into it, everyone was looking very jaded. The skipper suggested we go somewhere easier to get to.

A quick discussion among our group resulted in the consensus that we should go back towards the shore and dive the well-known wreck of a submarine. I personally wasn't enamoured of this idea because I find the wrecks of submarines a little featureless and a bit boring to swim round.

Once we got to this second-choice dive site, it was apparent to me that, unprotected from the east as it was, the sea there was still too rough to make a safe dive, but undeterred, Gerry and his buddy entered the water. When we dragged them out shortly after they looked shaken rather than stirred.

It was turning out to be yet another disastrous club outing with no actual diving to speak of. I was determined to get wet and suggested to the skipper that there must be somewhere protected from this easterly swell. At his suggestion we set off to the western side of Portland Bill to dive the St. Alban's ledges. Although everyone was still wearing their dive suits and looked ready to dive, all but one of them declared they no longer felt like it. I put this down to it being likely to be a scenic dive without any rusty metal to look at, so only two of us got into the water. My buddy was a gentleman by the name of Tony Gifford.

Neither of us was incredibly experienced as divers in those days but at least the sea here was calm and the seabed was not very far below the boat at about 12 metres deep. It should have been easy.

The undersea terrain was composed of big boulders covered in huge fronds of kelp and the two of us enjoyed swimming among it and being off the rocking and rolling boat. At this point we came across a huge shark.

It wasn't swimming. It was lying lethargically among the boulders doing a very good

impression of the nurse sharks that by now I had got used to seeing during holiday dives in the Caribbean.

We cautiously swam round it, taking in the sight of an animal much larger than we ever anticipated seeing in British home waters. The grey beast lay there torpidly. In fact, I wasn't even sure if it was alive. It had two dorsal fins like a nurse shark, the small eyes of a nurse shark and the long extended upper lobe to the tail the same as a nurse shark. In my ignorance of such matters, I was absolutely convinced it was a nurse shark. I never realised that home water sharks could grow to be so big.

It didn't move. I got closer and closer. Tony stayed a safe couple of metres away surrounded by the kelp gently waving on the swell. Eventually I was able to get so close that I was able to lie next to it. It was as long as I was, including my diving fins, so that made it more than two metres. Still, it was unmoved by my presence.

I started to get bored in that it did nothing but lay there. I thought it might have been injured or even dead. In case it wasn't I went round it in an extended circle so that I would not disturb it until I was directly behind it while Tony was in front. At this point I decided to test if it was alive and healthy. I prompted it to move.

Tony recounted seeing a gloved hand stretch through the kelp. He couldn't believe what I was going to do. I tweaked the shark by the tail end. It reacted instantly, shooting off blindly and crashing violently headfirst into one of the big kelp-covered boulders. Meanwhile Tony had shot upwards. I know not what happened to the shark next. I followed my buddy and found him at the surface with his mask ripped off in the fast flow of water caused as he panicked his way to the surface. A fast ascent like that is much more dangerous to health than any shark. We never saw the shark again despite searching for it.

I told everyone on board that we'd been with a nurse shark. They all looked very much the worse for wear and totally unimpressed. It was to be years later that I found out that most of these people were more interested in their extra-curricular activities at night than in the diving. The dive club was merely a cover. It wasn't a nurse shark either. Years later I was able to confirm that it was a smooth hound.

Textbooks describe the common smooth hound as a slender species. Of its two large and prominent dorsal fins, the first is larger. This first fin originates immediately over the base of the pectoral fins while the second smaller dorsal fin originates just forward of the anal fin. The dorsal caudal lobe is large with a strong terminal notch and lobe. That said, I never realised they could grow so big. Divers in Cornwall go out in fast boats to interact with blue sharks and basking sharks. Blue sharks (*Prionace glauca*) are slim, fast-swimming open ocean sharks that are often described as handsome. They can be found in both temperate and tropical waters and feed mainly on squid but they sometimes school, a fact that has led to them being named 'Wolves of the Sea' by fishermen. They sport long pectoral fins that reveal their ocean-roving habits. Sadly, most other boat operators that seek out these animals do so for the benefit of anglers.

The more ponderous basking sharks (*Cetorhinus maximus*) come into coastal waters during

warm weather when the plankton they feed on blooms. Basking sharks are the second largest species in the sea and feed in the same way as the larger whale shark species, swimming along near the surface with vast jaws agape. This has led to stories in the popular media of *Jaws* being sighted off popular south coast summer beaches. A typical headline in the *Daily Telegraph* read "Snorkeller Almost Swallowed By Shark!"

A small group of friends, including my wife, found ourselves scuba diving off the coast of Lewis in Scotland's Outer Hebrides. During a ride by inflatable to our intended dive site we came across the tell-tale dorsal fin of a whale shark breaking the surface. The coxswain steered a wide circle around where the shark was, dropping each of us off at regular intervals so that we surrounded the animal. It swam inside this circle of swimmers for a time giving each of us a precious close encounter. Long strands of algae hung from its long outstretched pectoral fins almost like abandoned fishing line and I was fascinated to notice the barnacles that clung to parts of its body. None of us were 'almost swallowed by the shark'.

Shane Wasik runs diving encounters with basking sharks out of Oban in Scotland. He explains that these giant sharks are harmless plankton eaters that usually arrive around the west coast of Scotland during the summer months. They might have gaping mouths when feeding but represent no danger to any swimmer, snorkeller or diver.

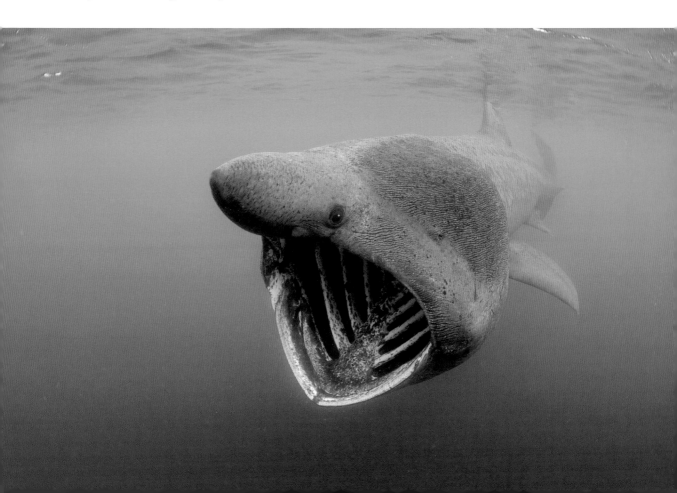

Chapter 30

What Eats Sharks?

"There's a very large grouper down there, John," Kenny MacDonald insisted.

"I know. There are some big grouper around," I replied, confident in my knowledge of all things 'marine-life'.

"No John. I mean there's a very, very, very large grouper down there," Kenny insisted. He eyes were standing out on stalks as he said it and he was rolling his Rs to give added emphasis like only a Scotsman can.

We were in the waters off the Yemeni coast, diving where no-one we knew had dived before. As dive guide, my choice of sites had been somewhat hit and miss. For example, when I spotted the site of a wreck indicated on the chart, I thought it would make a good dive site until it became apparent once we arrived that the wrecked ship was standing high and dry out of the water. We were at another spot I'd chosen simply by looking at the chart and second-guessing what it might be like underwater.

Mike, the captain, and Kenny had made an exploratory dive and I was about to take our passengers in, armed with the new found knowledge obtained from them. Kenny explained where this large grouper was to be found.

"There's a ridge of rock that extends away from the plateau formed at the end of the reef," he told me. "Follow that ridge to the end. There are a lot of whip corals and a big school of jacks.

The current is really strong. That's where you'll find the very, very large grouper."

I led our passengers down to the plateau and out along the ridge of rock. The current was so fierce that there was a risk that divers might get swept away so I was particular to ensure they clung to the ridge as they inched their way along it. To turn your head to one side risked dislodging your mask or sending your regulator into an uncontrolled free-flow. I was kept busy checking the divers following me were safely holding on.

We reached the end of the ridge where I found the whip corals bending in the flow of water. There were the jacks, huddled together in a tight school just off the reef in blue water. But there was no sign of any grouper, very big, very very big or even small.

I stared out into the blue in case it was far off but was startled by the realisation that what I had thought was a second ridge of rock in front of me and below me was actually the long serrated dorsal fin of a fish so huge, I hadn't taken it in. I hadn't recognised it for what it was.

I reached forward and touched it to be sure it was what I thought it was. This interference with its privacy was enough to make the animal move reluctantly out into open water. It was a very, very big fish.

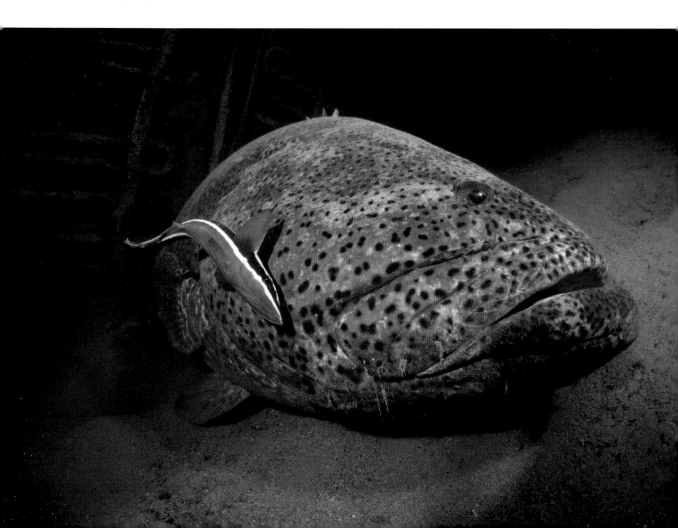

With the exact same proportions of any other grouper, this one was as big as a Transit van, around five metres long, with eyes the size of dinner plates. Groupers feed simply by gulping the water and swallowing the hapless victim that gets sucked in with the inrush. This grouper could have swallowed me if it chose to. If I'd photographed it, with nothing to give it scale, it would have looked like any other grouper. We named the dive site 'Grouper Rock'.

*

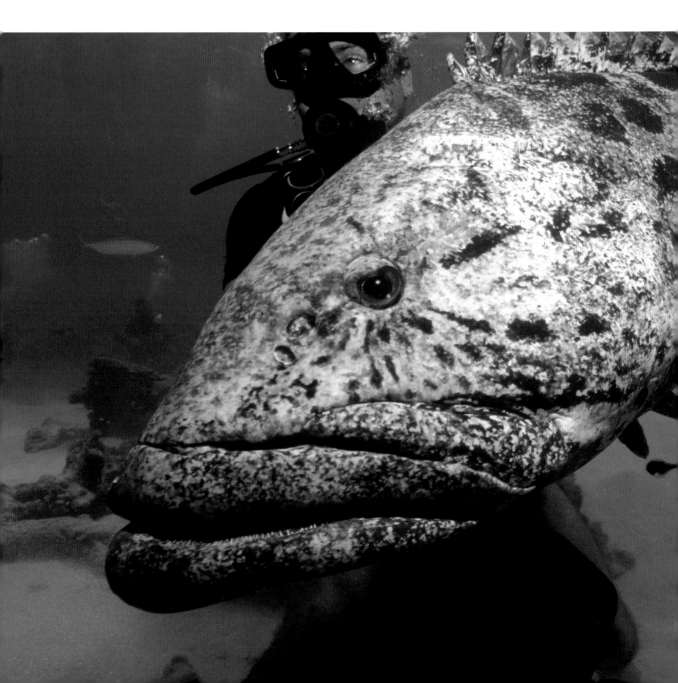

I saw what might have been an equally large grouper living in the wreck of a sailing dhow, down further south in the Gulf of Tadjoura, but we only glimpsed it as it vacated its hiding place and vanished out into open water. These wreckfish are incredibly shy and don't normally hang about to be photographed. However there are exceptions to this.

I was diving the wreck of the burnt-out refrigerator ship, the *Chikuzen*, in the British Virgin Islands. Inside, I came across a couple of large wreckfish and one stood its ground and let me photograph it where it sat comfortably on the layer of silt in one of the holds. It was decorated with a large remora.

More famously, at Ribbon Reef No.10 in Queensland's Great Barrier Reef, huge grouper have learned to take food from divers. These groupers are often known as 'potato cod' because when pioneering divers Ron and Valerie Taylor first took film-maker and anglophile Stan Waterman there to dive with these large fish, he was so thrilled at the experience that when he surfaced he is reputed to have said, "We've got the fish. All we need now are the potatoes." He was of course refering to the traditional English / Australian meal of cod-and-chips. The name stuck and they have been known as potato cod forever since.

A grouper feed at Ribbon Reef No.10 is carried out in much the same way as a shark feed elsewhere except that the feeder only bothers to wear a chainmail glove to protect him against the sharp teeth of the fish as it sucks in the bait handed to it. These spotty groupers are very large indeed and can be as daunting as sharks at a feed, or even more so. Whereas sharks need to swim round in an orderly fashion, passing oxygenated water through their gills, grouper can hover stationary until the opportune moment when they can dash in to grab the bait. In that way they are difficult to anticipate. I can imagine that more people have sustained accidental bites from grouper than from any sharks.

Afterwards when the dive manager of the liveaboard boat I was on asked me what I thought of the dive, I was full of enthusiasm but added the rider that we were diving in the shadow of a boat as big as an office block and in the lee of the current. That had to affect the likelihood of seeing anything that was not accustomed to being there.

I pointed to where the current struck at the opposite end of the reef and suggested that would be a more exciting place to dive. He reasoned that it would not be safe to take a group of passengers there but agreed to drop me on the spot from the vessel's inflatable, provided I promised to stick close to the reef and not allow myself to be washed out into the Coral Sea. I duly agreed.

My reward was to enjoy probably the best dive I have ever done in Australian waters. Instead of spotty potato cod, huge Queensland groupers coloured battleship grey came out to inspect me, a strange air-bubbling creature that had entered their territory. These fish were almost twice the size of the enormous groupers at the Cod Hole. I confess it was somewhat daunting to be alone in the water with grouper a lot bigger than I was.

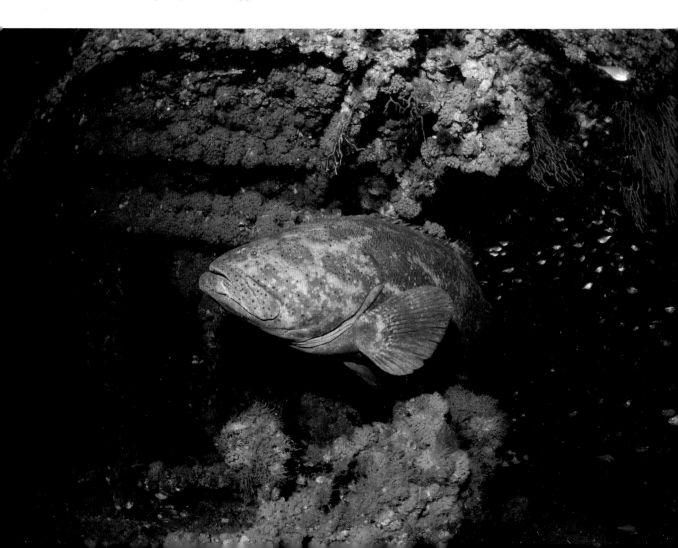

I then came across a full-grown tawny nurse shark that had recently sustained a massive injury to its head. It lay on the seabed with small fishes feeding on the blood that still oozed from its head. I could not imagine what had caused such damage to a shark, but it had definitely been attacked and probably fatally. I returned from the dive none the wiser.

*

You don't have to travel to really exotic and distant destinations to see huge grouper. Off the east coast of Florida, numerous wrecks have been dumped to provide an artificial barrier reef to help reduce coastal erosion. There's everything there from oil rigs to freighters, from private yachts to private cars. Naturally these wrecks provide home to wreckfish and the Goliath grouper has made a comeback in numbers over recent years.

Enjoying a degree of protection from fishing, these grouper are able to live long enough to attain huge dimensions. Despite the fact that they can grow to almost five metres in length and weigh up to 360kg, they tend to hide out of sight within the wrecks, sometimes in remarkably small places, except during the spawning season when they can be seen aggregating in large numbers.

The range of the Goliath grouper includes the Florida Keys, the Bahamas, most of the Caribbean Sea, and nearly all of the tropical and sub-tropical coast of Brazil. They have even been caught in New England waters. They also range into the Eastern Atlantic where they can be found in waters from Senegal to the Congo. The world record catch at the time of writing was 309kg for a specimen caught off Fernandina Beach, Florida in 1961. They enjoy a catholic diet of crustaceans and other fish, octopus, barracuda and young turtles. They are known to ambush spearfishermen and take their catch.

It is a unique experience to dive in the wild underwater world but surface in sight of the Florida coastline's urban sprawl. Imagine the surprise of some boat-based anglers in Florida in 2014 who had caught a two-metre-long reef shark and played it to the surface. They were about to haul it aboard when a huge fish barrelled up from below and swallowed their catch with one gulp. All they were left with is a brief moment of footage to run on YouTube. That's the Goliath grouper. Big grouper also eat sharks!

Chapter 31

Shark-feeding: Right or Wrong?

When famous natural world photographer Michael Aw was bitten on the wrist during a shark feed dive in 2013, I was amazed at the outpouring of anger and vitriol towards him on the internet – mainly by people who had never experienced such a dive but had strong opinions as to why it was wrong to feed sharks for the purpose of photography.

It was ironic that he had actually been bitten by a small grouper rather than by a shark. Shark feeds always attract other fishes that hover around in the hope of getting some scraps left by the sharks and nearly all carniverous fish have teeth. Any are capable of giving you a nasty bite if you are so unlucky.

Recently, on a liveaboard in the Maldives, I happened to show some close-up shark pictures that were on my computer from a previous trip. "We don't believe in shark-feeding," the dive guides commented rather snootily. We then spent 30 dives seeing plenty of sharks but only at the periphery of our vision and certainly none close enough to photograph.

Our last dive was a night dive. The dive guides dropped in a punctured can of fish cleanings, and two-dozen nurse sharks and numerous assorted big rays competed for what smelled like a free meal. It was frenetic and the best dive of the trip, but what was it if it was not shark-feeding?

Is it a sensible idea to stage these shark feeds for the benefit of attending divers? It seems that many modern-day divers have very mixed feelings about methods to get close-up and personal with sharks. They want to say they have dived with sharks but many don't want them close enough

to see properly or for them to feel it's they that have been seen by the sharks. Dive guides in the Red Sea will protest that they get plenty of close-up interaction with sharks without baiting, but these are oceanic whitetip sharks that are ocean wanderers and opportunistic feeders. They will make a close pass at anything including a diver to see if it's a potential meal. Interactions are exciting but brief in the extreme.

On the other hand, the big populations of grey reef sharks and other reef species have generally long since gone from Egyptian waters. Most sharks are cautious. That's how they get to grow old in a shark-eat-shark world, and size matters. Divers are usually bigger in comparison to most sharks, and sharks usually prefer to stay away from them rather than risk injury from what might be another large predator.

Offering some bait is generally the order of the day. Of course, there are many different ways to do it. Bearing in mind that sharks tend to be big animals with mouths full of sharp teeth, my opinion of the different methods I have seen around the world is quite variable, from the orderly method of using one piece of bait at a time at the end of a short spear, as developed by Stuart Cove, to the rather risky methods I witnessed in French Polynesia. There, the dive guide carried a severed mahi-mahi head under his BC and would cut bits off with a knife, offering it in his bare hand to passing hungry sharks. I questioned if this was not just a bit too risky. I think he finally agreed after he had his hand sewn back together later.

Probably more sharks get fed by divers in Bahamian waters than anywhere else. I recently spoke about the latest generation of shark feeders with Graham Cove, Stuart Cove's cousin, who used to feed sharks for the benefit of my camera when he was a younger man. Then, he went in protected only by chainmail gloves and arms, offering the bait at the end of a short spear. Today, the feeders at Stuart Cove's Dive Bahamas do the same, but wear full chainmail suits and helmets.

I asked him what he thought about those people who were so against shark-feeding. He said, "I'm sick of people living in cubicles looking at YouTube and chiming in with rubbish on things they know nothing about. It's crazy how people generate opinions not based on observation and sensible thought, but more on a 30-second spot on the internet."

I asked him if he thought that every operation was doing it in a safe way, and he replied, "I have found myself questioning it from time to time. Stuart has it down to a science, yet I find many other dive operators don't take the same care or precautions to keep it safe in the long term. There are examples of lack of organisation and dedication to safety and longevity of a dive area."

What about the people doing it, the feeders themselves? Are they doing it for the thrill or the glamour? Most of them sustain a bite at some time and I've noticed they soon lose their enthusiasm for it afterwards. Graham said, "Now that the shark feeders have full suits and helmets, everyone wants to do it. Even so, when I was back at Stuart's recently, it was clear that some people did not have a gift for it, though."

We hear all sorts of arguments about how sharks lose their ability to hunt naturally if they are fed. I would suggest that the amount of food offered at a typical shark feed is tiny in proportion to the number of sharks present, so it represents nothing more than a free snack. According to

shark behaviourist Erich Ritter, a bull shark needs to eat four per cent of its own body weight in fish each day. That means some of these animals are eating up to 30 pounds. So with 30 sharks at a feed, the feeder would need to take in 750 pounds of fish cuts to substitute for their normal feeding behaviour, whereas around 20 pounds is a generous estimation of what they actually use at Stuart Cove's Dive Bahamas feeds. Sharks have a hierarchy and defer to larger sharks. None want to get injured by another shark, so when dead bait is offered, there is little sense of competition among the animals.

When I, in years gone by, compared the different shark-feeding operations in the Bahamas, in some cases, safety was less than assured. Spearing live fish on site sent the sharks into a frenzy, whereas dead bait left them circling round in a relaxed manner. I've noted that many of the suspect operations have changed their methods now or are no longer in business.

Sharks are not the undiscerning predators depicted by the media. Stuart Cove will tell you that he uses different types of bait for attracting different species of shark. For instance, Caribbean reef sharks love grouper heads, while great hammerheads look for stingrays in the sand. In the absence of any stingray cleanings being available, the shark diver will use barracuda parts. For an expedition to photograph oceanic whitetips, I saw Stuart buy 500 pounds of bonito, and so on.

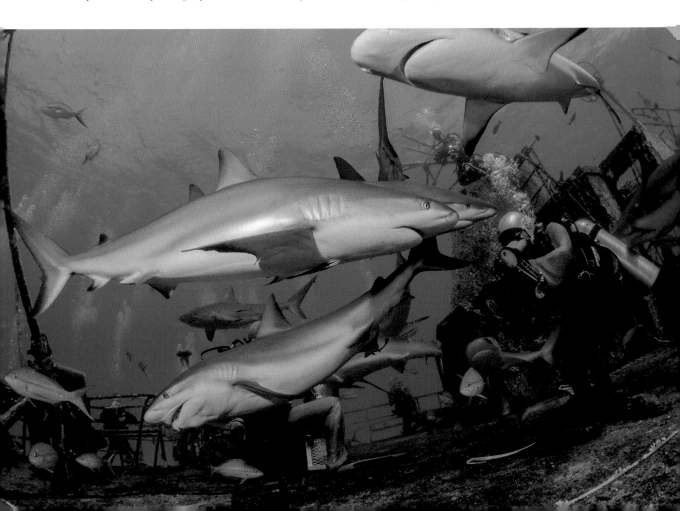

We also hear that shark-feeding encourages sharks to associate humans with food, yet there are no facts to back this up. There are still far more shark attacks off the coast of Florida, where shark-feeding has been banned for years, than almost anywhere else in the world. David Diley, a British diver who gave up his career to specialise in shark-awareness films, told me, "Between 2001 and 2012, Florida recorded the most attacks with 257, with Hawaii and Brazil not far behind with fifty-seven and twenty-four respectively. Feeding is banned in each location, or at least there are no recognized feeds. In the same period, Fiji recorded only eleven attacks, and the Bahamas, where feeding is a major industry, had just nine."

Even so, it is an emotive subject. A recent exchange between underwater photographers on Facebook revealed a lot of passionate opinion after Michael Aw received a minor injury from a grouper during a shark-feeding dive. However, it soon became apparent that some of those vehemently against it had never witnessed such a dive.

David Diley said, "The feeding discussion has been done to death, but rarely in a public medium by people qualified to discuss it with any real credibility. By that I mean behaviourists, researchers studying the effects on location-specific individual sharks, dive operators and science-based local conservation groups in areas where feeding provides economic and / or ecological benefit. Feeding sharks has been happening since the first time man went to sea, and when done with correct protocols, it's perfectly acceptable and causes no harm whatsoever.

That said, not all shark feeds are run responsibly, and not all shark feeds use proper protocols designed to ensure their well-being. Also, shark feed protocols are species-specific and location-specific; some dives are riskier than others. The arguments for and against feeding seemingly centre on people speaking on behalf of sharks. Unfortunately, most of those people don't understand how sharks work, their behaviour or the influence of the locations, and so the arguments rely on hearsay, rumour, misunderstanding and misinformation on both sides."

Underwater photographer Pete Atkinson, now Thailand-based, offered, "Sharks desperately need economic value with their fins still on, and shark feeds are one way to do this. Because it gives the sharks value, that value can be turned into dollars, for example, for Fijian villages. Without shark-feeding dives, they have far more value as fins. As a secondary benefit, feeds create thousands of ambassadors for sharks. And these ambassadors have helped push through protection for endangered species that might otherwise have failed."

Mike Neumann, the Swiss owner of *Beqa Adventure Divers* in Fiji, confirms he is against the "Shark huggers, those people who say that sharks are harmless and need our affection." I think we can all agree with him that sharks generally have a mouth full of sharp teeth, and if you want to get close to them, you should be aware of that.

Liz Parkinson, a senior shark feeder with Stuart Cove's operation who likes to free-dive with sharks, makes the distinction that different species have different feeding patterns. She had this to say:

"In the Bahamas we are fortunate to dive with several different shark species. It was only when I began working with them did I learn how much their behavioural patterns differ. Taking

photographs and videos of sharks gives a photographer the fantastic opportunity to get a closer look at these amazing animals. Depending on the species different feeding methods are used to draw the sharks in. We use the sharks' natural food source in all cases, be it live or dead bait, to attract the sharks to us. You have to feed sharks to get the close action shots photographers desire for education and publishing purposes. There is definitely a difference between a shark that is being drawn in by bait and a shark swimming up to a person on its own accord. Either way it is an experience you will never forget!"

A final word from Charlotte Faulkner, another young English shark feeder presently working for Stuart Cove. "Seeing shark dives daily, and a variety of species first-hand, I know the massive difference they make to educate people about shark behaviour and conservation issues. They are not completely safe, but I am proud to say no spectator has ever been injured here. All participants sign a statement of risk. Feeders get bitten and expect to be so, but they are the people who are most passionate about sharks and won't even register the injury as a shark bite. The importance of re-educating the brainwashed public about the nature of sharks is of such importance for the future. There have been many studies that show that feeding does not significantly affect the spatial pattern or sexual segregation of some shark species. The more we can narrow the gap between human and sharks, the more chance we have to stop sharks being wiped out in our lifetime."

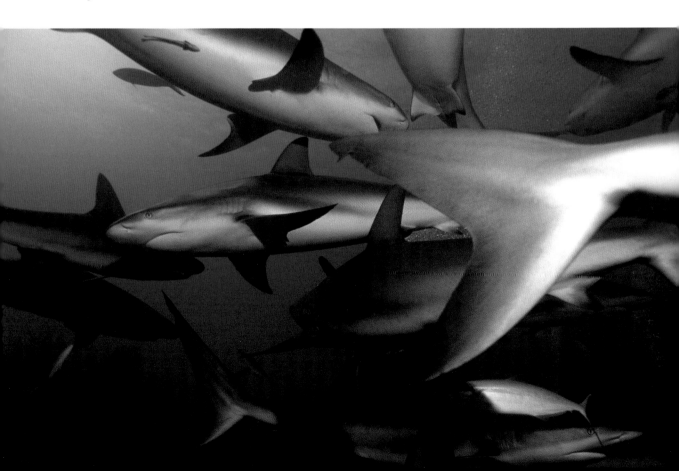

Chapter 32

Is the Only Good Shark a Dead Shark?

Scuba diving as a popular pastime only really took off in the last quarter of the 20th Century. In the first quarter of this century, the biggest revolution in scuba must surely be the popularity in recording underwater images, a revolution brought about by digital technology. Never has it been easier to get good underwater pictures. Added to that is the advent of miniature action cameras that can now record any activity, whether it be dropping from height from an aeroplane or swimming deep in the ocean. The swathe of images now brought back provide a weight of evidence of animal behaviour underwater that was never known about before. Of course, of all the animals encountered underwater, sharks must be the most sought after simply if only to impress the non-diving neighbours once divers return home.

*

I am not an expert. I have offered myself only as a witness and although my testimony goes back many years, the mass testimony of others will eventually drown it out as more and more people experience the underwater world. Sadly, this is balanced only by the fact that sharks are becoming rarer and rarer in many parts of the world, an explanation of which I will come to.

Peter Benchley has a lot to answer for. His best-selling novel *Jaws*, made into a movie and popularised by Steven Spielberg, brought the shark to prominence as an indiscriminate and

voracious killer that preyed on people. I was lucky enough to spend time with Peter Benchley before he died and, although he did in no way atone for writing the book that made him rich, he admitted that he could not have written it and got it accepted so readily in the forty years that followed. We've started to learn more about sharks – if a little belatedly. Even Peter Benchley put his energies into attempting to change this perception late in his life, with his support of charities such as *WildAid*.

That said, the public perception of sharks continues as more movies are made reinforcing the idea of the shark as a mindless predator. We've had a diet of such films offered to us, such as *Deep Blue Sea*, where a rogue mako shark is actually portrayed jumping out of a pool to grab and kill the character played by Samuel L Jackson. Another movie in this diet of death-by-denizen-of-the-deep, *Open Water*, was a fictional account of what might have happened to the Lonergans, the couple truly left behind by their boat to die while diving outside Australia's Great Barrier Reef. Naturally, they were preyed on by sharks in the movie version of the story even if they were clearly Caribbean Reef sharks a long way from home!

There are more than four hundred different species of shark, many with very different feeding habits. Only one is known to regularly feed on mammals.

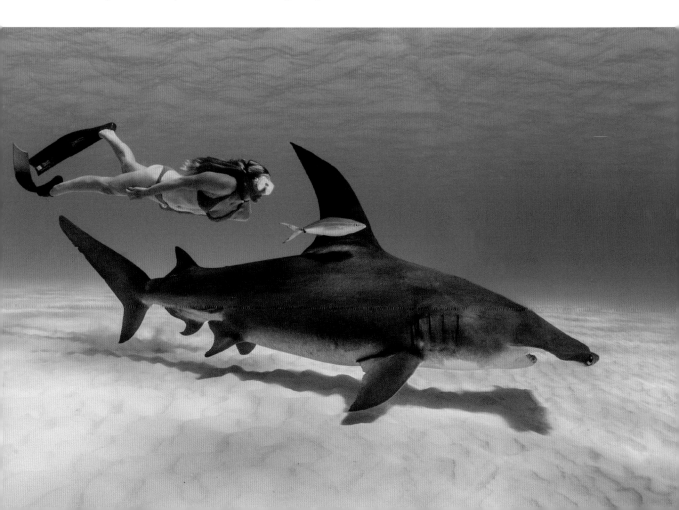

The great white shark or white pointer feeds mainly on sea lion populations and people swimming at the surface can be misidentified and sustain an investigatory bite that is often fatal. Surfers are particularly vulnerable since they do such a good impression of a sea lion when viewed from below. The number of 'attacks' on surfers in the waters of New South Wales has given the Australian public a degree of paranoia about shark attacks that is matched nowhere else in the world.

The novel *Jaws* was loosely based around events that happened when it was apparent that a lone shark was terrorizing the beaches along the coast and up the rivers of New Jersey and Long Island in 1916. You can read a full account in Michael Capuzzo's book *Close To Shore* (written long after *Jaws* but based around the same news reports that fed Peter Benchley's imagination). The people reportedly dragged from the water after being bitten invariably died from loss of blood but before doing so insisted that a shark had attacked them. It's incredible to think that at that time sharks had no reputation for attacking people and, way back then, the stories of the casualties were met with disbelief, even if they were their dying words.

Although a great white shark was eventually formerly identified as the culprit, it is likely that more than one shark species was involved since one such attack happened far up river in sweet or brackish water and only bull sharks are known to be able to enjoy both saltwater and fresh water environments.

Peter Benchley explained to me that the shark makes the perfect villain for a horror movie. "Few members of the public know anything about them and you can be scared to death in the cinema but sleep soundly in your bed at home, safe in the knowledge that no shark can climb the stairs to get you!" He also reflected that the most popular newspaper headline in Australian newspapers had been along the lines of '*Mother-of-Four Eaten by Shark*'.

Marty Snyderman, a highly respected veteran underwater wildlife cameraman, reminisced that Peter Benchley had despaired when people used the movie as an excuse to slaughter sharks either for sport or for no better reason than they were 'making the world a safer place'. He is reputed to have said something along the lines of, "One thing I have learned is that if ignorant people choose to stay ignorant, there's not much anyone can do to change them."

Now you may think that I am proposing that sharks are friendly animals that deserve love and affection. Nothing is further from the truth. They are generally speaking large animals with flexible bodies thanks to a framework of cartilage rather than bones and they mostly have a distending jaw that affects a huge bite together with a mouthful of razor sharp teeth. They are eating machines. Consequently they constantly need to be treated with the utmost respect and although over the years I've enjoyed very many close encounters underwater, I've always been sure to keep my hands away from the sharp end.

*

The marine environment is mainly inhabited by members of the animal kingdom. There are

few plants. Even the brightly coloured coral gardens are made up of colonies of animals and all these animals feed on each other. Coral polyps feed on passing plankton but further up the food chain there have been some surprises revealed only recently by evidence collected by those aforementioned digital cameras. We've recently seen digital footage of groupers taking bites out of big barracuda, of giant wrasse killing territorial triggerfish that attacked them, even moray eels grabbing young sharks. It's carnage down there. So why isn't the sea littered with fish dying from their injuries so sustained?

We are now aware that ours is a Blue Planet and that most of its life forms live in the sea, but few people realise the essential role played by sharks in the health of the oceans. You will never see dead or dying fish, or fish suffering an epidemic of disease, where a healthy shark population is present. The shark's function is to weed out weaklings, the injured, the ill and the infirm and it is so designed to do this job. Its mouth carries such powerful bacteria that it can overwhelm almost any bacterium existing in anything it eats. A shark never gets sick, nor does its environment, so the presence of sharks can be an indicator of a healthy underwater world.

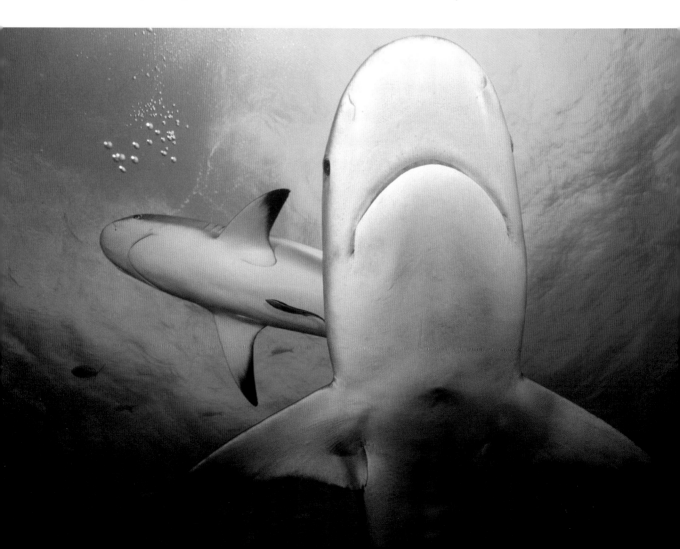

But this world is in peril. It is regularly estimated that more than 100 million sharks are slaughtered every year for their fins alone. Dried shark fin fetches more than US $500 per kilo in the fish markets of Southern Asia – so much that the trade has attracted the attention of Chinese Triad gangs. The existence of any species of shark is under threat and with it the whole underwater world.

Even in some of the most profitable dollar-earning dive locations, the sharks, the very animals that attract the diving tourists, are disappearing. In the Galapagos no less, the direct-action conservation organisation Sea Shepherd reports that Ecuadorian fishermen have rioted in protest and have tried to destroy the Darwin Research Station because they want to harvest shark fins, along with sea cucumbers, from the precious marine reserve, to meet the burgeoning demand in China.

Cocos Island, part of Costa Rica, also a marine reserve famous for its populations of scalloped hammerhead and whitetip reef sharks, is policed with only scant resources, much of which were donated freely by local diving operators, and the sharks must run the gauntlet of the long-line fishing fleets that operate around its fringes.

Extremely remote Bikini Atoll was famous for its huge grey reef population until publicity in diving media drew it to the attention of the Taiwanese fishing fleet that moved in from elsewhere in the Marshall Islands and now only the few surviving sharks patrol the reefs and channels.

Even the mighty yet harmless plankton-eating whale shark, the biggest fish in the sea, has been subjected to slaughter by a fishery in southern India as animals pass in an anti-clockwise migratory pattern around the Indian Ocean.

*

News magazine *The Week* reported that the Chinese economy is expanding so fast that it is responsible for a third of global economic growth. It is also fuelling an unprecedented boom in consumption of consumer goods within China. It has become the second largest importer of oil after the USA and, of course, it earns foreign currency from a boom in cheap exports.

If an increasingly prosperous country of 1.3 billion people wants to eat shark fin soup, it's not difficult to see how beleaguered the governments of small island nations with an eye to conservation can become. They are simply outbid on price in the demand for sharks.

I was present some years ago when a patrol boat from the tiny Pacific nation of Palau captured a Taiwanese fishing boat, the *Sheng Chi Hui No.7*, illegally long-lining for sharks in territorial waters near the island of Angaur. Palau is famous in the diving world for shark action at sites such as Blue Corner.

The Minister of Justice for Palau at the time, Michael Rosenthal, told me that, although all the members of the government were agreed about the seizure of the boat and confiscation of its cargo, many wanted to sell the cargo and add the money raised to state coffers.

The Palauan President, Johnnie Remengesau, a staunch environmentalist, insisted on

burning the fins publicly. "Our message is very clear today," he told me. "We will not tolerate shark-fishing in the waters of Palau." It was an impressive, if expensive, gesture. The maximum fine imposed was a puny US $13,000, while the harvest of fins would have been worth a staggering US $290,000 in the markets of Hong Kong.

In French Polynesia, another area in which shark-feeding by divers is almost routine, and further from Asia than the islands of Micronesia and Melanesia, the sharks have so far escaped the attentions of long-line fleets, but for how long?

Pascal Jagut, owner of a dive centre in Rangiroa, told me that divers visited the Tuamotu Islands only for the sharks, and without sharks there would be no diving industry.

In the Egyptian Red Sea, Amr Ali, the current chairman of the Hurghada Environmental Protection and Conservation Agency, seemed unaware of the market value of shark fin when I spoke to him a decade ago, but he said that a new threat to the unique Red Sea environment was that from the Nile fishing fleet threatening to move its zone of operations.

He told me that the fleet employed methods that included illegal nets and techniques. Neither was the necessary legislation in place to help. For example, he told me, a HEPCA patrol had arrested a fishing boat with the corpses of sixteen hammerhead sharks on board but was unable to prove that they had been taken from one of the existing marine parks. "We are making only painful progress," he said.

*

Although our knowledge is increasing, we still know so little about sharks. There is a shark-tracking project based in the Sea of Cortez, Mexico, using rebreather divers to fit electronic satellite tags to scalloped hammerhead sharks. This, it is hoped, will succeed in revealing migratory patterns, aggregating sites and pupping grounds.

This information is intended for the recommended placement of sanctuaries that can be protected from fishing. However, the tags can cost upwards of US $4,000 each, and what long-line fishermen will do with the tagged animals they might catch, or the tag itself, remains to be seen.

Sharks take years to mature and, having few young, are particularly vulnerable to over-fishing. Shark fin provides gelatinous bulk in soup but is tasteless so the soup has to be flavoured with chicken stock. Yet a Hong Kong diner will pay US $200 for a bowl of the stuff in a restaurant. Economic pressure to render this apex predator extinct is intense.

So what will happen to a world without sharks? Midway through the second decade of the 21st Century there were reports of mass fish die-offs throughout the world. Blame has been variously attributed to the Fukushima nuclear power plant disaster, run-off from pesticides used in industrial agriculture and fine particles of plastic waste that now fill our oceans. Epidemics of disease appear to have been overlooked as a possible cause and shark populations are there to control such epidemics. The fact of the matter is a dead shark is not a good shark. It is no longer effective in its important role.

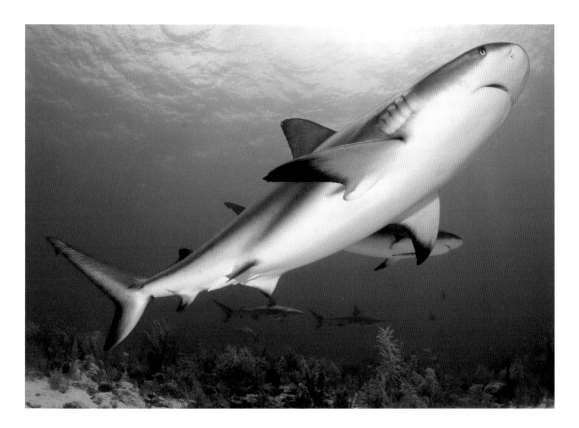

Sharks have recently been harvested from the ocean on an industrial scale and all the evidence, from the anecdotal ponderings of distraught dive operators through to proper scientific studies, shows that the populations of most species are in free-fall.

Diver Magazine in the UK reported "Several years ago, Julia Baum of Halifax University in Nova Scotia was tasked to examine fisheries records for various large shark species in the North Atlantic. Her subsequent report, published in *Science* in 2002, revealed precipitous declines in most large species.

Her study area was vast, from Newfoundland to northern Brazil, and included both inshore and deep waters. Most affected were the large species, with an average drop of sixty-one per cent in overall population numbers.

The report turns into an environmental horror story when broken down into individual species. Blue sharks, one of the species most resistant to overfishing because of their wide range and relatively high reproduction rate, had dropped in numbers by more than half. It was a similar story with tiger sharks, great whites, threshers, hammerheads and silky sharks.

The greatest catastrophe lay with one of the most impressive species. The oceanic whitetip shark, once thought to be one of the most abundant large animals on Planet Earth, had experienced a ninety-nine per cent drop in numbers in the past fifty years.

"The situation is akin to the herds of buffalo disappearing from the Great Plains, except this time no-one noticed," one of the scientists responsible for collecting the data in the study, was reported in the same article as saying.

Diver Magazine continued, "The situation in the Pacific is less clear, though anecdotal evidence is very strong for a similarly precipitous decline in shark numbers. Specific studies are hard to find but evidence from fishing fleets speaks volumes for the increased pressure on shark populations.

"Like the axe and the plough, the hook and the net can create major changes in ecological structure and function. We've been fishing the top off the food web," says Dr James F Kitchell of the University of Wisconsin, a specialist in the role of predators in ecosystems.

Data collectors note, "Pervasive overfishing of these species may initiate major ecological changes."

Other noted marine scientists have expressed the opinion that the world is not a giant experimental laboratory. We could be playing with the future of our marine food resources. Sharks are adapted to be predators rather than prey. If we take their species to the brink of extinction it might well be impossible to bring them back quickly.

*

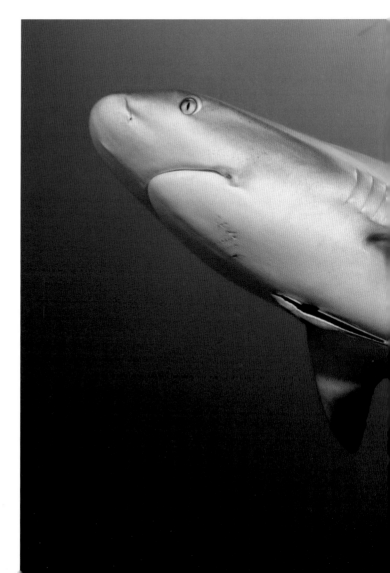

South African marine and shark conservationist Lesley Rochat proudly assumes the title 'The Shark Warrior', reflecting her energetic efforts in shark conservation, including free-diving with sharks, photographing and featuring in video productions. She said, "Like most people, I was once afraid of sharks, afraid of what I didn't understand. Now I travel the world to see them but there are relatively few places left where you can still see healthy populations of sharks. The demand for shark fin has caused many

shark species to decline by over eighty percent and has resulted in the collapse of entire eco-systems. Our oceans are our life support system, and sharks play a vital role in maintaining the delicate balance of marine ecosystems. In simple terms, if our sharks die, our oceans die, and if our oceans die, we die. Everything is connected. We have only a few years left to save our oceans, our critical life-support system, to stop the destruction and to enter a time of great recovery."

What of tag-and-release sports fishing for sharks? Since they have no bony structure, simply picking a shark out of the water probably causes it fatal damage as its internal organs get crushed.

Every year, Discovery Channel broadcasts its "*Shark Week*" when sharks are portrayed at their dramatic best or worst, depending on your point of view. The paying public seems to relish the idea of the shark as an aquatic monster. On the other hand, sharks are not the friendly animals that some shark supporters like to portray. Underwater wildlife photographer Marty Snyderman summed it up this way:

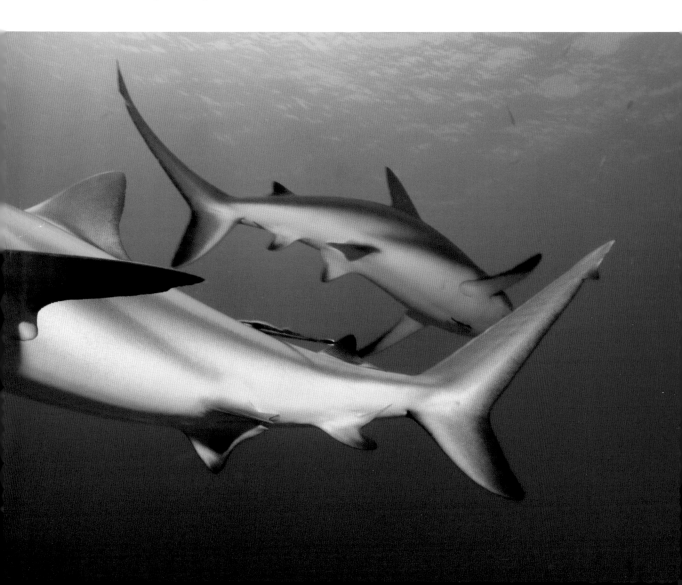

"When trying to explain what it is like to dive around big sharks, crocodiles, sea lion bulls, billfishes, toothed whales and other animals that might collectively be referred to as 'Mr. Big And Might Be Dangerous', I find myself walking a tricky line. If I say, of course they are dangerous and they will bite you (they are big, wild, muscular, toothy animals), I feel like I am being overly dramatic. If, on the other hand, I say no to all of that danger stuff made for television and movies, I am being a long way from truthful.

The truth is somewhere in the middle. Different species differ greatly. Different animals of the same species often differ greatly. The same animal can be very different on different days, and even different minutes.

Diving around and photographing big, potentially dangerous marine animals has been one of the great joys of my life. And along the way, I have also witnessed the other side. My advice is to always take them seriously. Never be cavalier. Never drop your guard. If you aren't comfortable in a situation, get out of it. All of the "they are just big puppy dogs" macho talk that we so often hear when alcohol starts doing the talking at cocktail parties scares me. I am afraid someone that doesn't know better will believe it.

I think diving with 'Mr. Big' is a wonderful way to have fun and learn about life on this planet, but it's a dumb reason to get hurt if you take those creatures for granted."

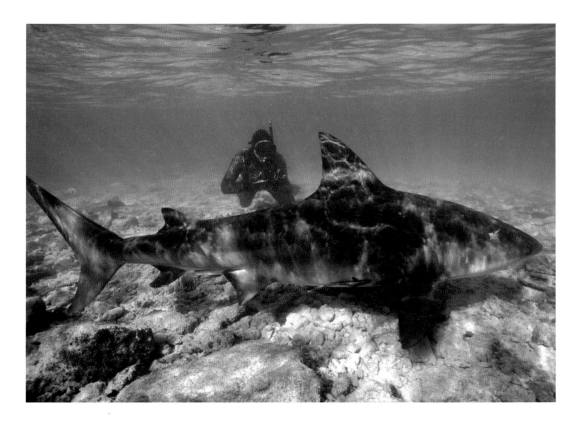

Sharks Keep Messing With My Wallet

by Bret Gilliam

Bret Gilliam is a 44-year veteran of the professional diving industry and has worked on scores of movie and documentary films and well as being extensively published. He is one of diving's most successful entrepreneurs and was inducted into the AUAS Diving Hall of Fame in 2012.

My father was a senior naval officer who watched the first episode of *Sea Hunt* with me back in 1959 while we were stationed in Key West, Florida. The exploits of Lloyd Bridges as underwater hero Mike Nelson sufficiently impressed him with scuba diving that he let me take one of the first local courses offered back in that era. I was already a very active snorkeler and freediver and he figured that I could handle the challenge.

Interestingly, I saw a shark on my first dive… under a fishing charter boat at the dock where my lessons were taking place. My instructor, who never actually went in the water with me, was cleaning grouper and snapper on the pier and tossing the discarded parts in the harbour. I was eight years old and surfaced briefly to report on what I'd seen. My mentor told me not to worry about a reef shark and to finish my 'ditch & don' exercise so he could 'pass me' on the scuba course and let me start cleaning the bottom of his boat hull of barnacles and seaweed. So I guess, in retrospect, that I earned my c-card and several 'specialties' the same day in 'Shark ID' and 'Bottom Cleaning'. My instructor was more worried that the shark was going to frighten me off and he'd miss out on the $15 training fee. And, of course, the free hull scraping that he'd already assigned me to complete.

A few years later, I started a fish trapping business and sold my live catch of angelfish, parrotfish, tangs, yellowtail, grouper, and hogfish to the local municipal aquarium. Some weeks I made over $75… a fortune at the time for a 10-year-old. But since I didn't have a driver's license, I had to hire a 22-year-old Navy ensign to drive me from the dock to downtown Key West to sell my wares. This was more than a bit ironic since I was actually making more money than the young naval officer was back then.

And he did not like sharks at all. Part of this was probably from his origins in landlocked Ohio. This became an issue when the aquarium asked if I could catch some sharks for their big tanks that would thrill the tourists. I got some bigger traps and managed to coax some small sharks into them with chum and fish carcasses and created a whole new division of my little enterprise. But my Navy assistant flatly refused to help remove the sharks from the traps when we hauled them up. Now this was hitting me in the wallet since sharks were getting me nearly three times what I was paid for reef fish. So I had to let him go and get an older grizzled character that was pushing nearly 30 years of age to help me. And he wanted to get paid more. I had no choice but to agree since I couldn't legally drive. And couldn't see over the steering wheel anyway. So I decided to make him a partner. It diluted my profits but ended any discussion of the hazards of our joint venture. I was off on my entrepreneurial path and I was still in the 5th grade.

Later when I was recruited right out of college into a Navy experimental diving project filming fast attack submarines in 1971, our team quickly found out that we had a lot of problems with aggressive oceanic whitetip pelagic sharks in the deep Caribbean waters where we worked.

Sometimes we'd have scores of these big fellows attracted to our support ship and crew members would have to push them out of the way with boat hooks so we could jump in the water to start our dives. One day when one of the sharks bit the flipper right off one of the divers we aborted and climbed back aboard. The captain immediately met us on the working deck and explained that this was an extremely high priority mission and that he had the authority to offer us a 'hazardous duty' pay supplement of $25 a week. Again, that was a fortune back then… nearly a 25% increase! So we scrounged another fin for the guy and went back in. It was simple economics.

When that project ended, I went into commercial diving on a project using TNT explosives in what were called 'shaped charge arrays' to blow up the bottom of the channel that Hess Oil used for their oil tankers. When these massive TNT racks were set off they caused a surface pillar of water that shot up to 3o feet into the air… usually carrying a lot of incidental reef fish kills with it. Within minutes, the reef and bull sharks moved in for feeding and chaos ensued since a lot of the nearly 120 divers on the project wouldn't go back in the water until the sharks cleared out. But others of us saw financial opportunity raise its head again and armed with bang-sticks of the era we'd go back to work… for another pay raise. Frankly, I think if they asked us to dive in a nuclear reactor in swimsuits we'd have done it… if the price was right.

Sharks continued to be part of my business model when I started my first company V. I. Divers Ltd. in St. Croix in the fall of 1973. Now I found that there were two types of diving tourists: those who were excited to see sharks and others who would pay more to be guaranteed that they would not. We accommodated both and quickly learned to charge the first group extra as well for the 'risk' we were taking to show them the occasional reef shark or giant nurse shark that could be found.

Then a totally unforeseen economic tragedy occurred. In the summer of 1975, a movie was released called *Jaws*. And it simply scared the total crap out of 90% of the audience that saw it. People stopped going in the water at the beaches back in the U.S. Water skiing almost ceased completely along with almost anything that required a sane human being to go in the ocean. None of that bothered me down in the Virgin Islands since most of our local population were, at least, somewhat used to seeing the occasional shark, and it also took nearly another year for the movie to show in our local theatres. But we didn't yet see the more insidious effects of large mechanical sharks eating naked pretty blonde skinny-dippers or lead character Robert Shaw right off the back of his boat in the big ending.

No… to our horror, diving certifications in North America plunged nearly 70% in the aftermath. We depended on those new entry divers to fuel our dive trips and fill my wallet. And now some skinny kid director named Steven Spielberg and a Princeton novelist named Peter Benchley had just sabotaged my business model! I needed divers to fill my boats and most of America and Canada seemed to have taken up golf or bowling. It took nearly two years to get people back in the water again. My dive tour business was off nearly 40%. A vicious hit to my wallet just when I thought I had some insight into the burgeoning diving industry.

But we were not ones to simply accept our fate. We found out that scaring the holy hell out of

people was actually good business if we lent ourselves to the various silly television specials that quickly came into production with nonsensical themes like 'shark tagging' competitions. The first one came down to the Virgin Islands in 1976 with luminaries like Ron and Valerie Taylor to judge the performance of then-unknown heroes like Howard Hall and Stan Waterman's son Gordy who got paid a pittance to compete against others desperate for cash, a cheap hotel room, and a couple of Piña Coladas. I rented several boats and support staff to these types of productions and made a small fortune. There was only one problem: we hardly ever saw any sharks. In fact, Howard won the contest when he tagged the only shark we ever saw in nearly a week of filming off St. Thomas.

More than once, Ron Taylor would suggest something radical like, "If ya wanna do a shark competition, let's make off to Dangerous Reef in South Australia and I'll promise ya more great whites than kangaroos on ANZAC day." But this didn't go over well with most of the competitors and airfare to Sydney was a bit steep. Secretly, I sighed with relief when the various television producers chose to ignore one of the world's leading experts on sharks and kept coming back to the nearby Caribbean with their budgets. Now if we could only come up with some sharks.

We'd managed to cultivate a few bull and lemon sharks off the small cays by chumming like mad and that kept the money streaming as fearless teams of 'competitors' would be brought down to stick a tag from a long pole into the back of a lemon shark about six feet long that was thoroughly disinterested in the whole process once we ran out of fish heads and carcasses. Oh, and did I mention that they accomplished these feats from the safety of massive shark cages? Again, we were not about to argue with the scripts as long as the Hollywood guys showed up with money.

In 1979, I think we hit the pinnacle of absurdity. A new cable network called HBO contacted me about their concept for a really daring new idea for a shark special: the fearless hero competitors would work without the safety of cages! When they breathlessly previewed this revolutionary idea, I immediately agreed. And raised my daily rate for boats and staff. The producer / director then asked me the key question that would be the determining factor as to whether he could get the budget from HBO: "Can I guarantee sharks?" He'd seen and heard about the previous TV specials that had about as much action as a mid-afternoon soap opera and wanted me to confirm that I could find sharks and get them in the camera frame. I swallowed hard, patted my wallet, crossed my fingers, and swore that I could produce more sharks than confetti on New Year's Eve – because I had an ace in the hole:

I was part of the Virgin Islands National Spearfishing team since 1971 and we had long ago stopped hunting the bottom reef fish since it was too easy. We'd taken up pursuit of offshore pelagics like dolphinfish, kingfish, tuna, wahoo, and other big fellas out there in the blue bottomless depths of the ocean between St. Croix and St. Thomas. We also dealt with the constant 'up close and personal' attention of the aggregations of oceanic whitetip sharks that I had first been introduced to back during the Navy project eight years before. They were everywhere and easily attracted. Give me a bag of chum and a couple of tuna chunks and I'd have 30-40 wonderful shark 'actors' in about twenty minutes.

So down came the film crew, producer, director, and the HBO guy with the chequebook. They chartered two of my boats and staff for eight days. And they hand-picked three teams of fearless shark tagging competitors to show off their skills. We met that first evening and I let them tour the dive vessels, meet the staff, and then pulled out the chart to show them our intended filming location about five miles north of St. Croix where we had already scouted our rich resource of oceanic whitetips. I showed them some film I'd already shot of these active 8-12 foot predators and waited for the hand-clapping enthusiasm to flow forth.

Wrong. It seemed that the chosen 'professional shark divers' flatly refused to dive with oceanic whitetip sharks under any circumstance. These sharks had a bit of a bad reputation for their aggressive behaviour and reckless chomping on anything within range. So without further discussion, I was ordered to come up with an alternative plan. I didn't have one since we really didn't have much of a shark population in the Virgin Islands and I thought the idea of the oceanic whitetips was perfect. I even reminded them of the great sequence from *Blue Water, White Death* that showed the Taylors, Stan Waterman and Peter Gimbel cavorting with hundreds of them as they fed on a whale carcass off South Africa. This retrospective only served to fuel the absolute denial of any such diving. So we spent a week desperately trying for any sharks we could attract around the coastal reef areas and completely struck out.

Mind you… I was getting paid top dollar anyway and really didn't see it as my fault that the chosen competitors seemed to come up a little short in the 'cojones' department. Finally, the director quietly came up to me and said he was out of money but had heard that some guy in San Diego was having some luck finding blue sharks. Since this was practically in the director's back yard, I urged him to get in touch with this upstart… a guy named Howard Hall.

So we put the HBO crew back on a flight home and they went out for a day with Howard and two other guys on an outboard boat off San Diego. They got more sharks in one afternoon than any of these silly shark competitions combined to date. The director even managed to provide a key big finish to the film when he accidentally got bitten in the head by a six-foot blue shark in the midst of all the chum. Yeah, that's the stuff action documentaries are made of.

It all seemed so easy in later years when we made films with tiger, hammerhead, and great white sharks over 20 feet in length. Howard and I hung in there. And the wallets got bigger, too.

Looking for **adventure?**

Amazing Stories

Treasure troves of incredible true tales from every corner of the globe.

Ultimate Adventures

Collections of 100 extraordinary experiences brought to life with striking full-page photography.

Discover all of these titles and much more at **www.fernhurstbooks.com**, *where you can register to receive our latest news, details of new books and exclusive special offers.*